Gift to the

EVANSTON · PUBLIC
LIBRARY

from **Evanston
LibraryFriends
in honor of the
LibraryStaff**

*Evanston Library Friends
Holiday Book Fund*

MAX BECKMANN IN EXILE

MAX BECKMANN IN EXILE

GUGGENHEIM MUSEUM

MAX BECKMANN IN EXILE
Guggenheim Museum SoHo
October 9, 1996–January 5, 1997

This exhibition is sponsored by

⊖ **Lufthansa**

Significant additional support has been provided by

Deutsche Bank

ISBN 0-8109-6899-1 (hardcover)
ISBN 0-89207-174-5 (softcover)

Printed in Italy by Mariogros

Designed by Michelle Martino

Hardcover edition distributed by
Harry N. Abrams, Inc.
100 Fifth Avenue
New York, New York 10011

Guggenheim Museum Publications
1071 Fifth Avenue
New York, New York 10128

Deutsche Telekom is a proud sponsor of the
Guggenheim Museum SoHo and the Deutsche Telekom Galleries.

To be a human being means, more than anything else, to
communicate. To communicate about the world we live in, our past,
and our future. Art is one of the oldest means of fulfilling the human
need to communicate. Art is communication—a work of art
communicates how its creator sees the world, and it stimulates a
conversation between the artist and the viewer. Art encourages
communication—between people and between nations. That is why it
is only fitting for us to accompany our communications work with
support for Modern art and in particular for the Guggenheim
Museum. We invite you to join us on the journey into this fascinating
world through the art presented in the Deutsche Telekom Galleries.

Deutsche **T· ·**
Telekom

CONTENTS

PREFACE

Thomas Krens

The Guggenheim Museum is proud to present *Max Beckmann in Exile*, the first New York museum exhibition of the artist's paintings in over thirty years. Beckmann is unquestionably one of this century's great masters. Speaking to the depth of human experience, his works confront both our joy and our pain and probe the paths of our existence. He turned personal tragedy into one of Modern art's great triumphs, overcoming enormous obstacles during a tumultuous period of exile to produce some of the most important works of his career.

My sincere gratitude goes to Matthew Drutt, Assistant Curator for Research, who organized this exhibition with sensitivity and intelligence, resulting in an elegant collection of paintings and a catalogue that makes a significant contribution to scholarship on the artist. I am also grateful to Richard L. Feigen, who first suggested this project to us, and who was instrumental in helping us bring it to fruition.

The Guggenheim Museum has been extremely fortunate to work once again with Lufthansa German Airlines to bring about a landmark exhibition of an important artist's work. Lufthansa's long-term commitment and support of the Guggenheim has made possible some of our most significant and memorable projects, and we are most grateful to them for their assistance.

My thanks are also due to Deutsche Bank, in particular to Hilmar Kopper, Spokesman of the Board of Managing Directors; Carter McClelland, President and CEO of Deutsche Bank North America; Herbert Zapp, Member of the Board of Managing Directors (retired); and Michael Rassmann, Executive Vice President and General Manager in North America. Its global arts support is fundamental to the ongoing presentation of projects such as this one.

We are pleased to present this exhibition in the Deutsche Telekom Galleries of the Guggenheim Museum

SoHo, and I am indebted to Dr. Ron Sommer, Chairman of the Management Board, Deutsche Telekom, for his ongoing support of the Solomon R. Guggenheim Museum and the Guggenheim Museum SoHo, in particular. Deutsche Telekom's visionary dedication to the arts has once more enabled a compelling exhibition.

Finally, this exhibition could not have been realized without the extraordinary generosity of the lenders. Their willingness to share their collections and make these remarkable works available to a broader audience is greatly appreciated.

ACKNOWLEDGMENTS

Matthew Drutt

10

This exhibition came about as a result of a dialogue with Richard L. Feigen, whose passion for Max Beckmann's work has been a source of inspiration. My own love of Beckmann was previously confined to his brilliant paintings of the 1920s, but Richard opened my eyes to the power of his later works. His support of this project was instrumental, and I am deeply indebted to him for his counsel and generosity. I am also most grateful to Mayen Beckmann, whose assistance and advice was fundamental to numerous aspects of the development of this exhibition.

This project has been a team effort, and I wish to thank the museum's staff for their dedication and hard work in bringing this exhibition to fruition. I am especially grateful to Thomas Krens, Director, who allowed me to undertake this project and has been supportive at every step along the way. I would also like to thank Lisa Dennison, Curator of Collections and Exhibitions, for her invaluable advice. Ben

Hartley, Director of Communications; George McNeely, Director of Corporate and Foundation Giving; and Barbara Steffen, former Executive Assistant to the Director, are owed a debt of gratitude for their efforts in securing funding for the exhibition. Scott Gutterman, Director of Public Affairs; Christine Ferrara, former Public Affairs Coordinator; and Laura Miller, Director of Visitor Services, are responsible for the outstanding promotion of the project.

This catalogue could not have been realized without the expert management of Laura Morris, Senior Editor, whose editing skills and creative suggestions were invaluable. Anthony Calnek, Director of Publications; Elizabeth Levy, Managing Editor; Jennifer Knox White, Associate Editor; Carol Fitzgerald, Assistant Editor; and Melissa Secondino, Production Assistant, also made important contributions to this publication. I am especially grateful to Michelle Martino for her aesthetic acumen in designing the

catalogue. A special note of appreciation is due to Eric Fischl, Stephan Lackner, Reinhard Spieler, and Barbara Stehlé-Akhtar for their significant contributions to the publication. I am grateful as well to Diane Dewey, Assistant to the Director, and curatorial interns Patricia Druck, Angelika Gornandt, Nana Poll, and Ursula Tax, whose generous assistance was most helpful to me.

The difficult task of transporting Beckmann's paintings has been skillfully handled by MaryLouise Napier, Assistant Registrar, Exhibitions, with Suzanne Quigley, Head Registrar, Collections and Exhibitions. Linda Thacher, Exhibitions Registrar, provided assistance at early stages of the project. Dennis Vermeulen, Senior Exhibition Technician; Jocelyn Groom, Assistant Exhibition Design Coordinator; Peter Read, Production Services Manager/ Exhibition Design Coordinator; Christopher Skura, Museum Technician; and Adrienne Shulman, Lighting Designer, orchestrated the myriad details of the exhibition's installation with great care and sensitivity. I am grateful as well to Gillian McMillan, Conservator, and Carol Stringari, Associate Conservator, for their counsel.

Numerous research institutions in the United States and Germany provided key assistance in the development of this project, but I am especially grateful to the staff of the Max Beckmann Archive in Munich. My thanks are also extended to Susan M. Bielstein of the University of Chicago Press.

To the sponsors of the exhibition, I am most thankful. Without their generous support, an exhibition of this complexity and import could never have occurred. Finally, I owe my deepest gratitude to the lenders. Their generosity in making these extraordinary works available will allow many to experience the richness of Beckmann's art for the first time, and in so doing, help fulfill his vision of art's ability to fundamentally transform our lives.

SPONSOR'S STATEMENT

For Lufthansa, the exhibition *Max Beckmann in Exile* at the Guggenheim Museum forges yet another link in the artistic chain of events coupling a major international airline with a universally recognized and respected cultural institution. We share a common global vision: bringing together artists and works of art to better understand the circumstances that foster communication—between different countries and cultures, and between voices expressing varying viewpoints.

Over the past ten years, Lufthansa has developed a mutually beneficial relationship with the Guggenheim, which has enabled us to show our support for a number of highly successful exhibitions. Earlier this year, we helped bring to fruition what has come to be regarded in the cultural community as an unprecedented undertaking, the recently concluded *Africa: The Art of a Continent*.

Lufthansa also took on the role of principal collaborator with the Guggenheim for the monumental 1992 exhibition *The Great Utopia: The Russian and Soviet Avant-Garde, 1915–1932*, bringing together both people and art in one of the most complex logistical endeavors ever undertaken by the museum. In 1989, we partnered with the museum on *Refigured Painting: The German Image, 1960–88*, a presentation of vital and relevant painting that attracted new audiences for contemporary work.

We believe that the art of today not only reflects the present and interprets the past, but also indicates some of our most immediate concerns for the future. Through our sponsorships, Lufthansa is encouraging worldwide cultural communications. We take pride in facilitating this exchange of ideas.

 Lufthansa

INTRODUCTION

Matthew Drutt

There are few German painters who have had as long and distinguished a career as Max Beckmann, and fewer still who have been able to sustain the consistent level of excellence he maintained throughout his career. Some, such as August Macke and Franz Marc, had their lives cut tragically short while serving in war, while others, such as Otto Dix, George Grosz, and Christian Schad, were unable to regain their creative edge following Nazi persecution. Beckmann not only survived such misfortunes but excelled in spite of them. Between 1905 and 1950, he created more than eight hundred paintings and produced hundreds of prints and drawings, a phenomenal output under any circumstances, and even more considerable when one realizes the challenges that faced him during the height of his career. Persecuted by the Nazis, he was forced to flee his homeland and work in relative isolation while the war turned Europe upside down.

A painter's painter, he eschewed identification with a particular school or style. His oeuvre is a celebration of painting's grand traditions—the still life, the portrait, history painting, and allegorical and mythological subjects—articulated in a visual style that has often been described as Expressionist. But while his frenetic brushwork and highly complex, metaphysical iconography have much in common with German Expressionism, Beckmann's paintings never succumbed to the Modernist tendency to render the world abstractly. In his 1938 lecture "On My Painting," Beckmann explained: "I hardly need to abstract things, for each object is unreal enough already, so unreal that I can only make it real by means of painting."

Beckmann has been celebrated in numerous group and solo exhibitions as one of this century's finest painters, but few shows have focused solely on his late work. *Max Beckmann in Exile* brings together twenty-two major paint-

ings, including seven of his nine completed triptychs, all of which relate in some specific way to the odyssey that brought him from Berlin to Amsterdam in 1937 and to the United States in 1947. Full of joy and hope in part, they are also laced with dread and anguish, reflecting the tumult of emotions and events that Beckmann experienced following his departure from Germany.

Beckmann was born in Leipzig in 1884, the youngest of three children. His father, a grain merchant, died when Beckmann was only ten years old. By the age of fifteen, after several years of boarding school and over his family's objections, he decided that his destiny lay as a painter. After failing the entrance exam for the Königliche Akademie der Bildenden Künste in Dresden, Beckmann was accepted by the Grossherzogliche Sächsische Kunstschule in Weimar in 1900. The school provided him with an academic art education, whereby he learned to draw from antique sculpture as well as from live models. At school, he met Minna Tube, a fellow artist whom he married in 1906 and who gave birth to his only child, Peter.

After completing his studies in 1903, Beckmann made the first of many trips to Paris, the city that to him represented the peak of artistic accomplishment. The political upheaval caused by two world wars, however, would prevent him from ever realizing his goal of permanently settling and pursuing his art there.

By 1906, Beckmann had become an accomplished painter. After moving to Berlin, he participated in exhibitions with the Berlin Secession, the predominant voice of Modern German painting at the time. Like the works by its senior members—Lovis Corinth, Max Liebermann, and Max Slevogt—Beckmann's paintings from this period are characterized by the legacy of Impressionism, with landscapes and beach scenes rendered in stippled brushstrokes to

evoke the play of light across forms. He was held in such high regard by his colleagues that, in 1910, he was elected to the executive board of the Secession, becoming the youngest member ever to achieve such a distinction. Preferring art making to policy making, however, he resigned the following year in order to devote himself full-time to painting.

In the years leading up to World War I, Beckmann's work evolved into grand compositions of religious and mythical subjects in the tradition of Eugène Delacroix, Peter Paul Rubens, and Rembrandt van Rijn. The war interrupted his work, however, and after serving as a medical volunteer for a year, he suffered a breakdown and was discharged to Frankfurt in 1915 to recuperate. When he began to paint again in earnest in 1917, his style changed radically, assuming a Northern Gothic sensibility couched in a Modern idiom. His forms became more mannered and polished; his colors became more intense; and his rendering of space took on a vaguely Cubist orientation, with figures compressed into torturous settings and angular forms tilting precariously toward the picture plane. His works became a mosaic of contemporary social criticism and religious or mythical themes, and he increasingly used masked or costumed circus characters as allegorical figures, a practice that became a hallmark of his art.

By the mid-1920s, Beckmann had become one of Germany's foremost Modern painters. His work was hailed as a leading example of Neue Sachlichkeit (New Objectivity), a short-lived movement distinguished by the rejection of Expressionism and the revival of realism. Often cynical in its outlook, Neue Sachlichkeit moved away from the subjectivity of Expressionist emotion and chronicled the bourgeois excesses of Weimar culture with a frighteningly detached demeanor. While Beckmann certainly

engaged in social criticism in his work during this period, he did so in a broader context than other artists associated with Neue Sachlichkeit, such as Dix and Grosz, continuing to confront metaphysical issues in his paintings.

In 1925, Beckmann was appointed to teach at the Kunstgewerbeschule of the Städelsches Kunstinstitut in Frankfurt, a position he held until 1933. Also in 1925, he divorced Minna Tube and married Mathilde (Quappi) von Kaulbach, who became the subject of many of his important paintings. The following year, he had his first solo exhibition in the United States, at J. B. Neumann's New Art Circle gallery in New York, thereby expanding his reputation in the international art community. With several distinguished publications devoted to his art already in circulation, Beckmann was accorded a large retrospective exhibition in 1928 at the Kunsthalle Mannheim, organized by its director, G. F. Hartlaub (the originator of the term

Neue Sachlichkeit). That same year, Beckmann received one of the nation's highest honors in the fine arts, and a gold medal from the city of Düsseldorf in recognition of his artistic achievements. In 1930, a permanent gallery for Beckmann's art was established at the Städtische Galerie of the Städelsches Kunstinstitut. Two years later, he received further distinction when a room was dedicated in his honor at the Nationalgalerie in Berlin and ten major works by him were placed there on permanent display.

With Hitler's appointment as chancellor in 1933, Beckmann's good fortune, and that of German political and cultural life in general, abruptly declined. The Nazis viewed Modern art as socially and morally corrupt, and they began to purge Germany's cultural institutions of everything they perceived to be weakening the fiber of the country's heritage. Beckmann's work, along with that of many artists held in high regard today, was suddenly labeled "degenerate."

Art dealers who had supported Beckmann now shied away from him or left the country fearing Nazi persecution. Beckmann's art was methodically removed from German museums, and by 1937, nearly six hundred of his works had been confiscated. That July, following Hitler's radio broadcast at the opening of the infamous *Degenerate Art* exhibition—the Nazi propaganda exercise that definitively extinguished the avant-garde in Germany—Beckmann fled with his wife to live with her sister in Amsterdam, never to return again. It was an abrupt and humiliating transition for an artist who had been hailed only four years earlier as a national treasure.

For the next ten years, Beckmann worked largely alone, except for the company of his wife and a few close friends, using a large tobacco storeroom as his studio. The outbreak of war in Europe confined him to Amsterdam, except for occasional sojourns to Paris or the Dutch countryside.

Beckmann's diaries from these years are replete with accounts of his frequent visits to cabarets, carnivals, and the theater. On one level, these distractions offered temporary relief from the horrors of the war, the tragedies of which nonetheless found their way into his art. On another level, however, Beckmann regarded them as allegories of human existence. Thus, his paintings from these years—some of the most important works of his career—are abundant with subjects whose identity is both constructed and obscured by masquerade. Indeed, three of the triptychs, *Akrobaten* (*Acrobats,* 1939, cat. no. 8), *Schauspieler* (*Actors,* 1941–42, cat. no. 11), and *Karneval* (*Carnival,* 1942–43, cat. no. 13), make specific reference to these genres, offering grand theatricalizations of human tragedy rather than celebrating the lighthearted pleasure such spectacles usually elicit.

In the war's aftermath, Beckmann immigrated to the

United States, where he taught and painted during the last three years of his life. By this time, he had found widespread acceptance as a major force in twentieth-century art. When he died in December 1950, he had just finished *Argonauten* (*The Argonauts*, 1949–50, cat. no. 20), the ninth of the monumental triptychs that distinguish his mature career. His studio contained several unfinished canvases—including a tenth triptych—testifying to the boundless creative energy that he possessed in spite of his failing health.

What follows in this catalogue are several unique perspectives on Beckmann's life and art over the thirteen years he spent outside Germany. Time and again, his elation over critical acclaim was tempered by a feeling that his work was profoundly misunderstood. In "From Obscurity to Recognition: Max Beckmann and America," Barbara Stehlé-Akhtar probes the critical reception of Beckmann's work in the United States and discusses the stylistic evolution of

major works from the period that reveal Beckmann's contemplation of his own metamorphosis.

Reinhard Spieler's "Pictorial Worlds, World Views: Max Beckmann's Triptychs" offers a fresh reading of the triptychs, eight of which were painted outside Germany. These great works exemplify Beckmann's life-long confrontation with the themes of love, death, suffering, and redemption. Spieler identifies and examines specific characters and settings that the artist deployed, offering us key insights into the dense iconography of these works.

Beckmann was an intensely private individual. The diaries he kept between 1940 and 1950 offer only brief glimpses into his frame of mind. In "Shared Exile: My Friendship with Max Beckmann, 1933–1950," Stephan Lackner provides rare personal insight into the artist, sharing passages from their rich correspondence and describing their experiences of émigré life. Lackner befriended

Beckmann in 1933 and went on to amass one of the greatest private collections of his work. Thus, his writings on the artist over the past decades are a veritable bible of scholarship on Beckmann.

This catalogue also includes two lectures delivered by Beckmann after leaving Germany. "On My Painting" was first read in London in 1938 on the occasion of the exhibition *Twentieth Century German Art*, which was organized as a counterpoint to Hitler's *Degenerate Art* exhibition. "Letters to a Woman Painter" was written on the invitation to speak at Stephens College in Columbia, Missouri on February 3, 1948. It was read there for Beckmann by his wife Quappi, as well as at several other colleges and art schools in the United States. Both works provide us with Beckmann's eloquent voice on issues of art and aesthetics. Finally, artist Eric Fischl provides us with a personal reading of Beckmann's first triptych, *Abfahrt (Departure,*

1932–33, cat. no. 3), an homage from one celebrated painter to another. In so doing, he exemplifies one of the driving forces behind the organization of this exhibition: a consensus that Beckmann has served as an important touchstone for several generations of artists.

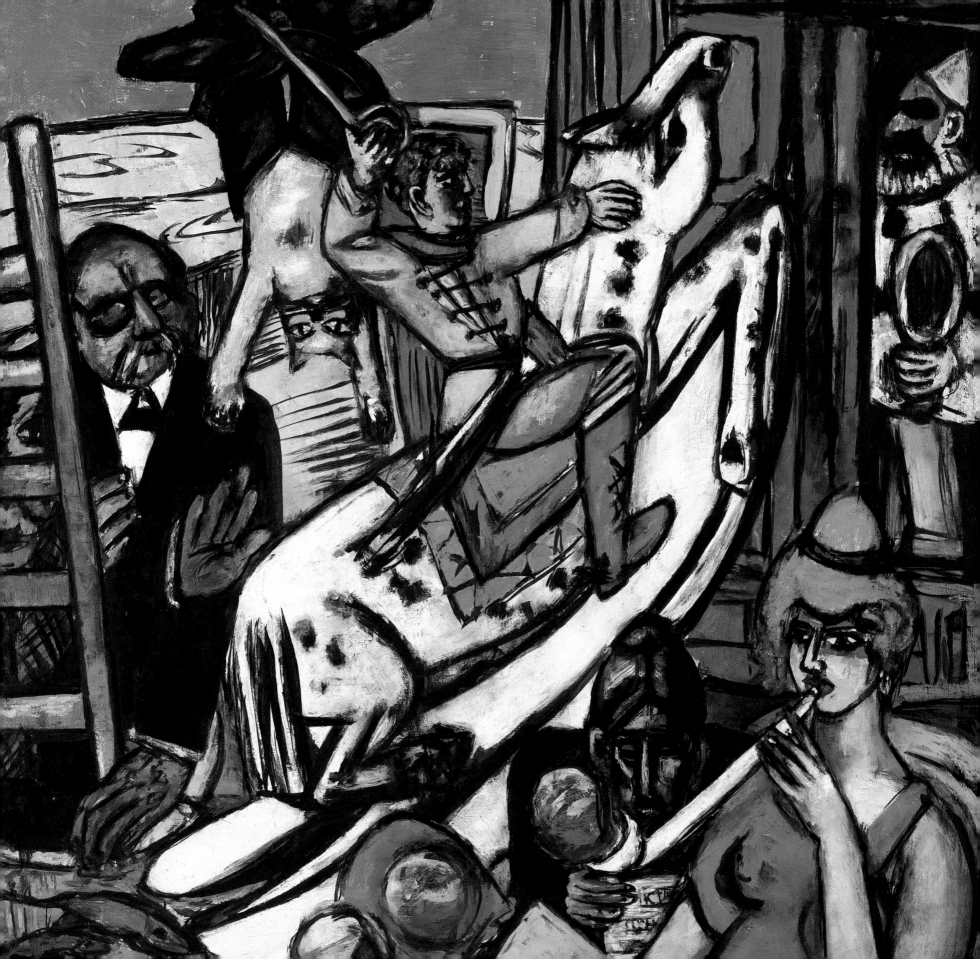

FROM OBSCURITY TO RECOGNITION: MAX BECKMANN AND AMERICA

Barbara Stehlé-Akhtar

Prejudice in the United States against German Art

Among the caustic remarks aired in New York during the 1920s, one might have read, "It is not news to say that the French lead the modern world in art. That fact was born out upon the un-French long ago."[1] Twenty years would pass before the comparison would be recast, giving unexpected credit to a German painter: "Only Picasso . . . approaches Beckmann's aesthetic power."[2] Renowned after being all but ignored, and sought after as a professor by American universities, Max Beckmann became the most popular of German artists in the space of two decades. His rise, which corresponds to the transformation of both his palette and style, began at the end of the 1920s, when his Berlin dealer, J. B. Neumann, decided to move to the United States. A few years earlier, in 1926, having resolved to exhibit the strengths of the new German painting, Neumann had taken on the difficult task of representing an unknown.

Far from the Old World, the audience in New York had only a limited knowledge of avant-garde work. The *International Exhibition of Modern Art,* commonly known as the Armory Show, had provided, in 1913, a selection of the artistic explorations of the twentieth century, focused in large part on the French aesthetic. That distorted reflection of the European movements created the impression that German art was of only minor importance—yet, ironically, the very idea of the American exhibition had been inspired by the example of the Sonderbund in Cologne.[3] At the heart of this voluntary pushing aside of Expressionism and German art in general lurked the pervasive belief that the great artistic achievements made since the nineteenth century, if not earlier, firmly belonged to the French. Despite the early, persistent efforts of Alfred Stieglitz and Katherine Dreier to foster a more complete picture of the European avant-garde, the far-reaching impact of the Armory Show

Detail from central panel of *Beginning,* cat. no. 19.

overshadowed what those two pioneers could promote through their respective galleries.

The German avant-garde movements had long remained a subcategory of Modern art. Ranked far below French art, the paradigm of Modern art, German trends were seen as lacking nuance and harmony of color. However, it was conceded that Germans had a talent for printmaking. *Contemporary German Graphic Art*, a major exhibition on view at the Art Institute of Chicago in 1912, did not change the way German art was viewed in the United States, but it contributed to the affirmation of a German art worth considering. The organizers of the exhibition strove to give as exhaustive a presentation of German art as possible, including the work of such artists as Ernst Barlach, Vasily Kandinsky, Ernst Ludwig Kirchner, Käthe Kollwitz, Wilhelm Lehmbruck, Franz Marc, and Max Pechstein. A *New York Times* critic, while enthusiastic, confessed, "Their taste [the Germans'] . . . is not so familiar to us and not always so acceptable as French taste. Their aesthetic expression is more often overpowering and not so easily understood."[4] Work by Beckmann was presented next to that of Lovis Corinth. They were described as "earnest artists of wild inspiration and almost brutal masculine power."[5] Grouping him with Corinth, who exerted great influence on Expressionist printmaking (especially on Pechstein), was tantamount to associating him with the greats. *Eurydikes Wiederkehr* (*The Return of Eurydice*, 1909) and *Sechs Lithographien zum Neuen Testament* (*Six Lithographs for the New Testament*, 1911) gave some indication that the young Beckmann, still working in an Impressionist style, had within him the energy and the desire to penetrate life's mysteries.

The promotion of German painters was then taken up by W. R. Valentiner, who in 1923 organized *Modern German Art*, an exhibition at the Anderson Galleries, New York. This great defender of German art, who in the 1930s would become a friend of Beckmann and have his portrait painted by the artist, did not include a single painting by Beckmann among the 274 works by contemporary artists shown at the Anderson Galleries.[6] The majority of those invited to participate were from the German avant-garde groups the Brücke (Bridge) and the Blaue Reiter (Blue Rider). Although many visited the exhibition, it was a financial disaster, coinciding with inflation in Germany, and it came up against conservative art critics. Royal Cortissoz panned it in a column in the *New York Tribune* titled "Modern German Art in Exhibit Here Is Crude."[7] While the technique of the works was generally praised, their beauty was usually not recognized. It would take many more encounters with various aspects of German painting before this attitude would change.

A Misreading

Beckmann's painting, as it was shown in 1926 and 1927 exhibitions at Neumann's New Art Circle, New York, was representative of what most critics found troubling. These works, dating from 1917 to 1925–26, concentrated on effects of volume created with color; their technique allied them to sculpture. The skin of Beckmann's figures was endowed with a stonelike quality comparable to Gothic statuary. Embracing distortion and sharp angles in his forms, Beckmann made use of Cubist techniques to subvert space and achieve a sense of suffocation, found also in the work of other artists during the years the Weimar Republic was failing. The press completely ignored the exhibition of 1926.

By 1927, although the work itself had not changed, Neumann had begun to carve out a place for himself in the New York art scene; as a result, it received subdued attention. Henry McBride objected, "Herr Beckmann puts his nose too close to the ground. Like the Zola of France, he thinks too much of the thing and not enough of the manner."[8] Adolph C. Glassgold saw in the work "the all pervading reality of hate, merciless devastation, or unmitigated misery as the truth of life."[9]

Beckmann, reflecting upon disorder and cruelty, did not hesitate to give his work a social connotation, but, unlike George Grosz, who often used sarcasm, he was rarely spiteful. Acerbic, but not allowing his outlook to get trapped in hatred for long, Beckmann tried definitively after 1923 to avoid cynicism. The journalists, however, finding the painter's discourse so clearly lacking in restraint, could not help but qualify it as pessimistic. Beckmann's work, however, had been proceeding since 1925 toward a new, open style, of which the critics were unaware. The works included in Neumann's exhibition of 1927, as the catalogue makes clear, demonstrate this renewal. Beckmann himself pointed it out: "My form has become clearer and freer without losing its precision, and, favored through several happy circumstances . . . I am now moving along the road toward the fullest harmony."[10] While it is true that a minor key dominated the exhibition, with such canvases as *Tanz in Baden-Baden* (*Dance in Baden-Baden*, 1923) and *Italienische Fantasie* (*Italian Fantasy*, 1925), there were also paintings that announced a revival of brilliancy.[11] A stylistic turning point is evident in the 1924 painting *Bildnis Käthe von Porada* (*Portrait of Käthe von Porada*). In it, the influence of Gothic art evident in Beckmann's work after he returned from the war has not completely disappeared, but a soft elongation has replaced the angular appearance of the sitter's limbs. The tall, narrow format of the composition heightens the hieratic melancholy of the subject, while a new element— the vivid red of the dress—enlivens the composition. *Bildnis Quappi in Blau* (*Portrait of Quappi in Blue*, 1926, see p. 24) best illustrates Beckmann's fresh direction. Among the "happy circumstances" he mentioned was his joy in living with his second wife, Mathilde von Kaulbach, nicknamed Quappi. This portrait of the young woman could be subtitled *Harmony in Blue*. The spontaneous, free brushwork, the energy of the composition, and the contrasts in light and dark work together to create a faceted, luminous composition. Although the frame crops her figure, the space does not hem in the young woman. Rather, Quappi asserts herself in it. Now using a thicker density of brushstrokes, Beckmann went to work in a manner comparable to that used by Henri Matisse when he painted *L'Algérienne* (*Algerian Woman*, 1909, see p. 25). There are many similarities between the two works, notably their luminous quality and the treatment of the bangs. Both portraits are also structured by the black used for the facial features and the geometric motifs in the backgrounds of the canvases.

Beckmann's modernity as reflected in this canvas is as indebted to the formal exercises of the School of Paris as to the themes of German Neue Sachlichkeit (New Objectivity). He was already combining different kinds of pictorial vocabularies in his canvases, such as the language of the Flemish *vanitas* and the Gothic style. He had learned to use the principles of Cubism to structure space, yet he knew to avoid using them systematically, returning instead in his landscapes to a formal naïveté that is indebted to Henri

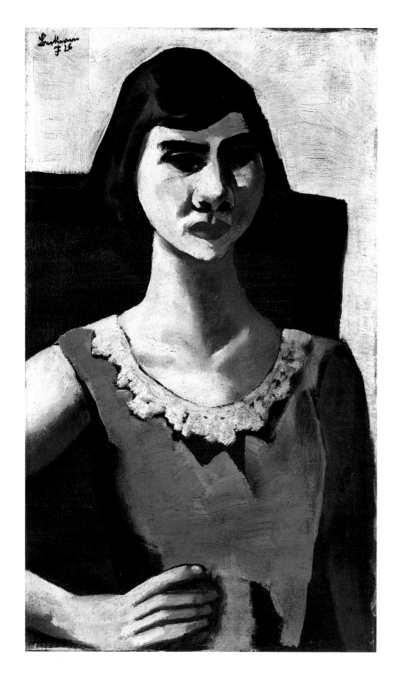

particularly defines his work of the 1920s. The later works, however, show that the artist had developed a more unified style that could be used in painting diverse subjects.

Yet at the time that he was showing at New Art Circle, the critics did not notice the diversity of his works and simply placed Beckmann among the ranks of German painters who were tied to a harsh and pessimistic view of the world. To the critics' eyes, the artist exhibited a lack of formal and thematic nuance. Their assessment, therefore, was based on a misreading of the work.

First Signs of Recognition

At the Carnegie Institute's *Twenty-Eighth International Exhibition of Paintings* of 1929, Beckmann won fourth honorable mention for *Garderobe. Die Anprobe (Dressing Room. The Fitting, 1928)*. In the wake of the award, the press reevaluated Beckmann, voicing more positive opinions and discovering new qualities in his work. A critic for the *New York Times* described the artist as "the most original and forceful of the Germans this year" and considered *Dressing Room. The Fitting* "a semi-abstraction."[12] Even more eager to revise his opinion, McBride included Beckmann among the greats, going so far as to find Pablo Picasso the only possible comparison:

Beckmann has shown before this in New York at the New Art Circle but never winningly. It was noticed that he was forcible but there was such unattractive morbidity in his manner that it was thought he was suffering from after-the-war defeatism. There is no hint of defeat, however, in his present group, and no vulgarity to speak of, but on the contrary a dynamic impact from his brushes that even Picasso could envy. He therefore practical-

Rousseau. Beckmann adopted pictorial techniques and concomitant styles best suited to his subjects, a practice that

Max Beckmann, *Bildnis Quappi in Blau (Portrait of Quappi in Blue)*, 1926. Oil on canvas, 60.5 x 35.5 cm (23 ¹³⁄₁₆ x 14 inches).
Bayerische Staatsgemäldesammlungen, Staatsgalerie Moderner Kunst, Munich, Stiftung Günther Franke.

ly makes his American debut in this exhibition in Pittsburgh and becomes a personage to be reckoned with.[13]

Dressing Room. The Fitting, which falls stylistically between tradition and modernity, became Beckmann's first work to be recognized on this side of the Atlantic. The painter, employing the theme of a woman on a balcony after Francisco de Goya and Edouard Manet, showed his model seated in the half darkness of a theater box. As in *Portrait of Quappi in Blue*, the artist used the scene as a pretext for executing variations in light and in color. Less energetically applied than those in the aforementioned painting, the brushstrokes here are broad and controlled. The woman, preening sensuously in her evening gown, seems to be wearing a pearly mask. The canvas's carefully balanced pictorial structure is effective. It recalls Fernand Léger's Cubist settings in which a similar mastery of geometrically unstable balances can be found. In a daring composition, *Dressing Room. The Fitting* marries the dexterity of its technique and decorative elements to the seduction of its subject. McBride could no longer reproach Beckmann for concentrating more on subject than on style, since the artist here demonstrated a stronger interest in formal issues.

When the Museum of Modern Art was founded in New York in 1929, Paul J. Sachs donated the first four prints to its collection, among them Beckmann's *Vor dem Spiegel* (*Toilette*, 1923).[14] Neumann, who had close ties to the museum's director, Alfred H. Barr, accompanied Barr on a trip to Germany to choose works for the exhibition *Modern German Painting and Sculpture*, which took place in 1931. Illustrating the progression of Beckmann's reputation is the fact that eight of his paintings were shown, which made him one of

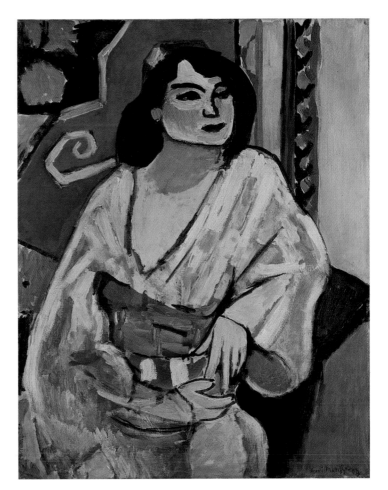

the featured artists. Neumann's influence upon Barr thus advanced the painter's career. The catalogue asserts, "Beckmann's originality of invention, his power in realizing his ideas, his fresh strong color, and the formidable weight of his personality make him one of the most important living European artists."[15] In his discussion of the exhibition, James Johnson Sweeney stated, "Possibly the most commanding figure is Beckmann. His work is not so well known in America as that of Klee, Grosz, or Kokoschka, but in the eight pieces hung here the power and fertility evidenced

Henri Matisse, *L'Algérienne* (*Algerian Woman*), 1909. Oil on canvas, 81 x 65 cm (31 ⅞ x 25 ½ inches).
Musée National d'Art Moderne, Centre Georges Pompidou, Paris.

places him definitely in the front rank of contemporary painters."[16]

Beckmann's dealer had reason to be pleased. The artist had impressed the public, and his success was confirmed by the sale of several paintings. Abby Rockefeller, who already owned *Bildnis einer alten Schauspielerin* (*Portrait of an Old Actress*, 1925), purchased *Familienbild* (*Family Picture*, 1919) after the exhibition, on the advice of Barr. Armed with this expression of interest, Neumann attempted to obtain a retrospective at the museum, which would bring the artist the ultimate seal of approval. In a letter of 1933, he proposed two projects to the director:

Dear Alfred, I have two suggestions for you: 1) Beckmann is in February 1934, fifty years old. How about giving him a small, but very good retrospective show? I could do the whole work— We would have to borrow perhaps twenty paintings—which we could get easily with very little expense (thirty are in the States). 2) A russian exhibit . . .[17]

Barr did not offer an exhibition for the painter's birthday, but his admiration for his work had not diminished. He would later contribute to the recognition of the German's talent by exhibiting his earliest triptych.

Paris/New York: A Conflict of Interest?

Despite the success of the 1931 exhibition, the new valuation of German art was put into jeopardy by the mounting tensions in Europe. In 1933, the political situation was such that Neumann, who was Jewish, felt he had to curb his correspondence with Beckmann so that the latter would not be punished for their association. As their contact grew infrequent, New Art Circle no longer held exhibitions of Beckmann's work. No major progress in the promotion of Beckmann in the United States would be seen before 1938. This decline in activity, mainly as a result of the increasingly tenuous political situation in Europe, allowed Beckmann's work to evolve in silence and to reemerge changed.

Like the Americans who regarded his work with suspicion, Beckmann belonged to a generation that considered Paris to be the main capital of the arts. Thus while his New York dealer was striving to conquer America, from the late 1920s the painter was placing his ambitions elsewhere—in France. Beckmann began to divide his time between Germany and France, living in an apartment on Paris's Right Bank. Between 1926 and 1939, he took part in ten exhibitions in the French capital.[18] As his letters to Neumann disclose, Beckmann clearly placed more importance on Paris than on New York:

In my opinion, you have to come here soon. Because now the field is wide open for you, and due to my exhibition your situation has significantly changed. I am now quite settled here and you must take commercial advantage now!!!! That is more important than your going into the American wilderness. Where they won't buy until I have been launched properly here!!! And now that is about to take place!!! Please write at once when you can come.[19]

Working in his Parisian studio, Beckmann moved away from Neue Sachlichkeit, absorbing local influences. He had once stated, "My greatest love already in 1903 was Cézanne and so he has remained, when I think about French masters."[20] The artist now found himself among the heirs of Paul

Cézanne: Georges Braque, Léger, Matisse, Picasso. Without losing their power, Beckmann's paintings combine Cubism's experiments with two-dimensional elements and his own efforts to create spatial depth. He shared Matisse's attraction for heavy black outlining, abstract motifs, and sensuous surfaces. *Bildnis Minna Beckmann-Tube* (*Portrait of Minna Beckmann-Tube*), realized in Paris in 1930, perfectly illustrates Beckmann's mastery of a sinuous and voluptuous form. Also notable are his compositional techniques that bring the armchair into the foreground and flatten the background, which is decorated with a Matissian wallpaper. The title of the newspaper that the pensive woman holds in her hand, *Le Journal*, is in itself an acknowledgment of the French influence. Léger's concerns can be seen in the cylindrical forms of the overlapping figures in Beckmann's *Fussballspieler. Rugbyspieler* (*Soccer Players. Rugby Players*, 1929). On the other hand, Beckmann's process approaches that of Picasso in the apparently arbitrary quality of his pictorial elements in conjunction with a certain fidelity to external reality. The drawing entitled *Spiegel auf einer Staffelei (Interieur mit Spiegel)* (*Mirror on an Easel [Interior with Mirror]*, 1926, Staatliche Graphische Sammlung, Munich), executed during Beckmann's first year as a resident of Paris, evokes the dialogue between abstraction and observation of reality that creates the mystery of Beckmann's art. Similar compositions can be found in the 1919–21 work of Picasso and Juan Gris.[21] The German absorbed the techniques he found in French art, adapting them to the framework of his own needs and his search to achieve "metaphysics within objectivity."[22]

At the beginning of the 1930s, Beckmann worked intensively in portraiture and genre scenes, while also returning

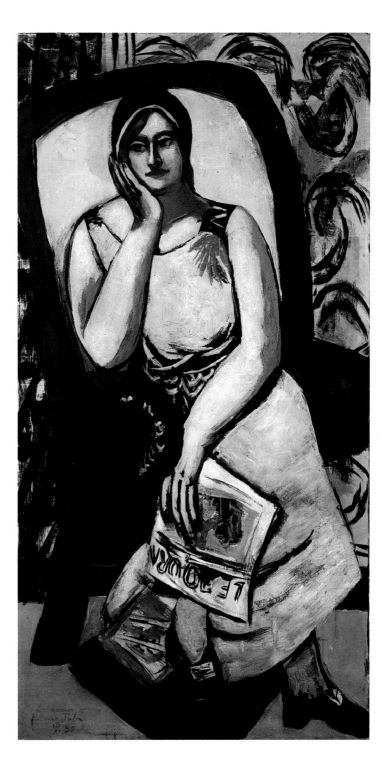

Max Beckmann, *Bildnis Minna Beckmann-Tube* (*Portrait of Minna Beckmann-Tube*), 1930. Oil on canvas, 160 x 83.5 cm (63 x 32 ⅞ inches). Pfalzgalerie, Kaiserslautern.

to mythology, which reassumed an essential place in his art. Rather than make literal illustrations of mythological themes as he had done in his youth, Beckmann drew on his own life experiences for the substance of his narratives. Like that of the Surrealists, his visual language took liberties with the appearance of things and explored a private symbolic domain. But beyond this personal introspection, Beckmann sought to transcend the limits of his own psyche in order to reunite with the universal: "to create a new mythology from present-day life: That's my meaning."[23] Although the inception of Beckmann's undertaking coincided with the rise of Nazism and the resulting political disturbances, it is inaccurate to attribute the iconographic evolution of Beckmann's work to a simple camouflaging of criticism of the new regime. Beckmann's imagery is complex; it draws on external as well as internal relationships, the political and social context, as well as the individual's spiritual quest for self-knowledge and peace. Beckmann thus reinvented the ancient myths by giving them a present-day coloration. He employed modern elements juxtaposed with symbols from different Indo-European traditions. Beckmann nourished his art with his interest in philosophy and religion.

Nevertheless, the rise of Nazism undoubtedly strengthened the metaphysical turn his painting took. Up until 1932, Beckmann lived a pleasant life, dividing his time between traveling in Europe, teaching at the Kunstgewerbeschule of the Städelsches Kunstinstitut in Frankfurt, and working in his studio in Paris. In 1932, financial difficulties resulting from the runaway inflation in Germany forced him to give up his apartment and studio in Paris. Because the National Socialist party's aggressive acts against Beckmann and other artists grew more and more frequent after Hitler took power in 1933, Beckmann decided to move to Berlin, hoping to find some peace in the anonymity of the big city. Also in 1933, he was dismissed from his teaching position in Frankfurt and was forbidden to exhibit on German soil. The situation soon brought him to consider the possibilities of immigrating to France or the United States. In 1937, on the day after the führer gave his speech condemning so-called degenerate art, Beckmann and his wife left for Amsterdam by train. His artworks followed by truck. Beckmann would never return to his native country.

First True Success in the United States
Banned by Hitler, Beckmann's work was welcomed with open arms by America. It was no longer Neumann but Curt Valentin who would introduce Beckmann's art to New York. During the period when his professional ties with Neumann were loosening, the painter met in Berlin this talented young man, who was working at Karl Buchholz's gallery. In 1937, Valentin went to New York to safeguard a portion of his employer's capital from the Nazis and opened the Buchholz Gallery, which later became the Curt Valentin Gallery. In him, Beckmann had found a strategic representative who would showcase his potential.

At the end of 1937, in the company of his friend Ludwig Mies van der Rohe, Valentin unwrapped the works sent by Beckmann for his exhibition of January 1938. Both were entranced by the discovery of the first triptych, *Abfahrt* (*Departure*, 1932–33, cat. no. 3), and the other works rescued from Germany. The dealer realized he was looking at one of the most complex works that Beckmann had created, and in order to help him exploit it commercially, he

asked the painter to write an analysis of the triptych. He received the artist's celebrated outraged response:

Remove this painting or return it to me, my dear Valentin. If people cannot understand it themselves with the help of their own inner world, it makes no sense to show the thing. . . . It can speak only to those who carry within them, consciously or unconsciously, a metaphysical code close to mine. . . . I should explain that Departure does not contain an interpretation specific to a particular point of view and could easily be applied to every period.[24]

For the first exhibition, Valentin did not dare to reproduce the painter's letter in the catalogue. He astutely used a text Barr had written for the *Modern German Painting and Sculpture* exhibition and George Waldemar's article for the periodical *Formes* about the Beckmann exhibition at the Galerie de la Renaissance in Paris in 1931. Beckmann was thus presented as an artist whose importance had been acknowledged by authoritative critics in New York and Paris. The two texts complemented each other, one proposing the artist as among the strongest of contemporary personalities and the other analyzing his painting in a lyrical way, highlighting his ability as a colorist.

The exhibition at Buchholz Gallery was well received. *Art and Artists of Today* declared Beckmann "A Man Alive" and continued in a highly laudatory vein:

Steaming from Rousseau and Negro art he paints with an audacity that is astonishing. He kisses all preconceived ideas goodbye and embarks on adventures that lead beyond Van Gogh and Matisse. Although his design is wonderfully brilliant he never

becomes merely decorative. His lines, planes and colors interlock with terrific force. Every aesthetic quality functions in unity.[25]

Yet Valentin was aware of the difficulties in promoting Beckmann, remarking to him, "People are still wild about their favorites—the French—and an exhibition of fifteen pictures by Matisse gets incredible publicity, likewise for fifteen pictures by Picasso."[26]

Valentin's exhibition traveled through the United States, with showings at museums in Kansas City, Los Angeles, San Francisco, Saint Louis, Portland, and Seattle. As Neumann had, Valentin maintained good relations with museum directors. In addition, he lent works to interested institutions for group exhibitions. In New York, the *New York World Telegram*, which organized guided tours of the galleries, included the Buchholz Gallery on its itinerary. Despite these publicity events, times were hard for German painting overall; the commotion that Hitler had created around it tended to stifle any efforts at establishing a good reputation for his country's artists. Valentin confided to Käthe von Porada, "I am ashamed when I realize that I have sold only one canvas by Beckmann."[27]

The dealer, however, had accomplished something more important than a quick sale. His emphasis upon the triptych *Departure* had brought the painter the attention of the press and many important members of the art world. A reproduction of the triptych appeared in the arts pages of the *New York Times*, with a journalist's comment that "the real *clou* of the current showing is a very large triptych, which was painted between 1932 and 1935."[28] Another newspaper asserted, "The large three-panelled 'Departure' gives the show away."[29] All agreed on the point that "Departure, the

29

tortured triptych on which he worked three years, dominates the present show at the Buchholz Gallery."[30] However, opinions diverged on its interpretation. Some preferred to deflect the issue: "The best way, no doubt, to approach this vigorous and (when viewed from the proper distance) this powerfully constructed work is to consider it in terms of visual music, discarding the 'program' altogether."[31] Other writers misconstrued the painting, less from their readings of it than from their attempts to reduce it to a denunciation of Nazism, which the painting itself resists. For example, one observer stated:

On its face is an allegory of social suffering and protest, just as many a fine German artist and writer of the age has been forced into the language of fable to express his social ideas. But the symbolism is by no means clear. Among the bound and gagged figures, one with his hands chopped off—is a man in uniform with his eyes blindfolded and two figures tied together, on his head—all this set down in Expressionist idiom with a few added Surrealist devices.[32]

One interpretation, however, stood out, that of Helen Appleton Read for *Magazine of Art*. It so pleased Valentin that he had it reprinted as a leaflet, which he used to arouse the interest of both neophytes and experts. This analysis of the painting conveyed the scope of the triptych's meaning and indicated the various levels on which it could be appreciated. Read saw in *Departure* "a confession of faith—summing up his philosophy of life. . . . The goblins and monsters which the medieval mind invented to punish sinful humanity have in this instance been transformed into the maladjustments and frustrations with which modern soci-

ety inflicts its members."[33] She placed Beckmann stylistically in the great German tradition, in the company of artists of exceptional renown who left behind some of the most beautiful multipaneled works in the history of art:

In this triptych Beckmann again affirms his Gothic inheritance. His paintings frequently seem to derive from some deep seated, atavistic folk fantasy. In its demonic "Walpurgisnacht" quality his work has affinities with Hans Baldung Grien and in its violence it suggests the Calvaries of a Cranach or a Maleskirchner.[34]

Departure initiated a pattern that would be continued with other triptychs. Each in its turn would play a major role in the perception of the artist's career, creating for him a legendary status through their grandiosity and mystery. Mouthpieces for the artist, they are the testimony of his reflections on existence and the universe. Nourished by his readings, their symbolism refers to various cultures and traditions of civilization. In the privacy of his studio, the exiled artist transcribed images from his mind by means of the physicality of paint. First and foremost a painter, Beckmann developed and realized his thoughts through the act of painting, thereby allowing him to say that he learned from his works. Beckmann's special relationship with the triptychs, and the maturation of the ideas he embedded in them, made their impact reverberate strongly. The triptychs simultaneously stunned, intimidated, and seduced, and they reaffirmed the observations of the painter on the role of art: "Art is creative for the sake of realization, not for amusement; for transfiguration, not for the sake of play."[35]

Valentin could not have asked for a better voice for the artist than *Departure*, with its impressive format, style, and

30

content. The dealer wrote to Barr in the hope that the work would be accepted by the Museum of Modern Art: "Dear Mr. Barr, A photograph of Max Beckmann's triptych *Departure* is attached. This painting is included in my current exhibition and I consider it one of the artist's most important works. I would be pleased if you could find the time sometime soon to come see the exhibition."[36] Barr visited the gallery twice, coming away unconvinced but interested. The director was prudent, the dealer patient, and an alternative to a sale was agreed upon. *Departure* would be shown in the exhibition *Art in Our Time*, to be held at the museum in May of the following year.

The exhibition that celebrated the opening of the museum's new building on Fifty-third Street as well as the museum's tenth anniversary coincided with the 1939 World's Fair in New York. Given the dramatic political context in Europe, the exhibition took on the role of defender of the liberal arts. Some works that had been declared "degenerate art" by the Nazis appeared in the galleries of the museum. The German paintings received a close scrutiny; America was determined to confer an elevated status on everything that Hitler had dethroned. *Departure* was hung at the top of the first-floor stairway, a location commanding attention. Picasso's *Guernica* (1937) was shown nearby. Comparisons between the German and French schools continued to be made:

In its exhibition of German Expressionism the Museum has maintained that the contemporary German school—that is the late contemporary German school—was secondary to the School of Paris. This opinion is substantiated in the present selection. Among the pictures is . . . Max Beckmann's powerful demonic triptych. By placing the German Gallery next to the Rouault's and the Matisse's of the Fauve period the fact is clearly demonstrated that expressionism was by no means an exclusive German production.[37]

Beckmann's "strong contribution" appeared in every account of the exhibition. In addition, although Barr did not decide to acquire it for the museum's collection, he reached an agreement with Valentin that the painting would be kept on loan after *Art in Our Time* closed. The dealer's patience and diplomatic skills would not prove fruitless, for in 1942, the museum finally exchanged a still life by Braque for the triptych. While this may not strike us today as a fair trade, it had the merit of giving Beckmann a secure introduction into one of the lofty palaces of Modern art.

Beckmann enjoyed a similar success with his second triptych, *Versuchung* (*Temptation*, 1936–37, see p. 64). This work represented the painter in the German section of the Golden Gate Exposition in San Francisco in 1939. The triptych had already caused a stir in London in 1938 at *Twentieth Century German Art* at New Burlington Galleries. Since the German government did not send a single painting to the Golden Gate Exposition, only those already outside Germany were shown. *Temptation* came from the collection of Stephan Lackner, who had emigrated from Germany, settling in California. The triptych, whose format and title indicate Beckmann's religious preoccupations, was also a contemporary polemic on the condition of the artist, depicted in the figures of Saint John and Saint Anthony. Beckmann's enigmatic vocabulary, joining tradition and modernity, philosophy and sensuality, won over America. The thread that connects *Departure* and *Temptation* is easily traced; both

engage the theme of myth in the context of the contemporary. The *New York Times* solemnized the event, writing:

Max Beckmann's triptych "Departure" in the museum's "Art in Our Time" is quite in the manner of the prize winning "Temptation" and bears added interest in being a symbolic and somewhat tragic treatment of Beckmann's exile, since his art has fallen under the displeasure of the Nazi regime. Beckmann was a leader and remains one of the most powerful exponents of German Expressionism.[38]

Ever the German, Yet to Be European

The image of Beckmann grew clearer. For America, he was first of all the man in exile, condemned by the Nazis to carry the epithet of "degenerate" artist. Many articles published began by stating that he was banned in his own country, thereby justifying the attention paid to the painter: "Not with Hitler's O.K. Recent paintings and some a bit older by Max Beckmann who has moved out of Germany. Der Fuehrer's museum of art is closed to him, but the sometimes almost savage power of this brush keeps no rendezvous with tears."[39] Another example reads, "The German painter Max Beckmann, who now lives in Amsterdam, is one of the more original and potent innovators shelved by the Nazis."[40] Finally, starting in 1940, he became "Max Beckmann, the ex-German."[41] It was thus not only acceptable to look at his work, it was even recommended, as it constituted an act of defiance against Hitler.

However, if being a "degenerate" artist was enough to attract attention, it was not enough to win the approval of the American public. The exhibition *Contemporary German Art*, held at the Boston Art Club in 1939, offered a great number of works by the German avant-garde, including some by Beckmann, that had escaped Hitler's purges. One critic's observation allows a glimpse into the rocky reception that German art received in the United States:

There are probably many people—art lovers—in Boston, who will side with Hitler in this particular purge. There are others who will insist that he knows nothing about art and that these pictures and sculptures prove it. . . . So it is that the war of opinions about Hitler has come to Boston—the judgment seat of the United States in Art matters—with the emphasis slightly on the side of traditions which Hitler seems to respect. . . . Such a picture as "Christ and the Adulteress" by Max Beckmann would certainly astonish such great German artists of the past as Albrecht Dürer or the Holbeins. They would also be inclined to smile at Beckmann's "Family Picture."[42]

Valentin had to persevere in order to create an image of Beckmann that did not entirely depend on his "degenerate" status. He contrived to paint Beckmann as an artist not so much German as European, stressing his time spent among the major cities of Berlin, Paris, and now Amsterdam, and deemphasizing Frankfurt. In 1940, Valentin sent out an informal, yet entirely strategic, press release, which *Art News* reproduced almost verbatim:

The director of the Buchholz Gallery has talked with Beckmann in Berlin, Paris and Amsterdam; and he gives us the following impressions: "I spent many hours before his paintings, which he would show only with the greatest reluctance. Appointments made with him were put off again and again because he was not in the mood to show his work. There was the large studio near

the Tiergarten in Berlin with its adjoining room stacked with many of his paintings. Here it was that I first saw the two large triptychs of which the first one was shown this spring in the 'Art in Our Time' exhibition at the Museum of Modern Art, and the second, Temptation, is now being shown here in New York for the first time. (It was awarded first prize in the European Section of the Golden Gate Exposition in San Francisco).

"Out of his windows in his Paris studio one had a beautiful view over the entire city, and the Bois de Boulogne which gave him many an inspiration for his landscapes. And in Amsterdam where he is working at present, he took a huge room in what was formerly an old tobacco factory.

"It is easier to discuss politics with Beckmann than to talk about art or even about his own work, and I may say, more often one would meet him over a cocktail in a night club than in an art gallery. . . . It is difficult to discuss his pictures with him, because he thinks that each person should decide for himself what they mean. Figures seen in events through which he lived are mixed with dream phantoms. Strange and puzzling characters which we know from Bosch or even Grünewald are to be seen in his canvases as well as familiar faces.

"Recently Beckmann wrote me that he had just finished a new triptych—in addition to the work which he began in 1932 with Departure. *In all these works, Beckmann has tried with philosophical wisdom and the power of an artist to portray the tension and complexity of our time."*

All the components for the construction of a legend are combined in this text: the importance of Beckmann's works, recognition by major institutions, the continuation of the work, and its meaning. Beckmann's character has something of the temperamental star as well as the mysterious creator, the man of the world and the reticent artist. Beckmann comes across above all as the mystical painter of the contemporary scene, with historical Northern roots. Valentin was continuing to promote an image that Beckmann himself had established in his speech in London two years earlier, given at the opening of the exhibition *Twentieth Century German Art*. The dealer, having learned that "the American psychology . . . would like an explanation for everything," used the London text, "On My Painting," to enlighten the visitor: "What I want to show in my work is the idea that hides itself behind so-called reality. I am seeking the bridge that leads from the visible to the invisible, like the famous kabbalist who once said: 'If you wish to get hold of the invisible you must penetrate as deeply as possible into the visible.'" Beckmann integrated imaginary elements into his penetration of the realistic environment, lending the work an aspect of the fantastic, which, as in Goya's work, calls for a redefinition of the concept of realism. For it is, finally, into the heart of the real that Beckmann's paintings lead us.

Up until 1942, Beckmann showed work regularly in the United States. The critics continued to give him favorable reviews, even if Beckmann was "for the American, an artist who requires 'getting used to.'"[44] But then the rupture of relations with Europe placed the painter's career in limbo. His friends advised him to emigrate and gave him all the help they had at their disposal, but Beckmann did not get the visa necessary to allow him to pursue a teaching position in the United States. He had to stay in the Netherlands until 1947. After that, as he had foreseen, America would be next: "This country has always struck me as the fitting place to spend the last part of my life."[45]

The "Man with a Rainbow in His Pocket"

Having spent time in Paris, where he pursued a deeply personal pictorial imagery that mined the French stylistic mode—and continuing to develop in Amsterdam—Beckmann reappeared in an even better position to seduce the American public. When his paintings were exhibited again in New York after World War II, they finally dispelled the myth of the noncolorist Germans. A journalist from *Time* magazine made the journey from New York to Amsterdam at the end of March 1946 in order to meet Beckmann, reporting that the artist "had splashed on colors with the lavish hand of a man who wakes up to find a rainbow in his pocket. And he made each color count."[46]

The exhibition that Valentin offered the painter in April 1946 was an event. Some of the works shown had been lent by collectors or museums that had bought them during the war. Beckmann's paintings were in the collections of the Museum of Modern Art, the Fogg Art Museum in Cambridge, Massachusetts, and the City Art Museum of Saint Louis. *Art Digest* reported:

They [the paintings] are dated from 1939 to 1945, the war years, but these years seem to represent to Beckmann a new peace. The note of fateful tragedy and enslavement on which Departure *is based . . . is replaced with a joie de vivre expressed in the tone of his color and his subject matter. . . . That a man who survived the violences of the war should be able to project to us so joyous a sensation is one of the mysteries and magics of art.[47]*

The selection of works exhibited reveals a man who went through the war painting from his imagination and memory. Beckmann painted his recollections of luminous landscapes in the South of France. He worked harder than ever on the structure of the canvas, while seeking to capture brilliance and harmony of color. His canvases become receptacles for enigmatic scenes imagined by the painter, the key to understanding his meditations on existence and the world. Even though the exhibition also included notes of violence and melancholy, like the triptych *Perseus* (1940–41, see p. 70), the selection of works remained relatively true to the work in exile. Unlike his experience of World War I, Beckmann did not feel the need to remove himself from the world as it was. The painter's effort to escape all direct conflict by seeking shelter in the Netherlands had been in vain. He lived in anguish, moved by the folly of the world, but his distress did not undermine his vision. Instead, it gave rise to images in which light and darkness joined together in an intimate ordered union. Starting in 1938, when the artist announced, "I must look for wisdom with my eyes,"[48] he envisioned a deeply original path that would take him far from the chaotic hubbub of the world. Society was not going to challenge the spiritual withdrawal he had entered: "I assume, though, that there are two worlds: the world of spiritual life and the world of political reality. Both are manifestations of life that may sometimes coincide but are very different in principle. I must leave it to you to decide which is the more important."[49]

The letters between Valentin and Beckmann beginning in September 1945 resume their practical discussion of the painter's career, addressing exhibitions, money, supplies, and then also emigration. In a letter of September 4, 1945, the painter expressed the desire to come to America, for "there is always the danger that I would be forced to return to Germany." Although a strong man, Beckmann had been

weakened by heart disease and tested by the events of the war. The day of his sixty-second birthday found him somewhat depressed; he noted in his diary, "'We are awaiting one illusion and yet another.' All is not going to be wonderful in America either."[50] Despite his reservations, the painter had placed his hopes on the possibility of immigrating to the United States. Allowing artists both economic security and integration into an artistic community, teaching had served as the bridge for many artists to emigrate from one country to another. Like many others, Beckmann had not entirely mastered the language of his new country, but as an art teacher this was merely a hindrance.

In December 1946, Beckmann had his second show of the year at the Buchholz Gallery. It paid homage to the triptych *Schauspieler* (*Actors*, 1941–42, cat. no. 11), presenting in addition two other canvases—*Geburt* (*Birth*, 1937) and *Tod* (*Death*, 1938)—thus emphasizing the idea of the pendant, of a dialogue between paintings. The density and complexity of the two earlier works ties them directly to the triptychs. Unlike Picasso, Beckmann did not work in series but preferred to set up an active relationship among his compositions, conceiving them almost as cycles. The process was clear in the triptychs, but its effects were more subtle in independent works. In presenting these three major works with the portfolio of lithographs *Tag und Traum* (*Day and Dream*, 1946), Valentin drew attention to this point. Offering the lithographs for comparison across mediums served to suggest the diverse facets of Beckmann's world. Each of the images stood for different, indeed, opposing moments, although inseparable, like life and death. The exhibition revealed the logic of the work and the independent personality of Beckmann.

Invitation to Saint Louis

At the end of March 1947, Beckmann still had not received a serious invitation to the United States. It was in a state of suspense that he left the Netherlands for the first time since 1939 to travel to Paris, Nice, and Monaco. On passing the border, the painter wrote in his diary, "French border—France was passing me by—dream of former times."[51] New York had now replaced Paris in his thoughts. News of America came to Beckmann at the Hôtel Westminster in Nice. His triptych *Blindekuh* (*Blind Man's Buff*, 1944–45, cat. no. 14) was on view at the Museum of Modern Art, where it was well received. Likewise, *Max Beckmann Paintings from 1940 to 1946* at the Albright Art Gallery, Buffalo, got good press. After Buffalo, the exhibition was bound for Bloomington, Indiana, the source of an invitation to fill a position in the Department of Fine Arts at Indiana University. Henry Hope, the department's director, admired Beckmann and owned one of his paintings. The artist's indecision over his response lasted long enough for a second offer to materialize.

A letter from Kenneth Hudson, the director of the School of Fine Art of Washington University in Saint Louis, would simplify matters. Since the professor of painting for the senior students, Philip Guston, had just received a John Simon Guggenheim Foundation fellowship, his position would be vacant for a school year. After offering the job to Rufino Tamayo, Hudson asked Valentin if Graham Sutherland or John Piper would be interested. The dealer brought up the subject with his friend Perry T. Rathbone, director of the City Art Museum of Saint Louis, and they decided that Beckmann would be happier in Saint Louis than in Bloomington. Taking advantage of the opportunity, Valentin

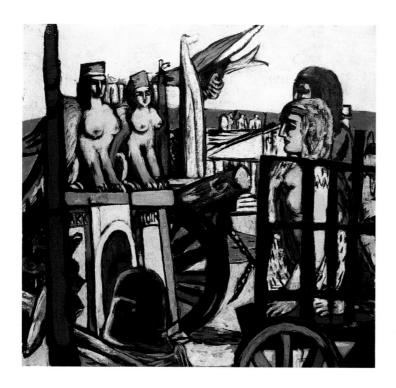

responded to Hudson by proposing Beckmann, an idea that was accepted.

Removal of the Sphinxes: Closing the War Experience

While America had become the stage best adapted to accept the work of the German, Beckmann had some reservations. Before he left for the United States, he wrote to his first wife, Minna, confiding his hesitation about leaving the Old World of Europe and exposing his identity as a German painter in the New World: "Okay, let's go, forward, always forward, things are really happening and I look forward to it all. Have I done right? I don't know. But after all I am still a painter and I must pursue my calling as well as I can. A certain Holbein spent his entire life in England, and yet remained a real, true Swiss-German painter."[52] He antici-

pated the departure for America as "except for death . . . certainly the last great excitement life offers me—[the departure] if beautiful or ugly—no matter—that's why I want to enjoy."[53] Beckmann was uncertain of what awaited him, yet he accepted his fate, soberly assenting, "But this great interruption of my life was necessary in every respect."[54] Weary, he dared not hope too much. "Germany is dying, and so am I," he wrote in his diary on November 29, 1945.[55] The tragic fate of his country moved him deeply. For Beckmann, the painting *Abtransport der Sphinxe* (*Removal of the Sphinxes,* 1945) closed the experience of the war without obliterating its tragic meaning. At the edge of the sea, against a background of white neoclassical architecture, large wagons transport a striking pair of sphinxes and a triumphal arch. The presence of the wounded creatures as well as of an anonymous army, represented by a dark helmet, diminishes any feeling of liberation. A sense of tragedy and threat remain. The elements of the architectural setting may refer to parades under Hitler, while the colors of the Netherlands—blue, white, red—and the bird taking flight evoke a recovered freedom.

Before Beckmann, Yeats had put sphinxes in his poem "The Second Coming" of 1921:

The second coming! Hardly are those words out
When a vast image out of Spiritus Mundi
Troubles my sight: somewhere in the sands of the desert
A shape with lion body and the head of a man,
A gaze blank pitiless as the sun, is moving its slow thighs, while all about it
Reel shadows of the indignant desert birds.

Max Beckmann, *Abtransport der Sphinxe* (*Removal of the Sphinxes*), 1945. Oil on canvas, 130.5 x 140.5 cm (51 ⅜ x 55 ⁵⁄₁₆ inches). Staatliche Kunsthalle, Karlsruhe.

Like Yeats, Beckmann used this archetypal image sprung from the spirit of the world. Tyrannical monster and symbol of the ineluctable, the sphinx evokes the terror that Oedipus confronted in Thebes. By solving the riddle, Oedipus wins his life and the kingdom, but he does not escape his fate. In Beckmann's painting, the sphinxes, as in the story of Oedipus, have been vanquished, their tyranny overthrown. Nevertheless, the wise painter, like Oedipus, knows that the departing sphinxes signal the beginning of a new destiny, no less mysterious or inevitable. No animosity is visible among these creatures, instruments of fate, as they go off on their own path. Wounded Germany would heal, but Beckmann would never go back.

Begin the Beguine: Doubts

The painting of 1946 entitled *Begin the Beguine* (cat. no. 16) reveals the artist's uneasiness. Was it possible to start living normally again? Was a new beginning in the American style imaginable? The painting, the title of which was borrowed from a Cole Porter song popular during World War II, refers directly to the lightheartedness of the other side of the Atlantic, and to Europe's liberation by the United States. The painter orchestrated this unusual cabaret turn. Sharing Picasso's penchant for anomalous profiles in black, Beckmann included such a shape at the lower left of the painting, that of a man who could well be himself viewing the figures in his painting. Have we simply gained access into the recesses of Beckmann's imagination? Perhaps. Familiar elements of Beckmann's iconography stand out: the exotic birds related to those in *Temptation*, and the mutilated woman, and the one with exposed breasts, typical examples of Beckmann's representations of women turned into sexual objects, simultaneously glorified and oppressed.

As in many of Beckmann's paintings, a wallpaper pattern structures the background of the composition and lends plasticity to the bodies, thus emphasizing the theatrical effect. The dance, the beguine, seems to be placed in jeopardy by the physical condition of the figures. No one has been spared the effects of mutilation. The woman in red stockings below has lost an arm; the dancer held in the air has no feet. The man who holds her is not firmly planted on the ground, with his wooden leg and his shoe sliding on what looks like a bottle fragment. This dance of the miraculously healed has its irony; the inscription "Roi" (king) on the label of the broken bottle emphasizes its resemblance to a crown. Here then are kings for just a day. With shattered features, they are pathetic actors attempting to carry off roles for which they are no longer suited. This falseness disturbs the painting's brilliance. The improvised beguine cannot and will not be: it lurches, stiffens, tapers off, becomes wretched.

The only figure who can salvage the situation is the man dressed in green and armed with a giant key. He is equipped with a crutch, although, paradoxically, his two legs and enormous feet look perfectly sound. Thus propped up, he functions as the dance master. Decked out in a tunic and feathered cap, he seems to be some mysterious figure connected with the large birds that rest on perches against the wall. Like Papageno of *The Magic Flute*, this character seems to belong to magical woods and to have received a gift from the gods. The key, which he proudly shows to the dancing woman, promises some grandiose opening. Beckmann, using visual techniques from medieval art, exaggerates the size of the important parts of the painting and focuses atten-

tion on this salvational key. It is difficult, however, to believe in a positive result. Beckmann's situation in departing for the United States was in many ways identical to that expressed in *Begin the Beguine*. The painter left without conviction but with the faint hope that the journey would bring him the key to a new life.

Retrospective Exhibition and the Birth of a Legend

Beckmann's arrival in Saint Louis was celebrated by Rathbone's organization of a retrospective at the City Art Museum in 1948. The only comprehensive retrospective presented during the artist's lifetime, it elicited the first thorough analysis of its subject in the English language. The recognition accorded the artist in the exhibition catalogue was sizable:

One might say that Beckmann's greatest contribution to Modern art lies in his establishment of a new alliance and a new balance of power between form and content, between wonder and reality. This alliance—realized in his great triptychs, the City of Brass *[Messingstadt, 1944], the* Bird's Hell *[Hölle der Vögel, 1938, cat. no. 7], the* Removal of the Sphinxes, *the* Begin the Beguine, *the* Soldier's Dream *[Traum des Soldaten, 1942], to name but a few of the great compositions of the last ten years— is successful because these paintings bear the essential quality of* true myth *where the human drama is neither beautified, nor prettified, nor idealized, and where magic becomes real and convincing through the artistic power of its rendition.*[56]

The exhibition was seen in seven major American museums, and a reduced version traveled in the United States until 1950, stopping in seven more cities. Although New

York and Chicago were not included on the list, the exhibition represented a major step forward for the painter's career. In February 1948, *Look* magazine published the results of a questionnaire distributed to sixty directors of American art museums. Beckmann appeared among the twenty most important artists. Judged by his peers in a poll of the same month, Beckmann was named one of the top ten artists. From 1947 to 1950, works by Beckmann were included in more than eighty exhibitions on American soil, of which thirty-three were devoted exclusively to the artist. It had been a long time since the painter had witnessed such a positive reaction to his work. While sales had improved at the Buchholz Gallery, the painter was far from comfortably off; he continued to worry about his finances, his visa, and his heart. In Saint Louis, Beckmann became the center of a small group of art lovers, among them the loyal patron and enthusiastic collector Morton D. May. The portraits executed during this period, either spontaneously or on commission, retrace the circle of Beckmann's friends and admirers.

Beginning in 1947, works by Beckmann appeared in exhibitions dominated by artists who were citizens of the United States. He exhibited at the Whitney Museum of American Art, New York, and at the Pennsylvania Academy of the Fine Arts, Philadelphia, which is still devoted to American art. (When Beckmann died at the end of 1950, that institution even saluted his memory with an exhibition.) The Metropolitan Museum of Art, New York, included the celebrated *Selbstbildnis 1950. Selbstbildnis in blauer Jacke (Self-Portrait 1950. Self-Portrait in Blue Jacket,* 1950) in its 1950 exhibition *American Painting Today.* The reception that Beckmann found in America made his last years

more pleasant and allowed him to devote himself to his work with some serenity.

From Saint Louis, Beckmann left for New York, where he taught at the Brooklyn Museum Art School starting in 1949. An exhibition of his prints held at the museum both honored and welcomed him. Beckmann, who had not seen some of his works for more than twenty years, never tired of going to look at them during the breaks between classes. Unlike Grosz, who led an active social life and was known for his sense of humor, Beckmann was reserved. When he went out in Manhattan, he was with his dealer, acquaintances passing through town, or members of the group Artist Equity: Marion Greenwood, Yasuo Kuniyoshi, and Tamayo. His students sometimes came to see him in his studio near Gramercy Park. Beckmann diligently visited museums, especially the Metropolitan Museum of Art. True to his penchant for bars, he spent time at both fancy ones such as the Plaza and cheap ones on the Lower East Side. This relish for the smartest as well as the most debased spots in the city corresponds perfectly to his aim of encompassing the totality of human experience by means of pictorial investigation.

Beckmann found resonances of his art in the United States, perceiving the naturally mythical aspect of modern America. The dizzying heights of New York seemed mythical to him; the "new Babel," as he often labeled it, struck him as congenial. The boundless spaces of the Rocky Mountains in Colorado, the power of the Mississippi River, the unfamiliar landscape of Chicago, and the tidiness of Saint Louis all beguiled him. He painted and drew the urban landscape and the wilderness, accenting their relationship to an *Urlandschaft* (primeval landscape). Geography inspired such radiant works as *Morgen am Mississippi*

(*Morning on the Mississippi*, 1949), which reveals something of the early style of Piet Mondrian. Like that Dutch painter, Beckmann discovered a new energy on arriving in the United States, which made his colors more vibrant than ever and softened his form. Just as the many journeys made by the artist in his life were reflected in his work, his moves within the United States left their imprints on his iconography. Skyscrapers, elevators, cowboys, and newspaper and magazine titles appeared in many paintings.

Little by little, during his years in the United States, Beckmann became a personality, a legend. For his 1948–49 contract with Washington University, Hudson wrote: "Professor and artist extraordinare. One of the greatest figures in the art world."[57] A charismatic man, Beckmann attracted a circle of supporters, none more fervent than his wife Quappi. It was through this English-speaking ambassador, who often voiced his ideas, that the artist expressed his conception of the world and of painting. For him, after all, it was the same thing. He described "the reality of the picture—the sole true reality which is to be found."[58]

Beckmann's personality remains swathed in mystery. The painter did not like to talk about himself for very long, but, paradoxically, he accepted interviews with the press, television, and radio. He thus veered between private man and public personality. In his writings, he styled himself the prophet who expressed himself in a mystic voice through the transcendence of form. He was the speaker of truth, the clairvoyant, influential artist, the personage of his *Selbstbildnis mit Glaskugel* (*Self-Portrait with Crystal Ball*, 1936). Like Rembrandt, Beckmann constructed his personality in painting. Year after year, he sent out an image of his self, a pictorial persona that had become his double, and perhaps

more real than himself. In his diary, Beckmann spoke of himself in the third person, writing an "Article on Max Beckmann" and referring to himself as "the artist." Although it is clear that such references were not devoid of a mocking irony about the distinction between the persona and the man, there are those who have perceived in the painter a trace of egotism: ". . . an egocentric oversensitivity. . . . He has little regard for contemporaries: Picasso is a clown and a 'painter of chamber pots.' Braque and Rouault display fine craft. The German contemporaries are all remote to him, especially Nolde. He wants nothing to do with the Expressionists."[59]

The artist never stopped seeking to explicate his identity and concerns. He considered himself grounded in a historic lineage, that of "the masculine mystique of the four great painters Mäleskirchner, Grünewald, Brueghel, and van Gogh."[60] Again and again, Beckmann offered the same story to whomever was willing to listen. In an interview for the *New York Times*, he explained, "Sometimes reality is a symbol. . . . To make the invisible visible I have to use reality— even dreams are reality—to transform three-dimensions into two, to fix figures as they appear to me." He continued, "In Christian iconography the fish signified Christ. I use it with its vapid stupid look—as a symbol of man's bewilderment at the mystery of eternity." About painting, he said:

These vultures are fate. But you don't have to respond to the painting so intensely that you get the whole meaning. When you look at a picture, first you should feel the quality of the painting; then later you can think it out. Every masterpiece has a quality of painting—but it must have an idea, a meaning too. And the elements of concrete reality, the symbols, prove to reinforce the

meaning. . . . With portraits too, first you must make a work of art, with form and space design and color, and then you get into it as much of the personality as you can.[61]

Supple Line and Fluid Form

The last years of Beckmann's life brought him philosophic and stylistic maturity. Starting in 1946, the female body took on a more monumental form in his painting, acquiring powerful, voluptuous proportions. The arms and thighs became his figures' most developed attributes, while chests and faces, on the contrary, preserved a precious daintiness. The women remain feminine, however, because Beckmann was using more sinuous curves, with elongations and contortions of astonishing, almost unreal, suppleness. It is tempting to link this picture of the feminine to a bewitching and foreign black magic. In 1947, Beckmann painted *Mädchenzimmer. Siesta (Girl's Room. Siesta)*. The fullness of its forms, the warm light, and the rhythmic, orderly structure of the painting indicate some of the directions Beckmann's work would take.

The siesta these beautiful young women enjoy takes place in a room with shutters closed to protect them from the light and the curiosity of passersby. They are guarded by an old madam. Beckmann preferred partly dressed figures to blatant nudes. The sinuous line defining the shape of the woman seen from the back turns her into a flowery serpentine in a printed dress. The artist had never before been so concerned with line. The women's full forms, with their Ingresque enhancements, are among the most sensually realized in Beckmann's oeuvre.

The stable composition, based on horizontals and verticals, respects the calm of the situation. The diagonals are

interrupted by the bouquets, which contribute their ephemeral beauty as in a *vanitas*. In the background, a seemingly stopped clock in the blackness—like that in a work by Cézanne—silently comments on the scene and endows it with a sense of timelessness. Dressed in red, the color of carnality, one of the young women, pensive, loses her gaze in the shadow of her being, beyond the mirror. In the sensual decoration of a house of ill repute, Beckmann, as is typical of his work, interjected a reflection upon fate.

The linearity and suppleness of form evident in *Girl's Room. Siesta* was maintained in the last, unfinished triptych, *Ballet Rehearsal* (1950, see p. 43). Its state allows the viewer to follow the way Beckmann constructed the painting, starting out with a linear composition drawn in colored chalks and charcoal. In his final years, Beckmann confirmed his conception of form through outline rather than by building up volume. In this, he allied himself with Jean-Auguste-Dominique Ingres and Matisse rather than Goya and Kirchner. The incomplete circle that suggests an ankle, and the clawlike hands, for example, are signs simplified by fluid line and left to be worked into volume in oils later on. Quappi reported some of Beckmann's words: "To draw an arc from top to bottom or a straight line in one fell swoop with absolute sureness has taken me thirty years."[62]

The mastery of artistic elements became of prime importance in his last works. The entire composition of *Ballet Rehearsal* would have been rooted in the preliminary drawing made directly on the canvas. Strong, emphatic, light, or barely sketched, line—ever precise and focused—describes angles, closed circles, and spontaneous zigzags. Despite the rigorous structure of this blueprint, it is likely that the intuitive gesture of Beckmann's brush would have

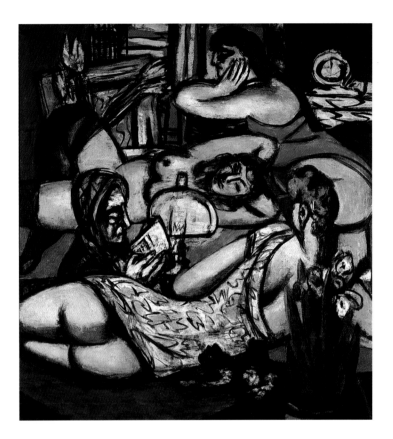

41

changed this order. In its present state, the clarity and chalky transparency of the triptych is akin to certain pastels by Edgar Degas depicting dancers. That this remark can be made fits in with Beckmann's mixture of social observation and imaginary construction. Degas said repeatedly that the dance made him think of the Greeks. Beckmann would have agreed; his mythical dancers sport helmets and arms with Hellenistic bas reliefs.

The energy of these amazons, as Beckmann called them when he began working on the triptych, defines an eroticism of strong, almost threatening vitality. His gigantic women are warriors, proud of their bodies. They carry their

Max Beckmann, *Mädchenzimmer. Siesta* (*Girl's Room. Siesta*), 1947. Oil on canvas, 140.5 x 130.5 cm (55 ⁵⁄₁₆ x 51 ⅜ inches). Staatliche Museen, Preussischer Kulturbesitz, Nationalgalerie Berlin.

small heads nobly and seem to assert a sexual independence even more attractive. Symbols of virility—the spear, the coiled serpent, the small, sketchy fish—accompany them in their games and performances. These women, it seems, have gained control of their vital energy and given themselves over to worldly pleasures with voraciousness. From the other side of the mirror, a masculine figure observes them in rehearsal. Is this a demiurge, as his size leads us to believe? Yet even a god who would be tempted to carry off the women would stop to think of the consequences. There is no Leda or lost nymph here. Beckmann, with humor and a surprising simplicity, drew from mythology in dedicating one of his last works to a powerful, free femininity.

Stained-Glass Effect

Throughout his life, Beckmann strove to produce the effect of stained-glass windows in his paintings. "The picture should work like a Gothic stained-glass window,"[63] he said in 1919, repeating that idea later and working toward that end long after he had left behind the Gothic influence. His mastery of fluid line allowed him to free up color within his well-defined grids. The direct gestures made the color, outlined in black lines, resonate like crystal. The parallel to stained-glass windows becomes clear when comparing two works, *Soldier's Dream* (1942) and *Luftballon mit Windmühle* (*Air Balloon with Windmill*, 1947, cat. no. 17).

The two canvases, with similar subjects, include comparable elements, in particular the cage. In *Soldier's Dream*, a soldier and a woman-headed serpent are face to face in a cage, which evokes Adam and Eve and the Garden of Eden. In Beckmann's work, the woman has already made a pact with the serpent, and the man is being tempted to join her.

They are shut in, held prisoner. The jailer, the master of space and time, is none other than God. In the beginning of his career, Beckmann had declared, "My religion is arrogance before God, obstinacy in the face of God. Obstinacy that he has created us in such a way that we cannot love ourselves. In my pictures, I reproach God for everything he has done."[64]

The later work, *Air Balloon with Windmill*, approaches the same subject more directly. Beckmann placed an inscription at the bottom of the painting: "Brasith Elohim," which leads to a key to the painting in Genesis:

In the Beginning of creation, when God made heaven and earth, the earth was without form and void, with darkness over the face of the abyss, and a mighty wind that swept over the waters. God said, "Let there be light," and there was light; and God saw that the light was good, and he separated light from darkness.[65]

It is easy to find elements from the Bible in the depiction: an illumination somewhere between night and day bathes the painting, largely coming from the luminous blue sky and green sea. The windmill that blows above the water has the face of God, the God who punished Adam and Eve, chained them to one another, and promised them they should know pain and toil.

Beckmann accused the demiurges of tying us to the wheel of fate or of reincarnation, of entirely controlling the hazards of our existence. The air balloons transport men and women who clearly share a painful connection. Their attempts to gain spiritual knowledge, to raise themselves aloft in the sky, if not in vain (a balloonist in the background seems to have narrowly escaped a fire), are dependent upon

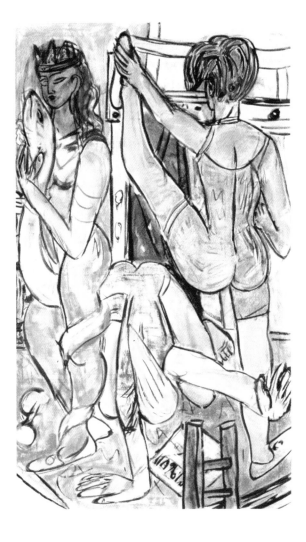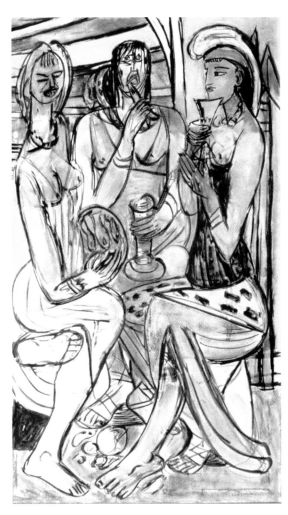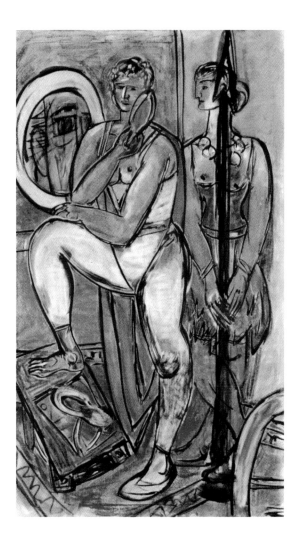

Max Beckmann, *Ballet Rehearsal*, 1950. Charcoal, ink, and colored chalk on canvas; triptych, each panel: 208.5 x 124.5 cm (82 x 49 inches). Private collection.

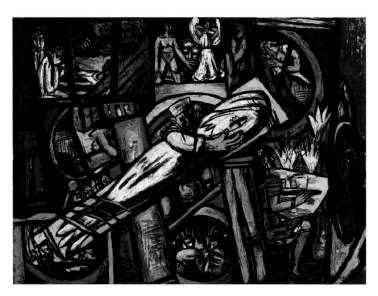

the master of the winds. There is no freedom in evidence; a world ruled by the gods is rendered as a train of suffering. People can be tempted by knowledge, as Adam and Eve were tempted to possess understanding, the first stage on the road to divinity. Beckmann did not believe in any other means to freedom:

If we are unwilling to profess the belief that at one time in the course of mankind's development we ourselves become God, that is, we become free, to recognize or to understand, finally and clearly, the concealed purpose of all that is incomprehensible, weak, and impossible, which we still call life, mankind as a whole will remain a farce from the beginning.[66]

The two paintings are thus doubles in their theme and close in their iconographic choices. Their treatment, however, is different. While they employ a similar range of colors—dominant blues and greens with white and reddish brown to create light—the values chosen are noticeably dif-

44

ferent. The canvas of 1942 is more somber, its black toning down—even invading—the clear colors. Black also emphasizes the forms, creating the motifs in the decorative areas and structuring the composition by constructing the principal elements: the cage and the black verticals that stabilize the right section of the canvas. It thus reduces the impact of a regularized grid, as in a stained-glass window, and instead spreads an encompassing shadow over the painting, producing a symbolic effect.

In the 1947 work, Beckmann set the black into specific areas rather than diffusing it over the canvas. Unlike *Soldier's Dream*, black appears in its full intensity and grays are avoided. The network of lines is built up with a saturated black that precisely outlines all the elements: the windmill blades, the masklike face of the demiurge, the cage. The color is laid on in an almost pure state, vivid and radiant. When he needed to paint a form or a shadow, Beckmann avoided mixing the color with black. Instead, he applied light zigzags of pure black or created an area of deep shadow, creating strong contrasts. With the intensity of color thus heightened, the forms gain in definition and the black brings out volumes. At the end of his life, the artist, who had always worked with color as a sculptor might, made paintings like stained-glass windows, with an intensity and saturation he had never before achieved. The triptych *Beginning* (1946–49, cat. no. 19)—with a tension between the sensual brightness of the colors and the emphatic energy of the structural black lines—is surely one of the last and most fascinating examples of this method.

Density of Composition and Modulation of Light
Certain works that Beckmann made near the end of his life,

Max Beckmann, *Cabins*, 1948. Oil on canvas, 139.5 x 190 cm (54 ¹⁵⁄₁₆ x 74 ¹³⁄₁₆ inches). Kunstsammlung Nordrhein-Westfalen, Düsseldorf.

whether drawings or paintings, are among the most daring compositions that he ever realized. Working from the idea of a triptych or polyptych, Beckmann began to play with reflected images and paintings within paintings. A number of canvases contain more than three images in one. *Film-atelier* (*Film Studio*, 1933) is one of the earliest examples. It is not a coincidence that it was painted in Berlin at the same time as the triptych *Departure*, because the concept of scenic plurality had always interested him. Starting in 1946, he returned to the idea, in works such as *Cabins* (1948).

Divided by many windows and realms of action, *Cabins* offers multiple points of view, in the guise of a steamer's portholes opening onto various worlds. The unity of time and place in the canvas has in no way been respected: each scene seems completely independent of its neighbor. It is even difficult to tell how to read the canvas. In its simultaneity of vision, a hierarchy is created visually by the proportions assigned to each subject as well as by its placement in the zones of the painting. Beckmann thus created order in the composition by framing the scenes and harmonizing certain ones with the element of the Greek columns. He constructed an irregular architecture between the temple and the boat by placing elements in tiers and playing with the arrangement of space. One of the major functions of the young woman at the table with large flowers is to give the illusion of depth. Similarly, through their sculptural appearance, the arm of the sailor and his fish make reference to real space outside the painting. The vertical element at the right side of the canvas solidly anchors that zone in the foreground.

Within this dark, almost cinematic space, the painter proposed a complete summary of his journey in the world,

depicted here in terms of sensuality, pain, and spirituality. Is the young woman, pencil in hand and seated in front of her drawing of the boat, the one conveying the painting's meaning? It is, perhaps, possible that Beckmann provided himself with a female double in this pictorial field. At any rate, her presence draws attention to the fact that this, after all, is nothing but an artwork, the product of the imagination of one person.

The appearance of the sailor recalls Beckmann's portrait in a sailor's cap, *Selbstbildnis mit weisser Mütze* (*Self-Portrait in a White Cap*, 1926). Beckmann may have identified with those who voyage habitually. All his life, the painter identified with Odysseus, the boldest of seafarers, who, condemned to wander for years in exile far from his homeland, learned wisdom after many encounters with the gods. Beckmann's philosophy draws upon the metaphor of this mariner voyaging with his enormous fish, undoubtedly symbolic of the soul. The scenes in *Cabins* suggest meetings with the gods, an enormous ebony face inhabiting the sky

Max Beckmann, *San Francisco*, 1950. Oil on canvas, 102 x 140 cm (40 ⅛ x 55 ⅛ inches). Hessisches Landesmuseum Darmstadt.

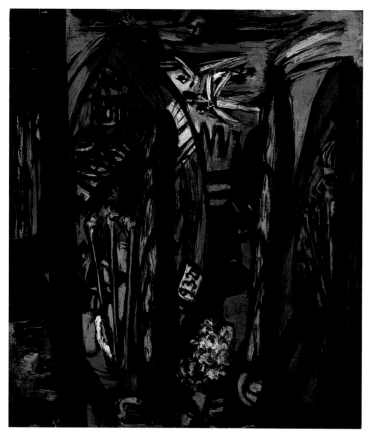

Hafen von Genua (*The Harbor of Genoa*). In his last years, he worked extensively on night pictures and scenes of darkly lit soirees, using his favored colors of pine green, cigar brown, and violet. These colors appear in dark interior scenes, of which *Hinter der Bünhe* (*Backstage*, 1950) is undoubtedly the most remarkable example. Just as Picasso used it in *Pêche de nuit à Antibes* (*Night Fishing at Antibes*, 1939), green lights up the darkness, and the yellow elements illuminate the black.

At the end of the 1940s, as in the 1927 canvas, Beckmann treated the night in his landscapes as a kindly friend who envelops sky and earth in a cloak of dark gold, which is accented by effects of artificial illumination. *Promenade des anglais in Nizza. Nice vom Hotel bei Nacht* (*Promenade des Anglais at Nice. Nice from the Hotel at Night*, 1947) is one such work. In the style of Rembrandt, Beckmann's favorite artist, the chiaroscuro and the deep blacks retain a sensual transparency, proof that nothing is fixed, that life is mutable.

A study of a summer night, *San Francisco* (1950, see p. 45) presents a city that remains active to the brink of day. Clouds, automobiles, and buildings seem to dance to an identical rhythm, giving life to this singular city. As he liked to do, Beckmann personified the city and explored its hospitable nature. Once more, it is light that brings together the different parts of the landscape. Tobacco brown and yellow ocher are leitmotivs, constructing a network of architecture and nature in harmony. Reduced to two-dimensional signs, the buildings have been textured like the sky. In looking for unity rather than contrast, Beckmann's solution was to paint everything in a similar manner, modulating the saturation only through changes in rhythm.

or the sea. He becomes a frightening figure, resembling a death's-head, when he appears near the angel, who makes a sign to a man in a bathing suit. In the large barred portholes, the painter arrives at sensuality and eroticism. And in the porthole still visible, a pensive man with reddened cheeks appears in profile; he is the anxious presence in the artist's life.

The colors of *Cabins*, springing out like fireflies in the night, give Beckmann's vision a dreamlike quality. The perfectly controlled variations in luminosity are effective in creating a symbolic atmosphere. Beckmann had tried his hand, with great success, at a night painting in his 1927 view *Der*

Max Beckmann, *Hotel de l'Ambre*, 1949. Oil on canvas, 91.5 x 79 cm (36 x 31 ⅛ inches). Bayerische Staatsgemäldesammlungen, Staatsgalerie Moderner Kunst, Munich, Stiftung Günther Franke.

We find the same process in the work of Picasso. In a view of Cannes in summer, *La Baie de Cannes* (*The Bay of Cannes*, 1958), a reduced chromatic range is used to unite the different elements of a city. Picasso brought these elements into the same plane, stacking them in tiers rather than projecting them back into depth. Picasso, like Beckmann, used repetitive, penetrating elements, then emphasized their importance by allowing them to dominate the rest of the landscape. This process creates a pictorial musicality, in which the various components are harmoniously united in a single sound.

The evening becomes a mysterious and dazzling night in such compositions as *Hotel de l'Ambre* (1949). Named for the Rue de l'Ambre in Paris, with which Beckmann was familiar, the hotel is here transformed into a strange, almond-shaped place. Lost in a primordial decor, it becomes something resembling a primeval planet's primitive wilderness. Lingams, or phallic columns, the Hindu symbol of fertility, decorate this land, where a woman takes refuge in a form shaped like fruit pits or eggs. An equally frightened man hides in the foreground behind what, in the darkness, looks like a ladder or a door. This couple seems to be terrorized by the large, dark profile of a giant's disembodied head, like the demiurges of *Cabins*. Civilization as we know it has not yet been born; it is still in germination or incubation, while giant birds dwell in the sky. In 1949, Beckmann completed a watercolor entitled *Frühe Menschen* (*Early Men*), begun in 1946, on this mythical theme of creation. In it, the same kind of almond-shaped eggs and obvious fertility symbols appear.

Beckmann turned repeatedly to the theme of the beginning of creation from the chaos of darkness. Present in *Air*

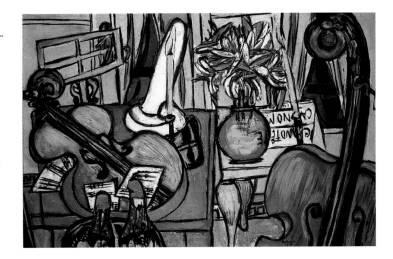

Balloon with Windmill, it shows up again in this painting that the artist called "Hôtel de l'ombre" (hotel of darkness) in his diary, making a direct reference to the quality of light. In addition to the artist's mythical preoccupations, are we to see in these gropings in the unknown before life dawns a metaphor for pictorial creation, for the mystery of his artistic search?

Toward a Lush Sensuality

Pursuing his experiments in illumination, the painter attempted compositions in pure light, which may be seen as the logical conclusion to his explorations with stained-glass-window effects. The last still lifes of the painter paid homage to the sun, the magic of light, and the sweetness of life. The peace that Beckmann accorded his objects and landscapes was but meagerly meted out to his human actors. The mystery of the object—which can also be observed in the work of Giorgio Morandi and Flemish curio cabinets—remained one of Beckmann's strongest iconographic elements. In his late years, he finally added the ele-

47

Max Beckmann, *Stilleben mit Cello und Bassgeige* (*Still Life with Cello and Bass Fiddle*), 1950. Oil on canvas, 91.8 x 139.6 cm (36 ⅛ x 55 inches). Hirshhorn Museum and Sculpture Garden, Smithsonian Institution, Washington, D.C., Gift of the Joseph H. Hirshhorn Foundation, 1966.

gant pleasure of the decorative to this mystical attraction to the inanimate.

Stilleben mit Cello und Bassgeige (*Still Life with Cello and Bass Fiddle*, 1950, see p. 47) is a prime example of Beckmann's new innovations in color relationships. As in a painting by Matisse, harmony and balance reign in an arrangement of serene objects that are evenly lighted without shadow. Like the French painter, Beckmann transformed the observed room into an essentially aerial space, in which the plasticity of matter is affected by the serene quality of the illumination. Modeling and a sculptural appearance give

way to a luminous spectrum. The solid structure of Beckmann's environments, however, cannot help but impart some stability to the objects depicted.

The objects gathered here constitute a visual vocabulary of celebration: musical instruments, bright flowers in a translucent vase, the sealed corks of bottles of champagne, and carnival accessories, a mask and a clown's hat. Yet amid this ordered selection of life's pleasures, a question arises: where is the light coming from? For the brilliant luminosity of the canvas does not come from the windows or the glinting candles; nor is it spread by any visible source. In this way, Beckmann preserved the mystery of the radiance of these elements.

Beckmann moved toward an art dominated by fire, whether produced by illumination or the heat of eroticism. The glazed appearance of skin that could still be seen in the triptych *Perseus* and in paintings from the beginning of the 1940s, such as *Traum von Monte Carlo* (*Dream of Monte Carlo*, 1940–43, cat. no. 12) had disappeared by the end of the decade. Work from this period, even the darkest paintings, include intensely luminous elements; even black seems to contain light. Over time, the work of Beckmann became more and more sensual; the feminine and the magnificent held as much importance as the painter's preoccupations with themes of "the masculine mystique." Examining the saturnalian in himself until his later years, the artist had not been able to conceive of the world other than as a union between black and white. In the last two years of his life, his art underwent a regeneration.

The still lifes with luxuriant bouquets, and scenes of lascivious Columbines, singers, or other unclothed beauties brought to his oeuvre a new, more organic energy. His

Pablo Picasso, *La Flûte de Pan* (*The Flute of Pan*), 1923. Oil on canvas, 205 x 174 cm (70 ¹¹/₁₆ x 68 ½ inches). Musée Picasso, Paris.

late work is clearly divided between dazzling color in scenes tied to the pleasures of life and more ascetic compositions. It integrates seduction and reflection, and moves toward an acceptance of the beautiful and the buoyant. In 1948, Beckmann explained in his "Letters to a Woman Painter," "If you devote yourself to the ascetic life, if you renounce all worldly pleasures, all human things, you may, I suppose, attain a certain concentration: but for the same reason you may also dry up." Beckmann avoided becoming dried up. "Certainly art is also an intoxication. Yet it is a disciplined intoxication. We also love the great oceans of lobsters and oysters, virgin forests of champagne, and the poisonous splendor of the lascivious orchid,"[67] he wrote. The painter had never communicated so eloquently about the pleasure of the senses as in this speech he wrote for the students of Stephens College. He had finally achieved a measure of reconciliation with life.

Wisdom through Painting

Approaching the end of his life, the painter embraced in his philosophy the many aspects of human experience. The enjoyment of life, the spiritual quest, and the tasks of the artist pervade the three panels of the last completed triptych, *Argonauten* (*The Argonauts*, 1949–50, cat. no. 20). The central panel contains two young men on a strip of beach, a lyre at their feet. The influence of Cézanne's bathers, as well as their impact upon twentieth-century art, can be seen here. Beckmann's combination of a sculptural analysis of the figure and a geometric simplification of volumes can clearly be seen in the celebrated *La Flûte de Pan* (*The Flute of Pan*, 1923) by Picasso. *The Argonauts* is the last of numerous attempts in Beckmann's oeuvre to approach from his

49

own angle this issue preoccupying Modern painting .

The central panel also includes other elements along

Detail from central panel of *Argonauten* (*The Argonauts*), cat. no. 20.

with the young men: the parrot, the stars, moon, and sun, the bearded old man, and the wood ladder. The position of these major elements gives them a symbolic power over the two adventurers from Argos. They are privileged with wisdom and knowledge about the order of the universe; the old man, for example, is an ascetic figure. Possessing an understanding of the forces that rule the universe, he can, like the bird, visit not only the heights but also the realms underground. The sky, embodying at once day and night, takes on an unusual connotation. It symbolizes complementariness: the flame and its extinguishment, light and darkness. The quest of the young men is thus not fruitless; they are in the presence of potential answers.

In this work, Beckmann depicted the search he led in his art and in his life:

In my opinion all important things in art since Ur of Chaldees, since tel Halaf and Crete have always originated from the deepest feeling about the mystery of Being. Self-realization is the urge of all objective spirits. It is this self that I am searching in my life and in my art. . . . And for this reason I am immersed in the phenomenon of the Individual, the so called whole individual, and I try in every way to explain and present it.[68]

The right panel consists of a chamber orchestra composed exclusively of women musicians. These beautiful singers and instrumentalists are rehearsing, it seems, the musical piece whose title appears on the program at their feet: "Argonaut." Beckmann once again was notifying the viewers that they are present at a performance. This side scene plays a role similar to that of the chorus in Greek theater: it comments on and distances the action. In the trip-

tych, however, this peaceful space adds a pleasant sensuality, a kind of carpe diem of painting. Serving as neither *vanitas* nor memento mori, these young women take part in an educational divertissement and are included essentially to please the eye. This work demonstrates that the painter accepted one of the paradoxes of art: that in order to instruct, it must first seduce, all the more so when the painting's meaning lies in the heart of the seduction.

The left panel directly addresses the theme of the artist at work. The intense concentration of the painter, who is squinting at his canvas, holds our attention. On the other hand, the product of his efforts remains invisible to us. Rather than ask the question *how* to depict, Beckmann concerned himself with the subject, the question of *what* to depict. The response is a puzzle: a proud female warrior, half nude, sword in hand, and seated on what is perhaps an African mask, with a green plant beside her. Eroticism is suggested, of course, but also the allegory of a struggle whose enemy remains undefined. The mask represents the face of good or evil gods associated with supernatural powers. To sit on the mask thus constitutes an act of blasphemy. The painter's muse has the appearance of a solitary warrior who has gone off to battle against the gods. Beckmann repeated the offense of Prometheus in recapitulating one last time what motivated the creation of his works: "Art is the mirror of God embodied by man. . . . The old gods lie in smithereens at our feet."[69]

Beckmann's last triptych realized in America gives us a better understanding of his address to a group at Washington University in 1950, some six months before his death: "Art, with religion and the sciences, has always supported and liberated man on his path. Art resolves through

form the many paradoxes of life, and sometimes permits us to glimpse behind the dark curtain which hides those unknown spaces where one day we shall be unified."[70] After exhibiting in the United States for more than twenty years, Beckmann finally transcended the evaluation of his work as "Germanic." He demonstrated that other qualities could be found in his painting and that the French painters, for all their critical success, were not the exclusive commentators on line, luminosity, and sensuality. He emphasized in his speeches, writings, and interviews that his preoccupations with form essentially constituted a search for self, that his art was the vehicle and the medium of understanding. If there is a philosophy to be found in Beckmann's art, it resides in the extraordinary relationship between the artist's view of life and the work of his hand. The philosopher emerges out of this experience of creation.

Translated, from the French, by Lory Frankel

Notes

1. Quoted in Dagmar Grimm, "Max Beckmann's Critical Reception in America, 1927–1950," Master's thesis, University of California, Los Angeles, 1987, p. 7. From Henry McBride, "Modern Art," *The Dial*, April 1926, p. 346.

2. Alice Bradley Davey, "Two Extreme Styles of Modern Art Top Week's Exhibitions: Max Beckmann's Paintings Contrasted with Exhibition of Purism," *Chicago Sun*, Jan. 10, 1942.

3. Among the major artists representative of the trends in German art were Vasily Kandinsky, Ernst Ludwig Kirchner, Wilhelm Lehmbruck, and Max Slevogt. The total number of Germanic names, out of 294 participants, was fourteen. See Milton Brown, *The Story of the Armory Show* (New York: Abbeville, 1988) for more information about the exhibition.

4. Quoted in Penny Bealle, "Obstacles and Advocates: Factors Influencing the Introduction of Modern German Art from Germany to New York City, 1912–1933: Major Promoters and Exhibitions," Ph.D. diss., Cornell University, 1990, p. 64. From "Extraordinary Exhibition of German Graphic Art by Contemporary Artists Early and Modern," *New York Times*, Dec. 1, 1912.

5. *Contemporary German Graphic Art*, exh. cat., introduction by Martin Birnbaum (Chicago: Art Institute of Chicago, 1912), p. 13.

6. For more information about Anderson Galleries, see Bealle, pp. 85–135.

7. Royal Cortissoz, *New York Tribune*, Oct. 3, 1923.

8. Quoted in Miriam Wiesel, "I. B. Neumann und Max Beckmann 1912–1937: Kunst und Kunsthandel zwischen Berlin und New York," Master's thesis, Johann Wolfgang Goethe Universität, 1984, p. 85. From McBride, "Beckmann's Art Portrays German Postwar Disillusion," *New York Times*, April 17, 1927.

9. Quoted in ibid. From *Arts Magazine*, May 1927.

10. Letter from Beckmann to J. B. Neumann, dated May 23, 1925, in Neumann, "Confession of an Art Dealer, Sorrow and Champagne" (1958, typescript in the Special Collections of the Museum of Modern Art Library, New York), p. 27.

11. The New Art Circle catalogue, *Artlover* (New York, 1927), contains reproductions of works that can only be assumed to have been exhibited, since no list of the exhibited paintings is known. The illustrated paintings are *Selbstbildnis auf gelbem Grund mit Zigarette* (*Self-Portrait on Yellow Ground with Cigarette*, 1923); *Landschaft mit Vesuvius. Naples* (*Landscape with Vesuvius. Naples*, 1926); *Dance in Baden-Baden*; *Stilleben mit Grammophon und Schwertlilien* (*Still Life with Gramophone and Iris*, 1924); *Portrait of Käthe von Porada*; *Bildnis Quappi in Blau* (*Portrait of Quappi in Blue*, 1926); *Stilleben mit Fischen und Papierblume. Stilleben mit Fisch und Windrad* (*Still Life with Fish and Paper Flower. Still Life with Fish and Pinwheel*, 1923); *Stilleben mit violetten Dahlien* (*Still Life with Violet Dahlias*, 1926); *Bildnis einer alten Schauspielerin* (*Portrait of an Old Actress*, 1926); *Brandung. Kleine Marine* (*Breakers. Small Seascape*, 1926); *Stilleben mit Holzscheiten* (*Still Life with Billets*, 1926); *Italian Fantasy*; and *Selbstbildnis mit Sekglas auf gelbem Grund* (*Self-Portrait with a Champagne Glass on a Yellow Ground*, 1925).

12. Edward Alden Jewell, "New Carnegie International Open at Pittsburgh," *New York Times*, Oct. 20, 1929.

13. Quoted in Neumann, "Confession of an Art Dealer," p. 36. From McBride, "The Pittsburgh International," *Creative Art* 5, no. 5 (1929), pp. xiiiff.

14. Paul J. Sachs (1878–1965) was a professor of fine art at Harvard University from 1917 to 1948 and curator of drawings at the Fogg Art Museum at Harvard. He exerted an influence over a generation of curators, who he trained by imparting to them his penchant for the German arts, particularly his appreciation of the German Expressionists.

15. *Modern German Painting and Sculpture*, exh. cat., introduction and

notes by Alfred H. Barr (New York: The Museum of Modern Art, 1931), p. 20.

16. James Johnson Sweeney, "Modern German Art Shown to New York," *Chicago Evening Post Magazine of the Art World*, March 24, 1931.

17. Letter from Neumann to Barr, dated July 14, 1933, in the Archives of American Art, Smithsonian Institution, Neumann Papers, roll 2165, image 21.

18. See Erhard Göpel and Barbara Göpel, *Max Beckmann: Katalog der Gemälde*, ed. Hans Martin von Erffa, vol. 1 (Bern: Kornfeld und Cie, 1976), pp. 89–101.

19. Letter (in German) from Beckmann to Neumann, dated April 20, 1931. For Beckmann letters (in German), see Beckmann, *Max Beckmann Briefe*, ed. Klaus Gallwitz, Uwe M. Schneede, and Stephan von Wiese, 3 vols. (Munich: Piper, 1993–), unless otherwise noted. In this essay, quotations from the German were translated by Isabelle Moffat.

20. "Aus den Erinnerungen Reinhard Pipers," cited in Beckmann, *Die Realität der Träume in den Bildern: Schriften und Gespräche 1911–1950*, ed. Rudolf Pillep (Munich: Piper, 1990), p. 25.

21. Pablo Picasso, *Nature morte devant une fenêtre ouverte à St. Raphaël* (1919), in the collection of Paul Rosenberg, New York, and Juan Gris, *La Fenêtre ouverte* (1921), in the collection of M. Meyer, Zurich.

22. Beckmann, "Juli 1919, Gespräch mit Reinhard Piper über das Gemälde 'Die Nacht,'" in Beckmann, *Die Realität der Träume*, p. 27.

23. Quoted in Stephan Lackner, *Max Beckmann: Memories of a Friendship* (Coral Gables: University of Miami Press, 1969), p. 31.

24. Letter (in German) from Beckmann to Valentin, dated Feb. 11, 1938.

25. "A Man Alive," *Art and Artists of Today*, Feb.–March 1938, unpaginated. In the Special Collections of the Museum of Modern Art Library, Valentin Papers.

26. Letter (in German) from Valentin to Beckmann, dated Nov. 31, 1938. In the Special Collections of the Museum of Modern Art Library, Valentin Papers.

27. Letter (in German) from Valentin to Käthe von Porada, dated April 24, 1938. The painting referred to is *Shore with Boats*, which appeared on the cover of the publication accompanying the exhibition. It sold for $220, although the asking price was $330. Beckmann received only $148, as Valentin deducted $72 for the cost of the framing. Correspondence and catalogue annotated by Valentin in the Special Collections of the Museum of Modern Art Library, Valentin Papers.

28. Jewell, "German Modernist Work Is Hung at the Buchholz with Triptych as Its Feature," *New York Times*, Jan. 15, 1938.

29. Jacob Kainen, "Departure Proves an Exciting and Revolutionary Painting," *Daily Worker*, Jan. 15, 1938, unpaginated.

30. Jerome Klein, *New York Post*, Jan. 15, 1938. Clipping in scrapbook in the Special Collections of the Museum of Modern Art Library, Valentin Papers.

31. Jewell, "German Modernist Work Is Hung at the Buchholz."

32. Elisabeth McCausland, "Gallery Notes," *Parnassus* 10, no. 2 (July 1938), p. 28.

33. Helen Appleton Read, "Max Beckmann's Latest," *Magazine of Art* 31 (Feb. 1938), pp. 105–06.

34. Ibid.

35. From "On My Painting," a speech given by Beckmann in 1938 at *Twentieth Century German Art* at New Burlington Galleries, London. Reprinted on pp. 119–23 of this catalogue.

36. Letter (in English) from Curt Valentin to Barr, dated Jan. 14, 1938. In the Special Collections of the Museum of Modern Art Library, Valentin Papers.

37. Read, "Art in Our Time," *Magazine of Art*, June 1939. In scrapbook in the Museum of Modern Art Archives.

38. "Prizes and Popularity—San Francisco Awards to Contemporary Favorites at Museum of Modern Art," *New York Times*, July 9, 1939.

39. Klein.

40. "Max Beckmann," *New York Herald Tribune*, Jan. 16, 1938. Clipping in scrapbook in the Special Collections of the Museum of Modern Art Library, Valentin Papers.

41. McBride, *New York Sun*, Jan. 6, 1940.

42. A. J. Philpott, "Modernistic Art Purged by Hitler Is Exhibited Here," *Boston Globe*, Nov. 5, 1939.

43. "Heard of the Galleries," *Art News*, no. 38 (Jan. 6, 1940).

44. McBride, *New York Sun*.

45. Letter from Beckmann to Neumann, dated March 3, 1939.

46. "German Seeker," *Time* 47, no. 18 (May 6, 1946), p. 64.

47. Ben Wolf, "Exile Beckmann Returns to Exhibition Arena," *Art Digest* 20 (May 1946), p. 13.

48. Beckmann, "On My Painting."

49. Ibid.

50. Diary entry dated Feb. 12, 1946. See Beckmann, *Tagebücher 1940–1950*, ed. Mathilde Q. Beckmann and Erhard Göpel (Munich: Langen Müller, 1984).

51. Diary entry dated March 29, 1947. See ibid.

52. Letter (in German) from Beckmann to Minna Beckmann-Tube, dated Aug. 24, 1947.

53. Diary entry dated Aug. 23, 1947. See Beckmann, *Tagebücher*.

54. Ibid.

55. Diary entry dated Nov. 29, 1945. See ibid.

56. Hanns Swarzenski, preface, in *Max Beckmann 1948: Retrospective Exhibition*, exh. cat. (Saint Louis: City Art Museum, 1948), p. 8.

57. Kenneth Hudson, salary proposal for Beckmann, Dec. 3, 1947, in the Archives of Washington University, Saint Louis.

58. Letter from Beckmann to Neumann, dated March 3, 1939, quoted in Neumann, "Confession of an Art Dealer," p. 43.

59. Fred Neumeyer, "Erinnerung an Max Beckmann," *Der Monat*, April 1952, p. 71.

60. Quoted (in German) in Neumann, preface, in *Max Beckmann Graphik*, exh. cat. (Berlin: Graphisches Kabinett, 1917).

61. Quoted in Aline B. Louchheim, "Beckmann Paints the Inner Reality," *New York Times*, June 13, 1948.

62. Quoted in Mathilde Q. Beckmann, *Mein Leben mit Max Beckmann* (Munich: Piper, 1985), p. 147.

63. "Aus den Erinnerungen Reinhard Pipers," p. 25.

64. Ibid., p. 28.

65. Genesis 1:14.

66. Beckmann, "Der Künstler im Staat," in *Die Realität der Träume*.

Reprinted from *Europäische Revue* 3, no. 4 (1927).

67. From "Letters to a Woman Painter," which was written in German for presentation at Stephens College, Columbia, Missouri. The talk was translated into English by Quappi Beckmann and Perry T. Rathbone and read by the painter's wife on February 3, 1948. Reprinted on pp. 125–28 of this catalogue.

68. Beckmann, "On My Painting."

69. Quoted in Hans Belting, *Max Beckmann: Tradition as a Problem in Modern Art*, trans. Peter Wortsman (New York: Timken, 1989), p. 113.

70. From "Speech for the Friends and Philosophy Faculty of Washington University," June 6, 1950. Beckmann delivered the speech in English.

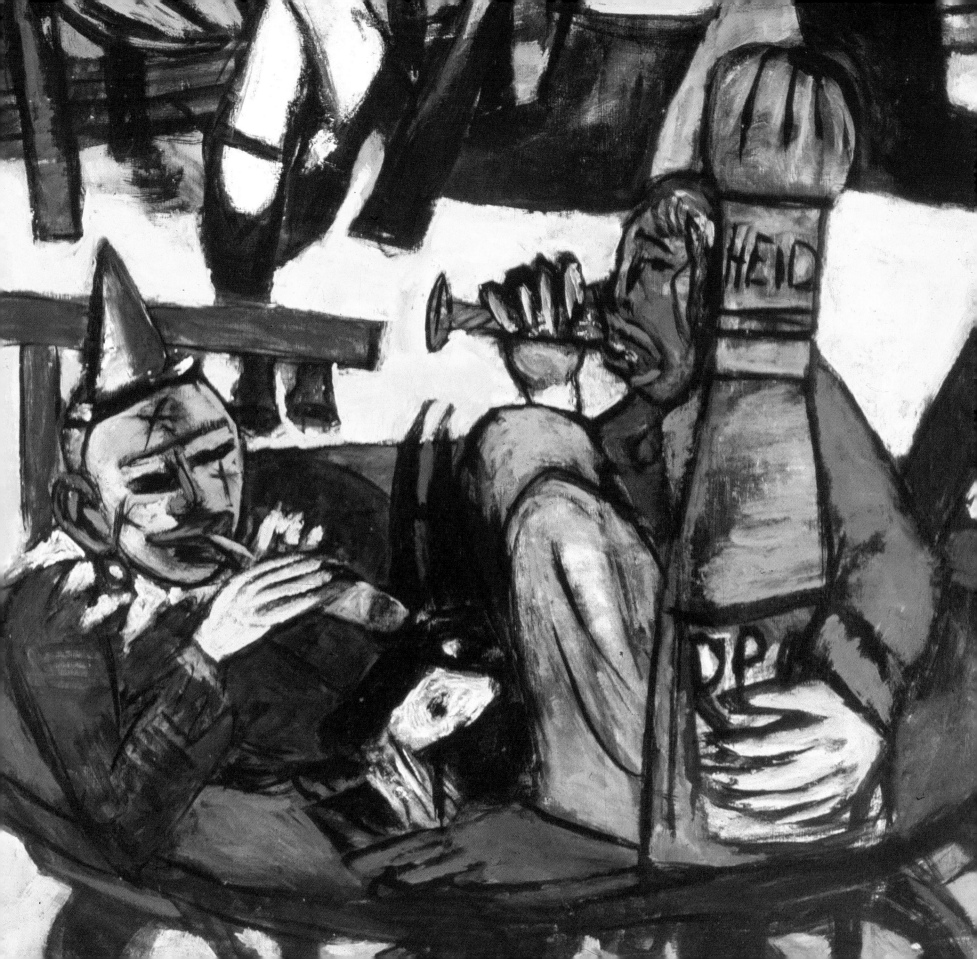

PICTORIAL WORLDS, WORLD VIEWS: MAX BECKMANN'S TRIPTYCHS

Reinhard Spieler

When he was nearly fifty years old, Max Beckmann dared to take on a new format in his painting: the monumental triptych. He had created many large canvases early in his career. However, after abandoning *Auferstehung II* (*Resurrection II*), which he worked on from 1916 to 1917 but left unfinished, he made smaller paintings for the next fifteen years; while *Resurrection II* measures 497 x 345 cm (sixteen feet four inches x eleven feet four inches), making it one of his largest canvases, his subsequent paintings are no more than two meters (six-and-one-half feet) high.

By the start of the 1930s, Beckmann was among Germany's most celebrated and honored artists, having been the subject of major retrospective exhibitions in Mannheim (1928) and Basel (1930); in 1930, Beckmann represented Germany at the Venice *Biennale* with six paintings, and in 1932 an entire gallery was dedicated to his work at the Nationalgalerie in Berlin. On the occasion of a Beckmann exhibition in 1929, Julius Meier-Graefe, the patriarch of German art criticism, wrote enthusiastically: "Even the hardened skeptic must recognize the breakthrough in this exhibition. One need only see one of these pictures, the harvest of a single year, in order to comprehend the incomprehensible: once more we have a master in our midst. God knows how this happened to us."[1]

Beckmann's success came after a long development that took him from late German Impressionism through Expressionism and on to Neue Sachlichkeit. At the end of the 1920s, Beckmann arrived at a new pictorial vocabulary combining classical figuration with nonmimetic or nonillusionistic means of constructing space, depth, and plasticity. This new pictorial language, which would not change substantially through the end of his life, coincided with his discovery of mythology as a primary source of subject matter.

In 1932, Beckmann began to work again in a monu-

Detail from right panel of *Akrobaten* (*Acrobats*), cat. no. 8.

mental scale. Beckmann's decision to make triptychs[2] reveals his ambition to concentrate his oeuvre into a single, special format, one that, through its religious association and its panoramic quality, reveals Beckmann's true aspiration: to use his paintings as a form of confession and to communicate his distinct worldview.

The triptychs punctuate his oeuvre from 1932 until his death in 1950. Beckmann worked almost continuously on triptychs, especially during the war years, which he spent in Amsterdam; as external circumstances became increasingly intense and disturbing, it seems, the greater Beckmann's need became to give form to these experiences. Only two weeks separate the completion of *Perseus* (1940–41, see p. 70), upon which Beckmann commented in his diary with a sigh of relief, "creation is redemption,"[3] and the preliminary sketch for *Schauspieler* (*Actors*, 1941–42, cat. no. 11). And again only about two weeks after Beckmann finished *Actors*, he wrote in his diary: "Began new triptych. With ADAM etc.—still undecided—but could be something."[4] An almost delirious compulsion drove Beckmann to transform his experiences of art and life into a kind of sovereign form, in order to give dignity, splendor, and sense to a life amid chaos and war, a life he perceived as insane. While working on the triptych *Akrobaten* (*Acrobats*, 1939, cat. no. 8), he wrote to his friend Stephan Lackner: "I'm utterly submerged in work. *Le nouveau Trois* is rising from dark waters up over champagne, cadavers and the small madness of the world to final clarity. —*O mon Dieu* life is worth living."[5]

The triptychs are kaleidoscopic: they combine the traditional genres of landscape, still life, portraiture, and history painting with a multitude of subjects from reality as Beckmann experienced it. The pictorial world of the triptychs is composed of relatively few motifs, yet they are so versatile and mutable that they produce extraordinarily diverse associations. But who appears in Beckmann's triptychs? What settings does Beckmann select, and what properties does he employ, in order to establish areas of interrelation? What pictorial means does he apply and what do they accomplish?

Characters

The dominant element of the triptychs is the human figure. In each panel of the ten extant triptychs (one of which he left unfinished), at least two figures are depicted; thus, the works may be seen as sites for Beckmann's exploration of human relationships.

With few exceptions,[6] Beckmann composed the figures in his triptychs at about life-size. The spectator, therefore, is confronted with a pictorial world in which the depicted characters constitute an equivalent, immediate mirror image; man determines the scale in this world. Formally, the figures play a key role as well: their strong black contours determine the compositional frame,[7] their effect has been compared to that of the leading in stained-glass windows.[8]

Despite the occasional portraits and self-portraits, the depicted figures are more types than individuals. A certain core group appears in almost all of the triptychs: "Beckmann remains loyal to his people and types; this makes him a dramatist among painters," Lackner remarked in his legendary 1938 essay, "Das Welttheater des Malers Beckmann" ("Max Beckmann's Mystical Pageant of the World").[9] But in each triptych, the function and expression of the figures vary markedly.

One can determine two major sources for the figures in Beckmann's pictorial world: first, the world of mythology, from which characters such as kings, warriors, and fabulous creatures are taken, and second, the world of artists in the widest sense, encompassing the theater and the circus. While Beckmann discovered mythology beginning in 1932,[10] the world of theater and circus had been one of his favorite subjects since around 1920, particularly in his graphic works.[11] The Baroque idea of the world-theater as a metaphor for life fascinated Beckmann.[12] Mythology and theater certainly overlap, since mythic figures often appear on stage, and both worlds are characterized by a "double reality": the former is one of historical reality—each myth contains a historical core, be it an event, setting, person, or group; on the stage, historical reality exists as the actual time of the performance and the reality of the actors playing roles. But there is another dimension for both worlds. Myth and theater are forms in which reality has been transformed into the pictorial. Drawing on this world gave Beckmann great freedom with his figures: they are experienced not only in terms of their immediate reality, but their very source communicates that they are allegorical, and thus to be understood as representations of other realms, at different levels of reality.[13]

Among the myriad inhabitants of Beckmann's triptychs, five figures appear in almost all of them. These are the king (appearing eleven times), the warrior (twelve times), the bellboy (thirteen times), the young man (fourteen times), and the woman (fifteen times). The last may seem generalized, but as opposed to his depiction of the male figures in his triptychs, Beckmann hardly varied or developed the figure of the woman. In almost all cases, she is young—about twenty to thirty years old—and her physiognomy is much the same from canvas to canvas. Other figures or types appear in the triptychs, but they are not as dominant.[14] In addition, fantastic creatures appear in seven triptychs.[15]

The figures in the triptychs comprise a population whose interrelationships mirror a range of human behavior in the world; they enact diverse aspects of social reality, particularly the distribution of power in society. Pairs of opposites, especially men and women, provide the underlying structure for many of the panels. With the exception of *Argonauten* (*The Argonauts*, 1949–50, cat. no. 20), problematic gender relations provide a context for larger conflicts throughout the works. For example, in *Abfahrt* (*Departure*, 1932–33, cat. no. 3), the first triptych, the right panel includes scenes of violence and bondage, which can be seen as referring to relationships between the sexes. This is juxtaposed with the left panel, in which scenes of torture and maltreatment allude to the historical-political reality in Germany at the time of the painting's creation. In *Karneval* (*Carnival*, 1942–43, cat. no. 13), the focus is mainly on the relationship between the sexes. Beckmann initially called the painting "Adam and Eve," and, indeed, the right panel shows the expulsion from paradise (represented by the Hotel Eden, which Beckmann had visited frequently in Berlin; in the background of the central panel one can recognize AMSTE[rdam], referring to the place of Beckmann's exile). And in the side panels of *Blindekuh* (*Blind Man's Buff*, 1944–45, cat. no. 14), a man and woman appear in the midst of chaos. Despite being blindfolded, they steadfastly try to find one another; where gods have fallen into a state of chaos and lethargy, two humans take control of their own fate.

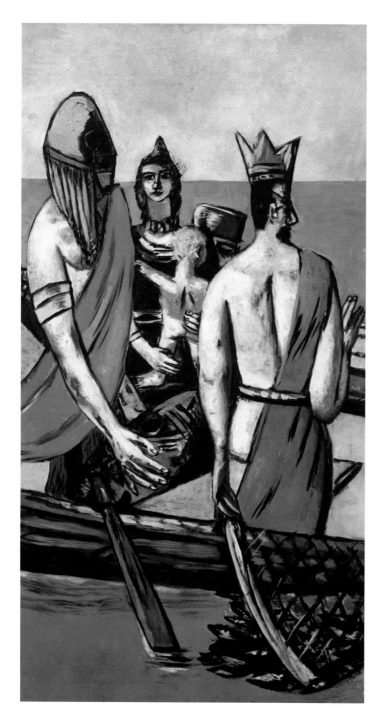

60

Another major pairing in the triptychs is between master (usually in the guise of a king) and subject, either a servant (such as a bellboy) or a warrior. In the central panel of *Departure*, Beckmann paradigmatically sets king and warrior in opposition, with colors signaling the difference between them: the king wears a cloth of cool blue, which represents the intellectual, rational principle; in contrast, the warrior is clothed in intense red, the color of fire, passion, emotion, and instinct. The king frees fish caught in a net—a sovereign act—assuming a statesmanlike pose and holding his arm in a kind of gesture of benediction; his countenance is superior and reasoned. Conversely, the warrior has seized a large (phallic) fish—universally, the fish symbolizes fertility and life[16]—indicating an aggressive stance. Likewise, his headgear, situated just above and askew from the horizon line, contrasts with the king's crown, the bottom part of which aligns perfectly with the horizon. The king's face can be recognized under the crown, further reinforcing the figure's noble character, whereas the phallus-shaped helmet conceals the warrior's face, suggesting that instincts are a nameless, anonymous force. Thus, Beckmann recreates an archetypal structure in which civilization and culture are pitted against instinct and violence.

The young man and the lackey form another pair of antagonists in the triptychs. Beckmann's young men exude none of the radiant, unapproachable aura of victory that describes the steely heroes in Leni Riefenstahl's and Arno Breker's Nazi propaganda. Beckmann's young men are consistently serious, suffering figures. In *Versuchung* (*Temptation*, 1936–37, see. p. 64), for example, the young man in the central panel is bound at the wrists and ankles; in the central panel of *Acrobats*, he is a clairvoyant with an expres-

Central panel of *Abfahrt* (*Departure*), cat. no. 3.

sion of tragic comprehension; and in the right panel of *Blind Man's Buff,* he has been blindfolded—another form of bondage. A group of young men is depicted in *The Argonauts,* which takes up the Greek myth in which a band of heroes sets out to win the Golden Fleece. But Beckmann's figures are not heroic; rather, they are presented merely as seekers. None of the adolescents depicted in the triptychs exert violence—they are not Sturm und Drangers; instead, they exhibit quiet, intensely introverted manners showing them to be serious and determined. In general, the young men are the protagonists around whom conflict develops. They manifest the will to withstand outside influences, to pursue their goals against opposition from without, and to trust their inner calling.

The figure of the lackey is the counterpart to the young man. Lackeys pursue no goals of their own, but only receive orders; they are, in short, conformists. They can observe much but are nonetheless always obliged to look away, for their function is acquiescent neutrality. "Today fate appears as an elevator boy," Beckmann reportedly said about this figure.[17] Only a uniform grants the lackey an identity, but, as the term "uniform" implies, it is one of an unindividuated everyman. The uniform also alludes to the military. For Beckmann, this figure embodies a faceless public whose role is not always as harmless as it may appear. In the right panel of *Temptation,* for example, the bellboy, having gained self-importance through his uniform, monstrously leads a woman on a leash as she assumes a doglike position.

In the right panel of *Acrobats,* Beckmann reveals another danger emanating from seemingly harmless

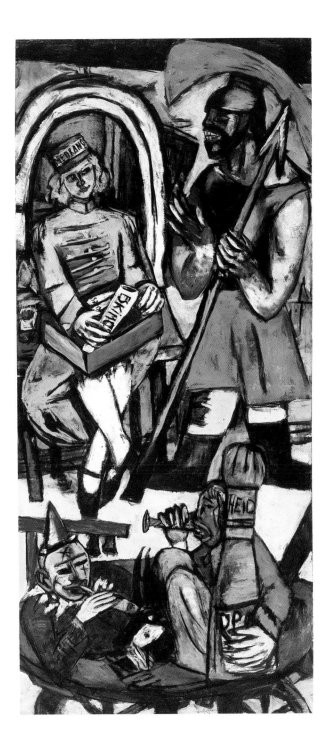

61

Right panel of *Akrobaten* (*Acrobats*), cat. no. 8.

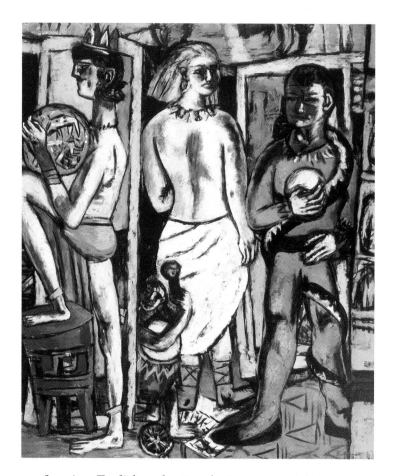

conformists. Foolish and naïve, the ice-cream girl is unaware of the identity of the ominous fellow she is flirting with—he is none other than Mars, god of war. According to the Beckmann catalogue raisonné, the triptych was completed around August 25, 1939.[18] On September 1, German troops invaded Poland, and thus began World War II. From 1937 on, the leading goal of the National Socialist foreign policy had been the "conquest of new living space": before the Polish invasion, Germany had pursued this goal through such means as the destruction of Guernica by the German Condor Legion (1937), the "annexation" (*Anschluss*) of

Austria (1938), and the cancellation of the German-Polish nonaggression pact on April 28, 1939. War could not have been a surprise to Beckmann. In *Acrobats*, the girl's flirtation with the ghost of war seems a clear allusion to Hitler's fatal game.

In the lackey and the young man, Beckmann presents two approaches to life: unquestioning acceptance as opposed to a serious coming to terms with the times and continued individual creation in spite of them. Throughout the triptychs, this reading remains largely constant. In the case of the lackey, this may be because Beckmann considered the conformist to be an integral part of any society. The young man, however, is intertwined with Beckmann's image of the artist as engaged in an intense, unfaltering search and pursuit of inner images and visions. In 1938, Beckmann wrote to Lackner: "Everything essential takes place away from the clamoring of day only to be even more effectual. Only the weak and belated try to gain fleeting influence among noise and pressure—let it. But that is not for us. . . . The essential must be the quiet show in your quarters."[19] Beckmann repeatedly sought the immutable force and constancy of this inner concentration, perhaps in order to reassure himself by representing it pictorially. The figure of the young man proves Beckmann's own existence as artist.

While Beckmann's vision of the lackey and the young man remained constant, his depiction of the king and the warrior, by contrast, underwent substantial changes. In the early triptychs, the king represents human existence on its highest and noblest level. The king plays a public role; he is a measuring rod of Beckmann's belief in a responsible, worthy, and dignified place for man in society.[20] In the first

Central panel of *Akrobaten* (*Acrobats*), cat. no. 8.

triptych, *Departure*, this notion has been staged accordingly: while the side panels represent man entangled in violence and slavery, the central panel is a utopian image of freedom, a departure into a royal existence. The king's gesture of benediction brings to mind the figure of Christ; the king assumes a role as both redeemer—he releases the fish into freedom—and redeemed, by departing into a new world. The theme of redemption is further emphasized by other borrowings from Christian iconography, such as the deluge mythologem[21] and the "Madonna and child" in the boat, as well as by a secular symbol of liberty, the Madonna's Phrygian cap. Beckmann began the triptych in Frankfurt in 1932. In January 1933, however, he moved to Berlin in the hope of escaping Nazi mobs. The purchase of the painting *Der Strand* (*The Beach*, 1927, G. 267) by the Frankfurt city council had provoked a public campaign against Beckmann; concerning his contribution to the Venice *Biennale*, the Nazi press wrote of "ignoble degenerate ghosts like those of Max Beckmann" and of "psycho-physical anomalies."

Yet, in spite of constant attacks against him in Frankfurt, the painter apparently still believed in the possibility of utopia, as indicated by *Departure*, which he completed that year in Berlin. As late as 1934, Beckmann optimistically wrote his dealer, Günther Franke, who was willing to risk a show even after the artist was banned from exhibiting: "There is no sense in bringing all this up for discussion already; we have to wait one more year for that. Otherwise several very good things (of which I will tell you at some point) but which are still in development could fail and that would be a shame. —I just have a more precise understanding of the situation and am in very good spirits and very well informed!"[22]

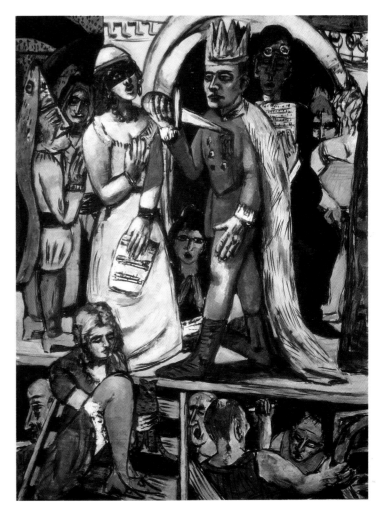

63

Beckmann was soon disabused of his positive opinion of the state of the world around him. Three years later, immediately before his escape into exile,[23] his assessment changed radically. *Temptation* shows no trace of a royal existence; the only element of kingly power left is the crown in the right panel—and, rather than resting on the head of a monarch, it is carried on a platter by a lackey.

The utopia promised in the central panel of *Departure* is deconstructed in *Temptation*. The main figures are ban-

Central panel of *Schauspieler* (*Actors*), cat. no. 11.

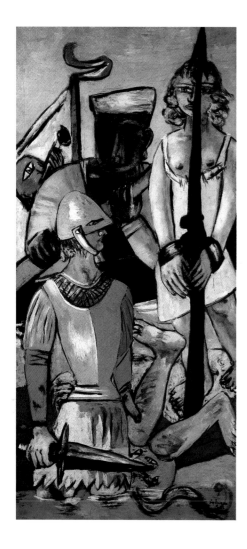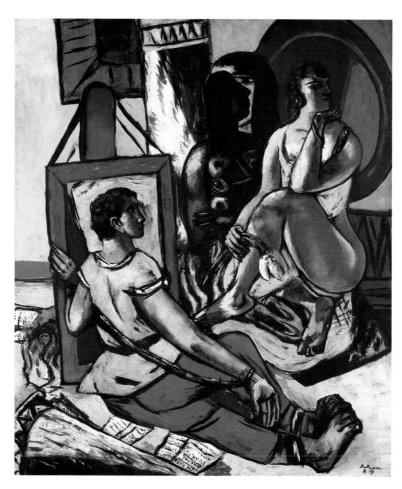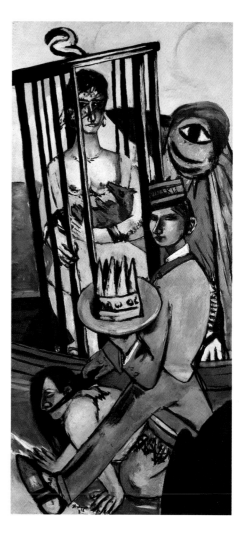

Max Beckmann, *Versuchung* (*Temptation*), 1936–37. Oil on canvas; triptych, left and right panels: 215.5 x 100 cm (84 ⅞ x 39 ⅜ inches), central panel: 200 x 170 cm (78 ¾ x 66 ¹⁵⁄₁₆ inches). Bayerische Staatsgemäldesammlungen, Staatsgalerie Moderner Kunst, Munich.

ished to the wings and in the course of this movement they are transvalued. The Madonna in *Departure* is no longer en route to freedom, but, rather, is caught in a cage. Instead of a child, she nurses a weasel, symbol of debauchery and uncontrolled sexuality.[24] Likewise, the warrior is transformed: in the central panel of *Departure* he grabs the fish—symbol of life—but in the left panel of *Temptation* he is a destroyer of life.

Two years later, directly before the outbreak of World War II, Beckmann caricatured the figure of the king in the central panel of *Acrobats*. Distorted proportions, awkwardly drawn anatomy (especially in the lower torso), crude features, and a shrunken crown make this king a sad, ridiculous character: by this time, Beckmann had transformed his vision of a royal existence into a grotesque farce.

While Beckmann's treatment of the king in *Temptation* and *Acrobats* can be considered rather sarcastic commentaries, in *Actors*, the vision of kingly—and thus ideal—existence has been determined by desperate seriousness. As in *Acrobats* and *Der König* (*The King*, 1933, 1937, cat. no. 4), the figure in *Actors* is not an "authentic" king, but one who acts the role.[25] All of Beckmann's figures who play such a role, however, live precisely on account of their ability to reactivate myth from within their role playing. *The King*, then, is not only a circus performer—his unyielding arrogance and his militant affirmation of life make him a truly archetypal royal presence.

For the people, the king is an embodiment and guarantor of secure living conditions, of faith in the possibility of human coexistence. It is this function that Beckmann caricatures in *Actors*, the most pessimistic of the triptychs. The king commits suicide, renunciating, rather than confirming,

life. The fact that we are dealing with a play heightens the pessimism of the statement. While the king in the eponymous painting, as a consequence of his role playing, becomes an archetypal, mythical figure and is able to draw strength and authority from this metamorphosis, Beckmann shows no such possibility for the king in *Actors*: the ability to transcend the role exists only through suicide. Remain in the role or die—these are the options Beckmann gives his king. The identification in *Actors* is no longer with the king, as it still was in the earlier painting, but with the actor playing the king's part—and here lies the pessimistic conclusion: Beckmann no longer believed in the possibility for the individual to become alive in myth. In the figure of the king, which precisely symbolizes free human existence, Beckmann presented an image of nonfreedom.

Only after the war, after Beckmann slowly redeveloped a perspective on life, does the role of the king become available again for a positive casting. In the left panel of *Beginning* (1946–49, cat. no. 19), a small boy appears as a king in the realm of his own imagination. "Imagination—perhaps the most divine characteristic of man," Beckmann stated in his 1938 London speech.[26] In *Beginning*, Beckmann shows that imagination not only changes what is perceived—the boy experiences a vision of angels—but also the person who is perceiving: whoever dares to trust the power of the imagination, Beckmann suggests, is capable of giving his own existence a royal air. Beckmann's projection of the royal metamorphosis back onto the gift of childish imagination, however, appears like a painful admission of the great distance of former times; it is an admission reminiscent of the threatening and admonishing words of Christ: "Indeed, I tell you: he who does not receive God's kingdom like a

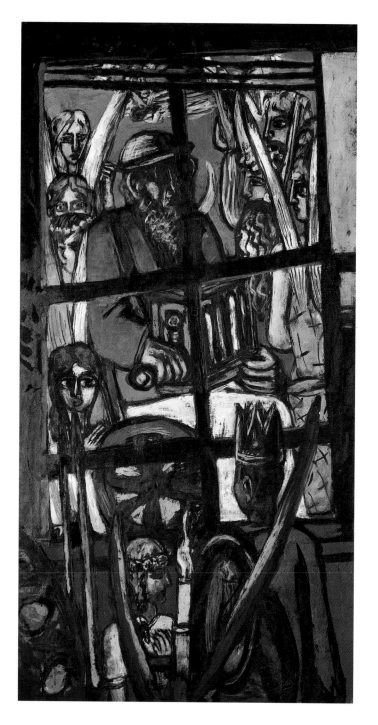

child, will not enter."[27] By that time, Beckmann seems to have known that his ability to attain such a regal plane was waning: "Hasn't 'my glorious vitality' disintegrated some time ago and is only an artificial window-dressing now?" he wrote in his diary on June 19, 1949, four weeks after the completion of *Beginning.* "What can I still extract from the last ruins of a royal house—how could I still make the planetary systems tremble?"

The evolution of the figure of the king in the triptychs allows us to chart Beckmann's attitude towards an "ideal" human existence: judging from *Departure,* the artist's view started out as utopian, but, by *Temptation,* quickly turned cynical; in *Actors,* freedom, dignity, and social responsibility are declared to be impossibilities, yet in *Beginning,* Beckmann's view is modified into a somewhat wistful projection onto childhood—allowing him a distanced, yet potentially redemptive, stand. The warrior undergoes an equally striking development. The figure first surfaces in *Departure,* and soon thereafter in *Geschwister* (*Brother and Sister,* 1933). In *Departure,* the warrior takes his place as an integral character in Beckmann's utopia of a redeemed existence; he is the counterpart to the king, and together the figures form an idealized model for Beckmann. The monarch's attributes—rationality, organization, and culture—perfectly complement the emotion, instinct, and affirmation of life embodied by the warrior. These are the fundamental components of the *conditio humanae* in Beckmann's work. In *Departure,* the warrior carries no arms, though the mask covering his features gives him a threatening, unpredictable air. Beckmann here accepts the "war elements" as necessary and fertile parts of human existence. In *Brother and Sister,* however, he indicates the warrior's

Left panel of *Beginning,* cat. no. 19.

potential for destruction: with unequivocally phallic connotations, the sword between the two siblings, Siegmund and Sieglinde, threatens to pierce the woman should she draw closer. The topic of incest, derived from the thirteenth-century epic the *Nibelungenlied*, seems to contain political dimensions transcending the problem of gender relations. It can hardly be dismissed as accidental that in 1933 Beckmann took up a Germanic myth that deals with an accursed relationship.[28] Furthermore, he adopted the version of the tale in Richard Wagner's operatic cycle *Die Ring des Nibelungen* (*The Ring of the Nibelungs*). In it, the siblings Siegmund and Sieglinde are victims of the godly conflict between Wotan, Freya, and Valkyrie; afflicted by a curse, they fall in forbidden, incestuous love, which leads, inexorably, to Siegmund's death. Beckmann originally titled the picture "Siegmund and Sieglinde," but finally settled on the more neutral *Brother and Sister*.

In the painting, Siegmund appears in the shining armor of a hero, but the positive attributes associated with a hero cannot be confirmed in this image. While Siegmund is less a perpetrator than the victim of his instinctual makeup and of divine intrigue, the warrior in *Temptation* purposefully and actively employs violence. He appears in the shining armor of a hero, but there is no evidence of any heroic intention. This warrior embodies brute force, his metallic outfit gleaming, his identity unknowable. Nothing indicates that he intends to liberate the captive woman, or that the "monster" he is dispatching had threatened anyone before meeting this fate. Formally, one can identify an equivalence between the warrior and the bellboy in the right panel; by association, the former is tainted by his mirror image, who leads a woman as if she were an animal.

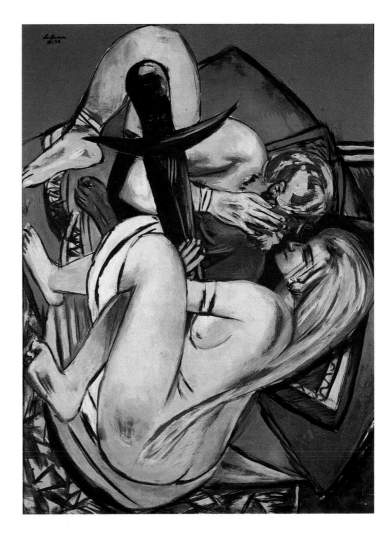

The warrior appears unmasked in the right panel of *Acrobats*; here, he is revealed as a malicious character who could have an easy time with the flirting ice-cream girl. A comparison of the facial features suggests that this is the same girl who will be overpowered and carried off two years later in the central panel of *Perseus*.

The development of the warrior figure clearly mirrors that of violence in German society during the same period:

Max Beckmann, *Geschwister* (*Brother and Sister*), 1933. Oil on canvas, 135 x 100.5 cm (53 ⅛ x 39 ½ inches). Private collection.

in 1937, violence was seen in heroic, mythic terms, as evidenced by the public rallies glorifying it.[29] In 1939, war was declared. By 1941, most of Europe had been subjugated.

In *Actors*, the image of the warrior takes another turn. Erhard Göpel connects the sword-bearing warrior in the left panel with an episode that took place in Wolfgang Frommel's apartment in Amsterdam during the German occupation. Frommel always hid artists and other people with illegal status in his apartment. One day, a Nazi sergeant appeared unexpectedly. In this moment of high danger, Frommel had an intense argument with the Nazi

sergeant, and—somewhat miraculously—in the face of Frommel's steadfastness, he withdrew, leaving Frommel's friends untouched. According to Göpel, the warrior in *Actors* represents this sergeant.[30] This theory has apparently seemed plausible to almost all others who have interpreted the triptychs.[31]

However, in my opinion, the scene suggests a different interpretation. The warrior's face expresses angry determination, but lacks the evil character evident in his counterpart in *Acrobats* or the diabolical nature of the central figure in *Perseus*. His gaze is straightforward. He does not raise his sword against the appeaser with the red scarf, whom Beckmann is said to have described as a "contemporary Christ,"[32] but rather pushes him gently to the side. The question of whether he is attempting to free the prisoners under the stage or is their guard must remain open.

A comparison may be made between the warrior in *Actors* and the apostle Paul, who, at Christ's arrest at Gethsemane, raised his sword against one of the soldiers and was held back by the pacifist Christ.[33] In this light, the scene may be read as an endorsement of violence for a good cause; this active scene contrasts markedly with the inaction of the man seated on the stairs, hiding behind his newspaper rather than taking responsibility for anything around him. More evidence toward a positive interpretation of this warrior is that in *Odysseus und Kalypso* (*Odysseus and Calypso*, 1943, G. 646). Beckmann endowed Odysseus with the same features; it would be odd, to say the least, that a Nazi sergeant (as Göpel sees the warrior in *Actors*) was somehow a model for Odysseus, a character with whom Beckmann himself identified.[34]

In *Beginning*, a small, saber-bearing boy rides a hobby

Public rally in Germany, ca. 1937.

horse in the central panel. Here, the childish conquest of life is the subject, and while the child's sword alludes to potential destruction, it is used only playfully. As in *Departure*, a second figure is paired with the "warrior." The king, who in the earlier triptych signified rationality, intellect, and culture, is here transformed into a bourgeois variant—the figure of the father, who stands for order and discipline. The saber rattling could certainly carry the positive connotation of a childish imagination rebelling against the bourgeois adult world.

Settings

Like their inhabitants, the settings in Beckmann's triptychs are types. Four main areas in which Beckmann staged his dramas can be identified: the theater or stage (including the circus); the temple (or place of ritual); the bar, pub, or dance club; and the artist's studio.

It is decisive for the structure of the settings and accordingly for the strategy of Beckmann's pictorial language that the settings are not hermetically defined. Almost all spaces and all scenes contain allusions to other settings as well. Each of these settings establishes a central theme for the triptychs. The temple or place of ritual invokes the question of the relationship between man and god; the pub is a public place of communion and thus reflects society's state of health; the studio thematizes self-understanding and the role of art. In the world of theater all domains converge; it is a place of intersection for ritual, amusement, and culture, for myth and contemporary history. Theater, like painting, can simultaneously incorporate all these elements. On stage, myth and contemporary history, art, and reality become identical and can exist alongside each other, because past

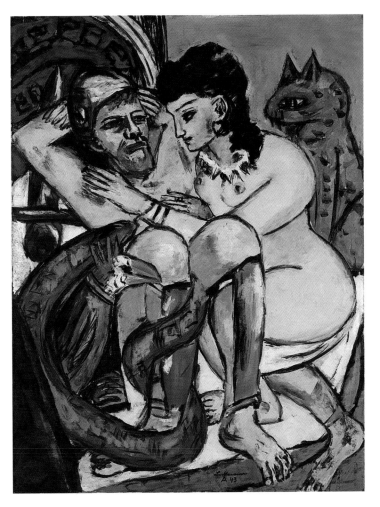

69

or imaginary events are staged and thus transported into the present.

Both Beckmann's spaces and settings have the potential for metamorphosis. For example, the setting in the central panel of *Temptation* can be read as an artist's studio or a temple; the scenario in the central panel of *Blind Man's Buff* could just as well be understood as a carnival band in a dance hall as an assembly of gods; the small strip of sand in the foreground of the central panel of *The Argonauts* could

Max Beckmann, *Odysseus und Kalypso* (*Odysseus and Calypso*), 1943. Oil on canvas, 150 x 115.5 cm (59 1/16 x 45 1/2 inches). Hamburger Kunsthalle.

Max Beckmann, *Perseus*, 1940–41. Oil on canvas; triptych, left panel: 150.5 x 56 cm (59 ¼ x 22 ¹⁄₁₆ inches), central panel: 150.5 x 110.5 cm (59 ¼ x 43 ½ inches), right panel: 150.5 x 55 cm (59 ¼ x 21 ⅝ inches). Museum Folkwang, Essen.

also be seen as a theater stage. Beckmann's perceptual mechanism entirely depends on this capacity for transformation, which allows mythic worlds and contemporary historical experience not to appear as opposites, but to be experienced as a totality in which each world nonetheless remains identifiable.

Art, war, and the pub collide harshly and without transition. In his diary, Beckmann wrote: "Earthquake in Rumania—champagne in the Kaperschip [a favorite pub]—idiocy or *irrationalisme?*"[35] In the diary, life's contradictions cannot be resolved. Only in art, that is, in the imagination, is a meta-level offered on which each contradictory experience is subject to a certain creative vision. Within this creative vision, experiences become mutable, and thus are able to acquire other meanings. In a lecture to students, Beckmann demonstrated this metamorphosis of the perceived in extremely vivid prose that emulates his pictorial language: "Weren't you sometimes with me in the dark caves of the champagne glasses, where the red lobsters crawl around and black waiters serve red rumbas that drive the smoldering heat through the veins into the wild dance—where white dresses and black silk stockings press around the hips of the young gods between orchid blossoms and the ringing of the tambourine?"[36]

What Beckmann spoke of so eloquently can also be observed in *Blind Man's Buff*, in which a dance-hall event undergoes a metamorphosis into a divine banquet. In the triptychs, two levels of reality can be experienced simultaneously. In plainer language, Beckmann revisited the topic in another lecture, given at Washington University: "Art, alongside religion and science, has always been the helper and liberator on the journey of mankind. Through form it frees the many contradictions of life and sometimes allows us to peek behind the dark curtain that veils the invisible chambers in which we will eventually be united."[37]

Themes

Every theme in the triptychs is expressed in such a way that it can be understood in the literal as well as in the metaphorical sense. For example, the joint appearance of a man and a woman in a panel suggests the theme of gender relations, yet the gender conflict can also serve as a model for broader social or historical conflicts. Conversely, scenes of conflict and destruction can mirror relationships between the sexes.

The complicated entanglement of man and woman in the central panel of *Temptation* suddenly changes into a question about art, if, on account of the studio props (a painting on an easel), one reads the scene as a painter with his model. The relationship between the sexes then becomes only an influential factor in the creative process and not the topic under examination.

In *Acrobats*, the dangerous flirtation in the right panel, which has its analogy in an equally dangerous act of love on the high wire in the left panel, changes into a historical drama that has as its subject Germany's foolhardy, feverish path into World War II. A destructive relationship between the sexes based on superficial attraction, about which Beckmann so frequently complained, serves as metaphor for the disintegration of society. Conversely, the politico-historical development mirrors the biblical fall of man, an event impelled not least by gender conflict. One of many diary entries relevant to this theme reads: "Cold rage rules my soul. Should one never become free from this endless

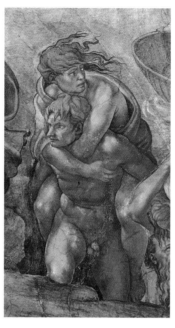

cage amuses herself with an animal that, since the late sixteenth century, has been associated with *lascivia*[39]—gender relations are inverted ad absurdum. Both scenarios can also be related to social circumstances. Violence under the cover of heroism; degradation and humiliation legitimized by a uniform; complacent retreat into the golden cage of high society, which willfully ignored the cruelties of the regime, amusing itself instead—these were all characteristics of Nazi society in the 1930s.

In *Acrobats*, Beckmann drew a similar analogy between gender relations and the historical constellation. Like the German people in 1939, the couples in both the right and left panels are engaged, amidst an explosive mixture of moods, in a risky and short-sighted flirtation with an extremely dangerous opponent. It is a dangerous situation that will inevitably lead to a fall.

In the first three triptychs, Beckmann presents such a congruence of the crisis between the sexes and in the social situation only in the side panels, contrasting them with an alternative world in the central panel. In *Departure*, for example, the central panel shows the utopia of departure; in *Temptation*, it is the space of quiet introspection as a source of energy for the young man. In *Acrobats*, the fall of man is depicted as an opportunity. Here, serpent and apple—the classical symbols for the fall of man—are sources of wisdom and prophecy: the serpent is also the attribute of Aesculap, the god of health, and it creeps around the young man as if he were an Aesculap staff. The woman then has the choice between two paths, that is, two men.

In *Perseus*, however, a catastrophic and violent relationship intrudes into the central panel, as the heroic myth of Perseus, who frees Andromeda, is turned into its oppo-

72

disgusting vegetative corporeality. . . . Boundless contempt for the lewd charms with which we are coaxed again and again to take life's bit."[38]

In the side panels of the first three triptychs, Beckmann focused on the congruence of the destructive forces he surveyed: in his view, gender relations were as fateful and full of violence as the social situation in Germany. In *Departure*, scenes of torture in the left panel are posed as an analogy to the image of the couple tied upside down to each other in the right panel. Degradation and violence dominate the relationship between the sexes in the side panels of *Temptation* as well. Bound to a spear, the woman is practically dismembered by this symbol of male violence; her clothes are already torn, signifying a rape, but it is unclear whether this has already happened or is about to take place. The right panel is equally disgusting: the lackey treats the woman like an animal, while another woman locked in the

Raphael, detail of *Incendio di Borgo* (*Fire in the Borgo*), 1514–17. Fresco. Stanza dell'Incendio, Vatican, Rome.
Michelangelo, detail of *Diluvio universale* (*Deluge*), 1509. Fresco. Sistine Chapel Ceiling, Vatican, Rome.

site. A brutish, diabolical Germanic giant violently takes possession of a woman, just as, at the same time as the triptych was completed, on May 2, 1941, Hitler had subjugated a large part of Europe. Beckmann leaves no glimmer of hope in this picture. "*Perseus* definitely finished. —Creation is redemption," Beckmann noted in his diary on May 2, 1941. Beckmann could not or would not portray redemption—or at least a counter-model to the world of violence and destruction—in this picture, as he had done in the central panels of the previous triptychs. For him, the promise of redemption remained accessible exclusively outside the painting, in the act of creation, as Thomas Mann once noted: "A work [of art], even one of desperation, can only have optimism, the belief in life, as its final substance."[40]

In *Carnival*, Beckmann no longer depicted human relationships as a mirror of destructive forces in the world; rather, gender relations are presented as a counterweight to and a shelter from historical circumstances. In the right panel, a couple is expelled from paradise by an archangel identifiable as a Nazi guard (if one recalls the torturing creatures in *Hölle der Vögel* [*Bird's Hell*], 1938, cat. no. 7). In each other's company, they are their own protection and consolation on the path into an uncertain future. Beckmann draws here on the iconographic tradition of representations of Aeneas carrying his father, Anchises, out of the burning Troy. Michelangelo and Raphael had already related this motif to other contexts. Raphael modernized the motif in *Incendio di Borgo* (*Fire in the Borgo*, 1514–17), a depiction of the burning of Rome, which Pope Leo IV reputedly extinguished with the sign of the cross. The wall in Raphael's painting, across which a figure is just reaching safety, is reminiscent of the background in Beckmann's version.

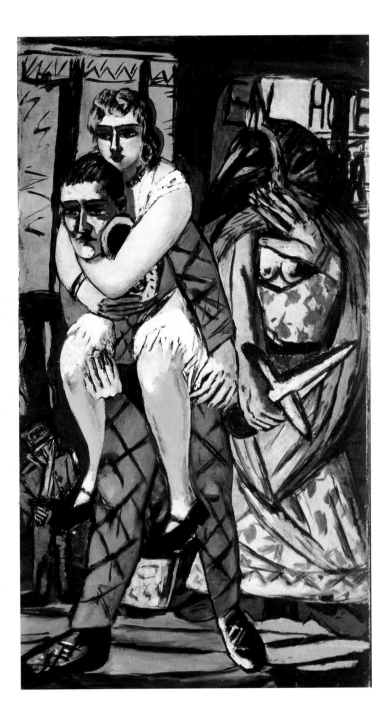

Right panel of *Karneval* (*Carnival*), cat. no. 13.

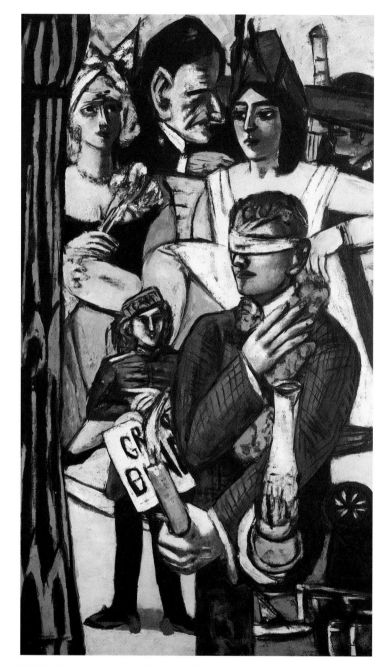

Michelangelo used the motif in his representation of the deluge in the Sistine Chapel, *Diluvio universale (Deluge,*

1509). Beckmann's version so resembles Michelangelo's work, it is likely that he had it in mind when he created *Carnival.* In 1925, Beckmann had traveled to Italy, and the Vatican was surely on his agenda when he visited Rome; moreover, Beckmann was very familiar with the work of these Old Masters. Like the figures in Michelangelo's and Raphael's works, Beckmann's couple are fugitives—unlike the protagonists of the biblical fall of man—and appear as victims rather than as perpetrators.

None of the three couples in the three panels of *Carnival* are entangled in violent conflicts, but rather, appear mutually dependent in a threatening situation and full of deep understanding for each other. The triptych as a whole would seem to be Beckmann's endorsement of the relationship of man and woman, which he had previously often viewed as antagonistic. The central panel of *Doppelbildnis, Max Beckmann und Quappi* (*Double-Portrait, Max Beckmann and Quappi,* 1941, cat. no. 10)—the most sensitive and harmonious of all his double portraits—provides further evidence of Beckmann's new, more favorable point of view.

Again, in *Blind Man's Buff,* one notes a change in Beckmann's attitude. The man in the right panel and the woman in the left hold steadfastly to their destiny despite the surrounding society and the clamorous orchestra of the gods. Up to *Perseus,* painted in 1940–41, the pessimism of Beckmann's view of society and gender relations had steadily grown, but after this time, a counterweight to the mechanisms of destruction is depicted in all three panels of the triptychs. Violence in the service of resistance entered Beckmann's thinking through the image of the warrior, and he began to see gender relations as a source of energy, with which to withstand external circumstances.[41]

Right panel of *Blindekuh* (*Blind Man's Buff*), cat. no. 14.

Beckmann's first six triptychs contain relatively obvious references to contemporary events under National Socialism: scenes of torture (*Departure*), violence against a seemingly inferior creature (*Temptation*), a personification of war (*Acrobats*), burning and destroyed houses (*Perseus*), as well as a violent Germanic thug (*Perseus*), bound and incarcerated people (*Actors*), expulsion from the Berlin Hotel Eden (*Carnival*)—as metaphor for his forced emigration—all these are obvious enough references. In addition, from scattered newspapers and writings on the lackeys' caps (such as "Eskimo" or "Kempinski"), it is clear that Beckmann represented events in contemporary Germany.

In *Blind Man's Buff*, however, such references are no longer as direct. This is surprising because the triptych was created in the last two years of war, in the face of dramatic historical developments—from the fall of Germany to the dropping of the atom bomb—which Beckmann followed with the greatest concern. Although the unfettered activities of the gods in the work's central panel can be related to contemporary history, the clock possibly alludes to an ultimatum, and the man with the horse's head could even be understood as an allusion to Picasso's *Guernica*,[42] but these references are not conclusive and far more generalized—that is, more metaphorical—than in earlier triptychs.[43]

In Beckmann's last three triptychs—*Beginning, The Argonauts,* and the unfinished *Ballet Rehearsal* (1950, see p. 43)—historical references are completely absent. In *Beginning*, there are still allusions to the mechanisms of violence, which Beckmann had portrayed with great vehemence in the earlier triptychs: the child, who in the right panel has to stand in a classroom with raised arms—apparently as punishment—is reminiscent of the tortured figure

from the left panel of *Departure*; the grates of the classroom imply confinement. In the left panel, Beckmann contrasts the world of school with the world of the childish imagination. Yet, despite such taunts toward the narrow-minded bourgeois society of adults, an accusatory bitterness and brutality are missing.

In *The Argonauts*, finally, social conditions are of no concern at all. Everything confining and hurtful in human social life that Beckmann had portrayed in earlier triptychs is excluded from pictorial events here. The old man with the ladder—who in *Beginning* was in a defensive attitude, disciplining a child—has become a reasonable, wise man who, together with, not against, the young man, points the right way—as all hands point in informal agreement toward the same direction. The women in the right panel have been associated, following a statement to this effect by Beckmann, with the Greek chorus. Lackner related: "When I asked him about the significance of the music-playing girls in the right wing he said 'That simply is the chorus.'"[44] In Greek tragedy, the chorus embodies the moralizing general public—and to this extent, society is again included in *The Argonauts*. But Beckmann offers no analysis of society as in the earlier triptychs, instead only noting its existence. The subject here is not conflict, but transfiguration through knowledge—achieved through art and leading toward art at the same time. The central image and the left panel can each be read in both directions. The path that the old man is showing to the young men leads to the artist in the left panel; the canvas, then, could be understood as the sought-after Golden Fleece, which traditionally has been a metaphor for knowledge. Conversely, the painter could be looking through the canvas, as if through a window, onto the central panel. In

this reading, the painter is seeking knowledge through creation; he invents the myth of the search for knowledge.

The ladder is a symbol for the ascent to enlightenment and wisdom, and not only in gnostic theory: in Christianity, also, the ladder represents the ascent to the highest levels.[45] Beckmann himself explained to his wife the imagery of this painting: "The old man in the center panel who is climbing out of the sea on a ladder is a god who shows the young men the way to a better world—the way to a higher level of awareness, above earthly life."[46] Here, the old man does not only climb up the steps, but bears the ladder like a yoke: wisdom is a heavy burden. Across the gap between the left and center panels, the painter's canvas and the ladder appear to lean against each other; supporting each other, art is an instrument of knowledge, as knowledge is an instrument, component, and goal of art. As Beckmann paradigmatically noted: "Art serves knowledge, not entertainment—transfiguration—or play."[47]

The Argonauts can be understood as a continuation of the central panel of *Departure*. The artists in the left and right panels of *The Argonauts*—Beckmann originally referred to the piece as "Artists," suggesting that they are the painting's main characters[48]—appear to have completed the journey begun in *Departure*; they have left the rolling ship and gained a solid footing. Attributes of the two figures representing utopian life in *Departure*, the warrior and the king, are now spread across the side panels, but here there is no longer room for the realities of violence and oppression depicted in the earlier triptych. The chorus stands for a (musically) ordered unity, corresponding to the principle of the king; the sensual and emotional, rather erotic element, embodied by the forceful warrior, is represented here

in the left panel by Medea, who insinuates the potential for violence that is latent in sensuality. Together, the various arts—painting, poetry (Orpheus is the grandfather of poetry; the chorus is part of tragedy), and music—introduce an ideal interplay: the arts engage in a common search for knowledge, as do the individual artist and the general public alike. One could compare Beckmann's legacy in *The Argonauts* with Friedrich von Schiller's poetic and Ludwig van Beethoven's musical legacy in *Ode an die Freude* (*Ode to Joy*). *The Argonauts* is Beckmann's painted hymn to the mission of the arts to assist humanity in its search for knowledge. This hymn, which defines a broad human mission but ignores current social reality, is unique in Beckmann's oeuvre; in no other picture did Beckmann lose sight of the sobering experience of prison bars, chains, and masquerade.[49]

Myth and Metamorphosis

The triptychs' potential for metamorphosis lends these pictures a profound complexity provoking the most varied, sometimes seemingly contradictory interpretations.[50] Their structural openness, which allows an ambiguous reading of all their elements, is a strategy shared by myths, which, as Gottfried Böhm states, "are not primarily defined by a certain content and also not by literary forms, but by a very specific form of narration."[51] Mythological narration operates with a few basic elements that can be reassembled in new ways, offering each narrative generation creative freedom for metamorphosis and change.

Transformation presumes the constancy of certain factors, within which the metamorphosis occurs. Hans Blumenberg called this the "iconic constancy" of myth.[52] The term befits the imagery of Beckmann's triptychs even

better than the texts about which Blumenberg originally wrote. On a formal level, the intensely linear pictorial and compositional structure, with its black contour drawings, is an element of "iconic constancy" in Beckmann's work. Despite this strong formal frame, the triptychs' spaces and settings tend to allow a wide range of possible metamorphoses, each suggesting a different interpretation. Against ambiguous spatial boundaries and backgrounds and discontinuous horizon lines, a multiplicity of props and the paintings' themes connote specific locations and possible connections with the contemporary world. For the most part, Beckmann recruited his protagonists from theater and myth, opening up a further reading for his works: not only is there a possibility of a literal understanding, but there are also figurative, metaphorical, and allegorical levels of signification.[53]

The potential for metamorphosis, however, does not exist exclusively within any one of Beckmann's triptych. In their totality, these paintings reveal an explicit transformation from one to the next, each new triptych representing a metamorphosis in Beckmann's worldview. As a body of work, the triptychs have a strong inner cohesion, for each work takes from the preceding one motifs or structural elements and transforms them: the figures in the central panel of *Departure* wander into the left panels of *Temptation*; we re-encounter the ice-cream girl from *Acrobats* in *Perseus*; the composition of the left panel of *Actors* repeats itself almost precisely in *Acrobats*; the harp and the reclining figure playing the flute in *Blind Man's Buff* resurface in *Beginning*, from which in turn the man with the ladder wanders into *The Argonauts*. Beckmann's loyalty to certain types of figures such as the warrior and the king are also a constant. It is precisely because Beckmann holds onto such types that in them, or in their relationship to other figures, he is able to represent transformation.

Thus, Beckmann's triptychs reflect historical transformations in a dramatic and tragic period of world history, while also communicating the artist's own worldview. Yet the triptychs do not only capture changes in the outside world, but are themselves projection screens for transformations; they offer a tightly framed but flexible pictorial and narrative structure. This can be related to Blumenberg's discussion of myth, which must be continuously reinvented inside a certain frame; in Beckmann's terminology, this work would be that of the imagination—which he demands not only from the artist but also from the spectator.

In response to Curt Valentin, who had asked for an interpretation of *Departure*, Beckmann wrote: "Put the painting away or send it back to me, dear Valentin. If the people cannot understand it out of their own internal co-productivity, there is no sense in showing the thing. For me the painting is a kind of rosary or a chain of colorless figures that sometimes when the contact is there can take on a strong shine and tell me truths that I cannot express with words and did not know before either. —It can only speak to people that consciously or unconsciously carry within approximately the same metaphysical code."[54]

Translated, from the German, by Isabelle Moffat

Notes

1. Julius Meier-Graefe, *Berliner Tagblatt*, Jan. 15, 1929.

2. The triptych format has been extensively discussed by art historians. See, for example, Klaus Lankheit, *Das Triptychon als Pathosformel* (Heidelberg, 1959); *Polyptiques: Le Tableau multiple du moyen âge au vingtième siècle*, exh. cat. (Paris: Louvre, 1990).

3. Diary entry dated May 2, 1941. See Beckmann, *Tagebücher 1940–1950*, ed. Mathilde Q. Beckmann and Erhard Göpel (Munich: Langen Müller, 1984).

4. Diary entry dated Aug. 1, 1942. See Beckmann, *Tagebücher*.

5. Postcard from Beckmann to Stephan Lackner, dated July 3, 1939. See Lackner, *Ich erinnere mich gut an Max Beckmann* (Mainz: Kupferberg, 1967), p. 86.

6. For example, the bellboys in the right panels of *Carnival* and *Blind Man's Buff*.

7. For a discussion of the function and effect of these contours, see Ortrud Westheimer, *Die Farbe Schwarz in der Malerei Max Beckmanns* (Berlin: Reimer, 1995), pp. 42–44.

8. Paul Brach speaks of "black outlines that work like the leading in stained-glass windows." See Brach, "Beckmann on Beckmann," *Art in America* 81, no. 3 (March 1993), p. 105.

9. The text was written on the occasion of the July 1938 exhibition *Twentieth Century German Art* at New Burlington Galleries, London. Published in Lackner, pp. 51–73.

10. Before World War I, Beckmann treated some mythological subjects, as in *Mars und Venus* (*Mars and Venus*, 1908, G. 91 in Erhard Göpel and Barbara Göpel, *Max Beckmann: Katalog der Gemälde*, ed. Hans Martin von Erffa, 2 vols. [Bern: Kornfeld und Cie, 1976]) and *Amazonenschlacht* (*Battle of the Amazons*, 1911, G. 146). Mythological subjects appeared again only in 1932, in works such as *Adam und Eva. Mann und Frau* (*Adam and Eve. Man and Woman*, 1932, G. 363), *Geschwister* (*Brother and Sister*, 1933, G. 381), *Reise auf dem Fisch (Mann und Frau)* (*Journey on the Fish [Man and Woman]*, 1934, cat. no. 2, G. 403), as well as *Departure*.

11. For example, the drypoint *Jahrmarkt* (*Annual Fair*, 1921, H. 191–200 in James Hofmaier, *Max Beckmann: Catalogue Raisonné of His Prints*, 2 vols. [Bern: Galerie Kornfeld, 1990]), in which Beckmann himself figures as circus director. In painting, some early examples of theater and circus subjects are *Variété* (*Variety Show*, 1921, G. 213) and *Das Trapez* (*The Trapeze*, 1923, G. 219). Although they do not treat the subject directly, many of Beckmann's paintings from the early 1920s have the character of theater scenes; see, for example, *Fastnacht* (*Carnival*, 1920, G. 206), *Familienbild* (*Family Picture*, 1920, G. 207), *Der Traum* (*The Dream*, 1921, G. 208), and *Vor dem Maskenball* (*Before the Masquerade Ball*, 1922, G. 216).

12. See *Max Beckmann, Welttheater: Das graphische Werk 1901–1946*, exh. cat. (Munich: Villa Stuck, 1993).

13. See also Klaus Gallwitz, "Gli Argonauti ed altri viaggiatori: I trittici di Max Beckmann," in *Max Beckmann*, exh. cat. (Rome: Società Editrice Umberto Allemandi, 1996), p. 51. Gallwitz points out that almost all of the actors in the triptychs have a "profession of transition," that is, they play roles that mediate between various domains.

14. For example, the old man who appears in the central panel of *Actors* and the organ grinder in the left panel of *Beginning*. Other figures, which can also be interpreted as types rather than individuals, are usually restricted to one triptych and therefore do not belong to an "established stock" of the inhabitants of Beckmann's triptychs. These include the cook (*Perseus*); the painter (*The Argonauts*); the waiter (*Acrobats*); the clown (*Carnival*); the drummer (*Departure*); the musician (*Perseus* and *The Argonauts*); and the teacher (*Beginning*).

15. In *Temptation*, the cuttlefish and a one-eyed trumpeter in the left panel, as well as the giant bird in the right panel; in *Acrobats*, the drumming dwarf in the central panel; in *Perseus*, the sea monster in the

central panel and other strange figures in the right panel; in *Carnival*, the bird-headed figure with a sword in the right panel; in *Blind Man's Buff*, the Minotaur in the central panel; and, in *Beginning*, the angel in the left panel. One could also interpret the bird with the magical eyes in the central panel of *The Argonauts* as a fabulous creature.

16. See Friedhelm W. Fischer, *Max Beckmann: Symbol und Weltbild* (Munich: Fink, 1972), pp. 83ff.

17. Beckmann, *Die Realität der Träume in den Bildern: Schriften und Gespräche*, ed. Rudolf Pillep (Munich: Piper, 1990), pp. 47, 140.

18. Göpel and Göpel, vol. 1, p. 334.

19. Letter from Beckmann to Lackner, dated Jan. 29, 1938. See Lackner, pp. 36–37.

20. Beckmann reflected upon the role of the artist in "Der Künstler im Staat," *Europäische Revue* 3, no. 4 (1927); reprinted in Beckmann, *Die Realität der Träume*, pp. 37–41.

21. See Fischer, pp. 103–06. Many others have also drawn attention to the connection of the representation of the deluge with the idea of redemption.

22. Letter from Beckmann to Günther Franke, dated Jan. 30, 1934. See Beckmann, *Max Beckmann Briefe*, ed. Klaus Gallwitz, Uwe M. Schneede, and Stephan von Wiese (Munich: Piper, 1993–), vol. 2, no. 622, p. 239.

23. In a letter to Quappi dated April 28, 1936, Beckmann wrote: "Don't forget to speak with your people about the possibility of emigration once more. One never knows what will happen." See ibid., no. 646, p. 261.

24. *Lexikon der christlichen Ikonographie*, vol. 4, pp. 528–29.

25. In *Acrobats* and *The King*, the monarch wears a circus performer's clothes and is thus identified as a member of a circus or variety troop.

26. Beckmann, *Die Realität der Träume*, p. 52.

27. Mark 10:15; Luke 18:17.

28. See Reinhard Spieler, *Max Beckmann: Der Weg zum Mythos* (Cologne: Taschen, 1994), pp. 96–98.

29. Similarly attired figures appeared at parades, such as that for the opening of the Haus der Deutschen Kunst; in his propaganda speeches, Hitler showed himself enamored by a "new type of human being," one supposedly closer than ever to antiquity in appearance and sensibility. See Peter Klaus Schuster, ed., *Nationalsozialismus und "Entartete" Kunst*, exh. cat. (Munich: Prestel, 1987), p. 250.

30. Erhard Göpel, *Berichte eines Augenzeugen* (Frankfurt am Main: Fischer Taschenbuch, 1984), p. 146. Göpel emphasizes that no one made the connection between Beckmann's painting and the story at the time: "The reference to Frommel only became clear to us later."

31. For example, Peter Selz, "Max Beckmann 1933–1950: Zur Deutung der Triptychen," in *Max Beckmann: Die Triptychen im Städel*, exh. cat. (Frankfurt, 1983), p. 25; Charles S. Kessler, *Max Beckmann's Triptychs* (Cambridge, Mass.: Belknap, 1970), pp. 56–57. Quappi Beckmann did not want to confirm this version (Göpel and Göpel, vol. 1, p. 367).

32. Göpel writes in his memoirs: "Asked whom this figure [i.e. the figure with the red scarf] represents, Beckmann was able to answer: that could be Christ today." Göpel, *Berichte eines Augenzeugen*, p. 146.

33. John 18:10.

34. In a diary entry dated Sept. 27, 1948, Beckmann referred to himself as "*pauvre* Odysseus." See Beckmann, *Tagebücher*. Writing about *Odysseus and Calypso*, Uwe M. Schneede observed: "The concentrated gaze of the seeker Odysseus is also the expanded gaze of the artist Beckmann." Schneede, *Max Beckmann in der Hamburger Kunsthalle* (Hamburg, 1992), p. 41.

35. Diary entry dated Nov. 11, 1940. See Beckmann, *Tagebücher*.

36. "Letters to a Woman Painter," a speech written by Beckmann and delivered by Quappi Beckmann at Stephens College, Columbia, Missouri, Feb. 3, 1948. Reprinted on pp. 125–28 of this catalogue.

37. From a speech given by Beckmann at Washington University, Saint Louis, Missouri, June 6, 1950. See Beckmann, *Die Realität der Träume*, p. 75.

38. Diary entry dated July 4, 1946. See Beckmann, *Tagebücher*.

39. Letter from Beckmann to Günther Franke, dated Jan. 30, 1934. See Beckmann, *Max Beckmann Briefe*, p. 239.

40. Thomas Mann and Karl Kerényi, *Gespräche in Briefen* (Zurich, 1960), p. 146.

41. See Knut Soiné, "Das Mann-Frau-Verhältnis und das Fischsymbol: Zur Ikonographie Max Beckmanns und Bezüge zur zeitgenössischen Kunst," *Kritische Berichte* 12, no. 4 (1984), pp. 42–67. Soiné sees the relationship between the sexes in Beckmann's work as the "expression and cause of oppression and confinement of man, yet at the same time a source of energy and the possibility of validation" (pp. 45–46).

42. See Carla Schulz-Hoffmann, *Max Beckmann: Der Maler* (Munich: Bruckmann, 1991), p. 145. In *Guernica*, a bull appears at the same place as the man/horse, and a woman also appears below.

43. Similarly, references in *Guernica* that are not merely historical or political, but that also refer to contemporary art and humanities, have recently been demonstrated by Carlo Ginzburg, in "Picasso's Guernica: A New Reading," a lecture delivered at Siemensstiftung, Munich, July 11, 1996.

44. Lackner, *Max Beckmann: Die neun Triptychen* (Berlin: Safari, 1965), p. 29.

45. See Friedhelm W. Fischer, *Max Beckmann: Symbol und Weltbild* (Munich: Fink, 1972), pp. 225ff.

46. Mathilde Q. Beckmann, *Mein Leben mit Max Beckmann* (Munich: Piper, 1985), p. 179.

47. Beckmann, *Die Realität der Träume*, p. 50.

48. In his diary, Beckmann exclusively referred to the work as *les artistes* or *artists* up to Dec. 13, 1950.

49. This phrase is from Carla Schulz-Hoffmann, "Gitter, Fessel, Maske: Zum Problem der Unfreiheit im Werk von Max Beckmann," in Haus der Kunst, Munich, *Max Beckmann: Retrospektive*, exh. cat. (Munich: Prestel, 1984), pp. 15–52.

50. See Matthias Buck, "Vom mythischen erzählen: Max Beckmanns Triptychon 'Versuchung,'" *Von Altdorfer bis Serra: Schülerfestschrift Lorenz Dittmann zum 65. Geburtstag*, ed. Ingo Besch et al. (St. Ingbert, 1993), pp. 195–201.

51. Gottfried Böhm, "Mythos als bilderischer Prozess," in *Mythos und Moderne: Begriff und Bild einer Rekonstruktion*, ed. K.-H. Bohrer (Frankfurt, 1983), p. 534.

52. Hans Blumenberg, *Arbeit am Mythos* (Frankfurt, 1979), p. 165.

53. See Uwe M. Schneede, "Allegorien der Kunst: Zu einigen Triptychen von Max Beckmann," in Museum der Bildenden Künste, Leipzig, *Max Beckmann: Gemälde 1905–1950*, exh. cat. (Stuttgart: Gerd Hatje, 1990), pp. 37–45.

54. Letter from Beckmann to Curt Valentin, Feb. 11, 1938. See *Max Beckmann: Die Triptychen im Städel*, exh. cat. (Frankfurt, 1981), p. 37.

CATALOGUE

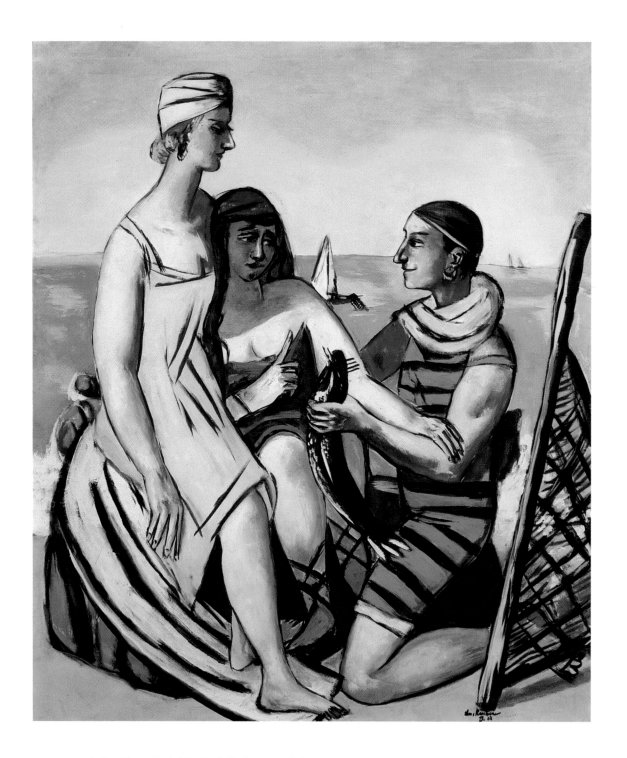

1. *Der kleine Fisch* (*The Little Fish*), 1933. Oil on canvas, 135 x 115.5 cm (53 ⅛ x 45 ½ inches).
Musée National d'Art Moderne, Centre Georges Pompidou, Paris.

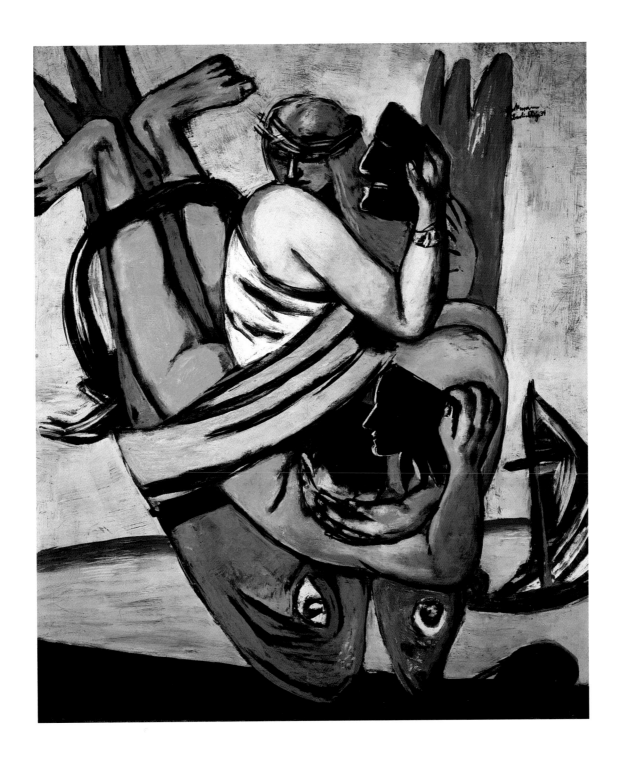

2. *Reise auf dem Fisch (Mann und Frau)* (*Journey on the Fish [Man and Woman]*), 1934.
Oil on canvas, 134.5 x 115.5 cm (52 ¹⁵⁄₁₆ x 45 ½ inches). Staatsgalerie Stuttgart.

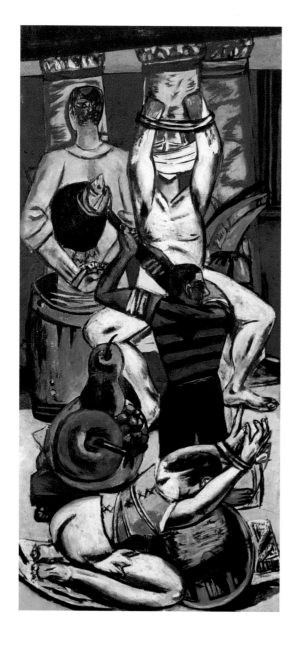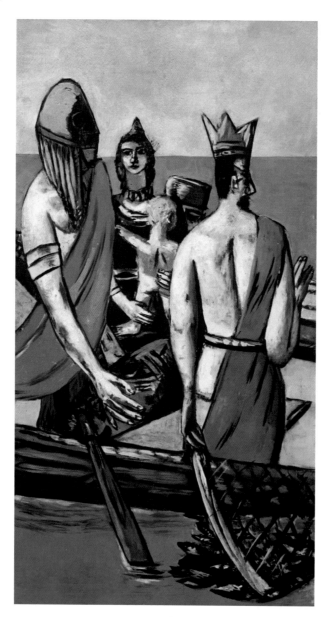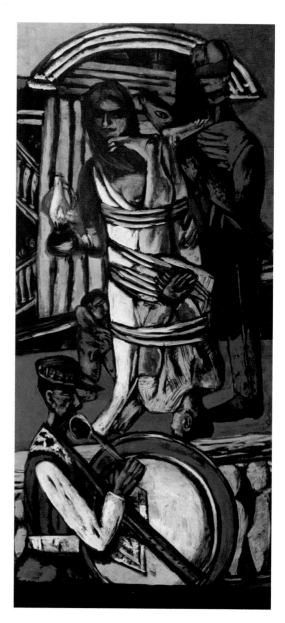

3. *Abfahrt* (*Departure*), 1932–33. Oil on canvas; triptych, left and right panels: 215.5 x 99.5 cm (84 ⅞ x 39 ³⁄₁₆ inches), central panel: 215.5 x 115 cm (84 ⅞ x 45 ¼ inches). The Museum of Modern Art, New York, Given anonymously (by exchange), 1942.

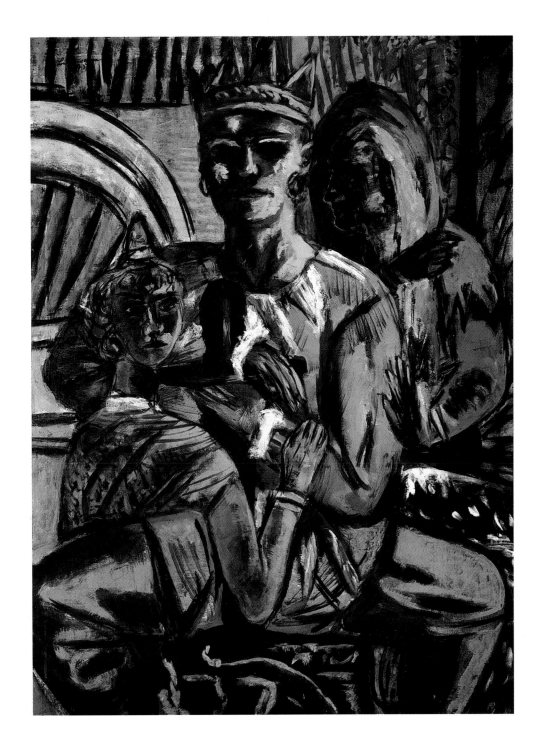

4. *Der König* (*The King*), 1933, 1937. Oil on canvas, 135.5 x 100.5 cm (53 ⅜ x 39 ⁹/₁₆ inches).
The Saint Louis Art Museum, Bequest of Morton D. May.

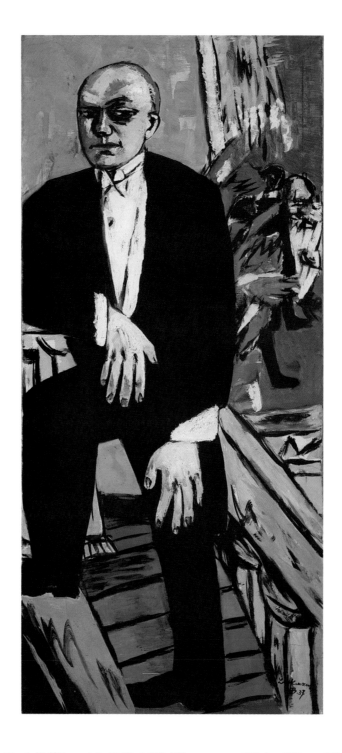

5. *Selbstbildnis im Frack* (*Self-Portrait in Tails*), 1937. Oil on canvas, 192.4 x 87.6 cm (75 ¾ x 34 ½ inches).
The Art Institute of Chicago, Gift of Lotta Hesse Ackermann and Philip E. Ringer.

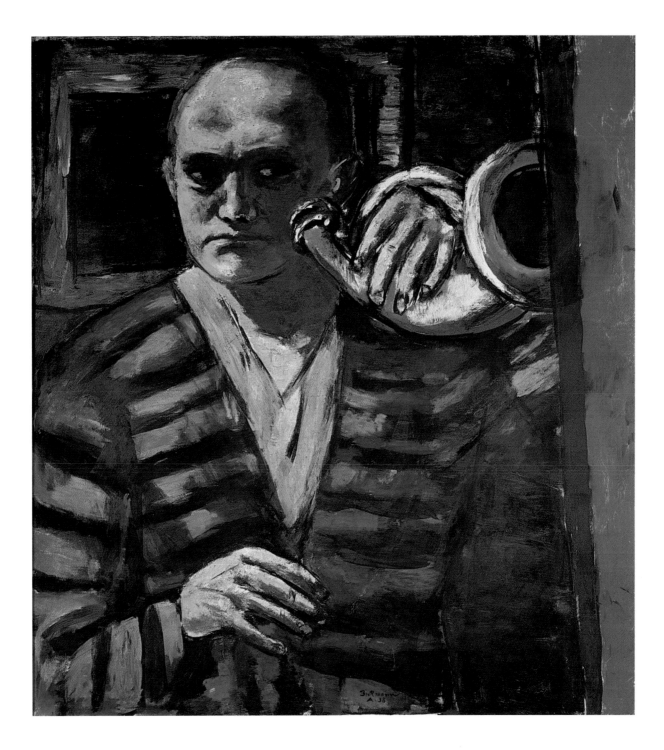

6. *Selbstbildnis mit Trompete* (*Self-Portrait with Horn*), 1938. Oil on canvas, 110 x 101 cm (43 5/16 x 39 3/4 inches).
Collection of Dr. and Mrs. Stephan Lackner, Santa Barbara.

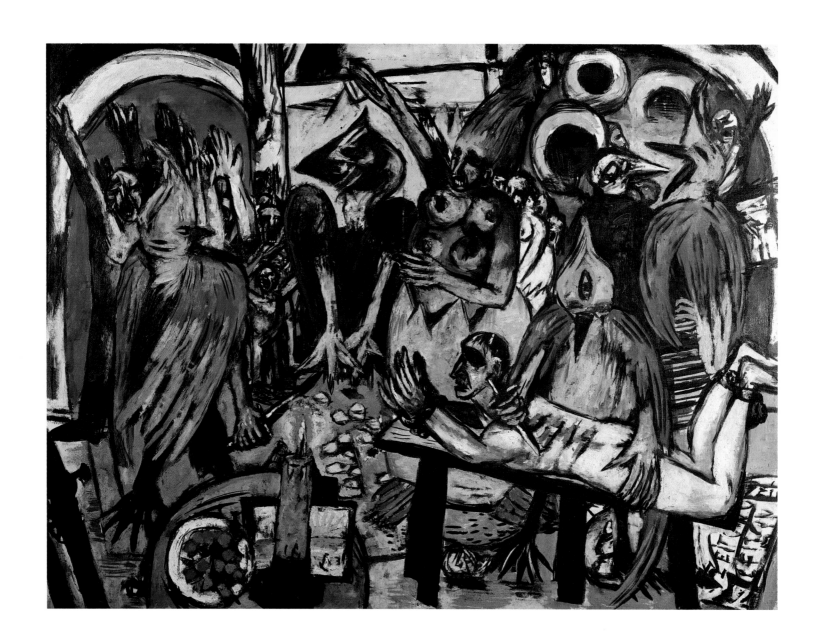

7. *Hölle der Vögel* (*Bird's Hell*), 1938. Oil on canvas, 120 x 160.5 cm (47 ¼ x 63 ³/₁₆ inches). Collection of Richard L. Feigen, New York.

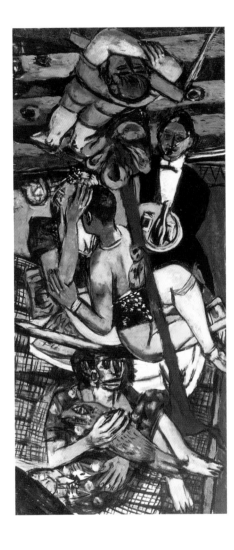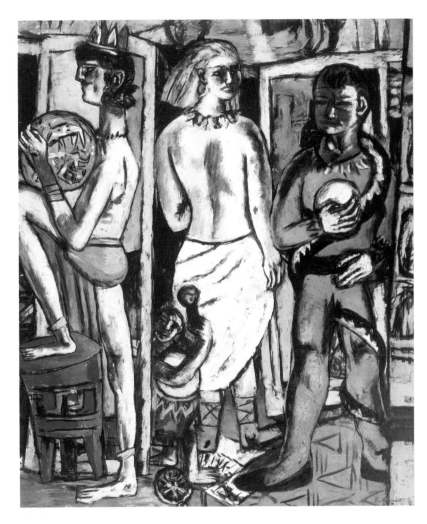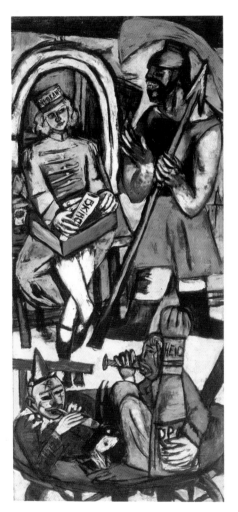

8. *Akrobaten* (*Acrobats*), 1939. Oil on canvas; triptych, left and right panels: 200.5 x 90.5 cm (78 $^{15}/_{16}$ x 35 $^{5}/_{8}$ inches), central panel: 200.5 x 170.5 cm (78 $^{15}/_{16}$ x 67 $^{1}/_{8}$ inches). The Saint Louis Art Museum, Bequest of Morton D. May.

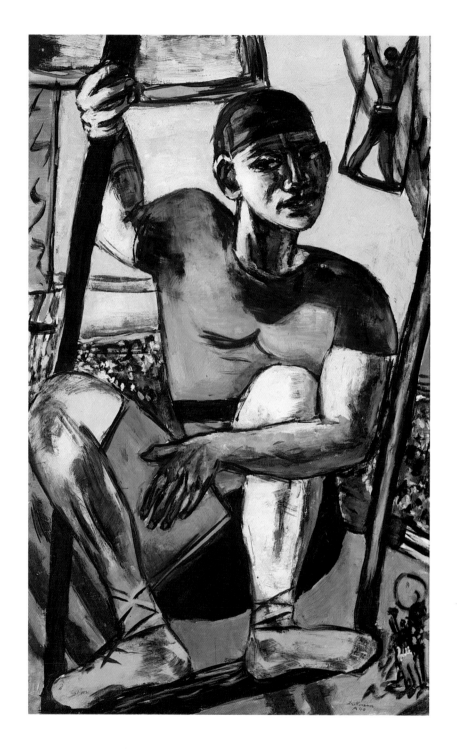

9. *Akrobat auf Trapez* (*Acrobat on the Trapeze*), 1940. Oil on canvas, 145 x 90 cm (57 $\frac{1}{16}$ x 35 $\frac{7}{16}$ inches).
The Saint Louis Art Museum, Bequest of Morton D. May.

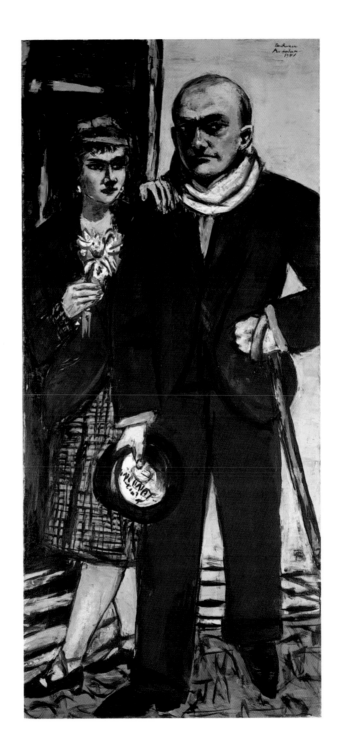

10. *Doppelbildnis, Max Beckmann und Quappi* (*Double-Portrait, Max Beckmann and Quappi*), 1941.
Oil on canvas, 194 x 89 cm (76 ⅜ x 35 inches). Stedelijk Museum, Amsterdam.

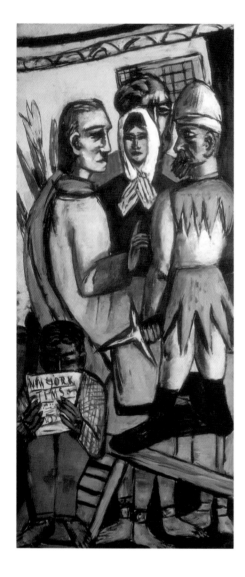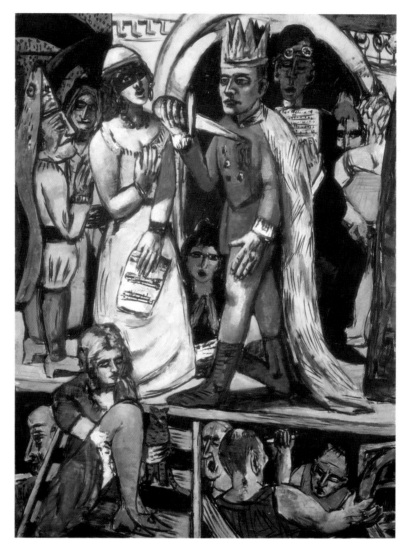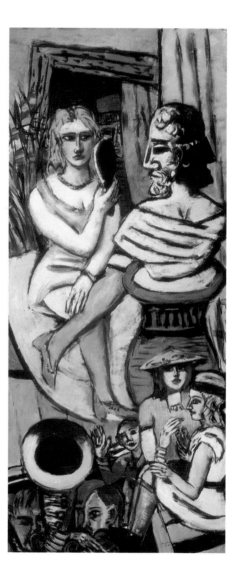

11. *Schauspieler* (*Actors*), 1941–42. Oil on canvas; triptych, left and right panels: 200 x 85 cm (78 ¾ x 33 ⁷⁄₁₆ inches), central panel: 200 x 150 cm (78 ¾ x 59 ¹⁄₁₆ inches). Fogg Art Museum, Harvard University Art Museums, Cambridge, Massachusetts, Gift of Lois Orswell.

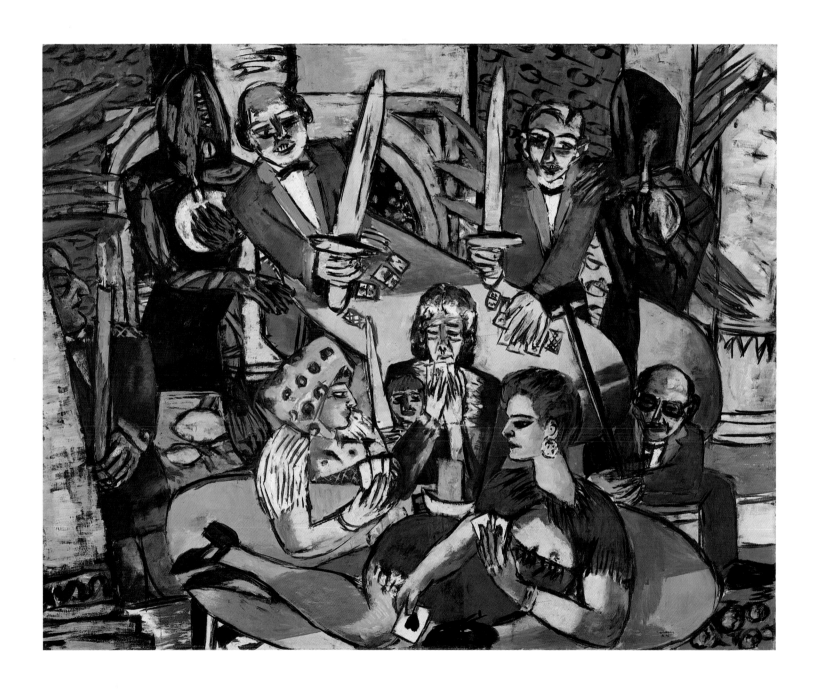

12. *Traum von Monte Carlo* (*Dream of Monte Carlo*), 1940–43. Oil on canvas, 160 x 200 cm (63 x 78 ¾ inches). Staatsgalerie Stuttgart.

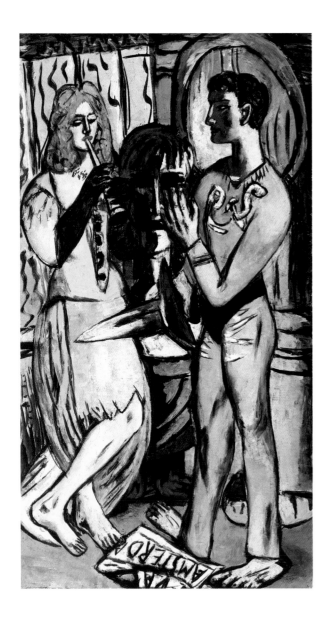
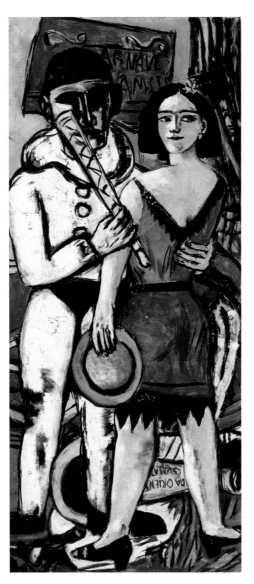
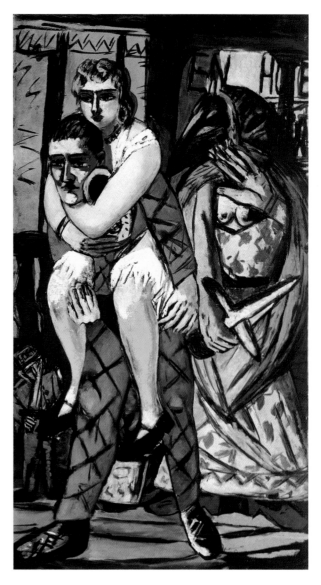

13. *Karneval* (*Carnival*), 1942–43. Oil on canvas; triptych, left and right panels: 190 x 104.5 cm (74 ¹³⁄₁₆ x 41 ⅛ inches),
central panel: 190 x 84.5 cm (74 ¹³⁄₁₆ x 33 ¼ inches). The University of Iowa Museum of Art, Iowa City, Purchase, Mark Ranney Memorial Fund.

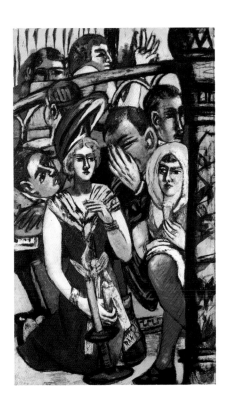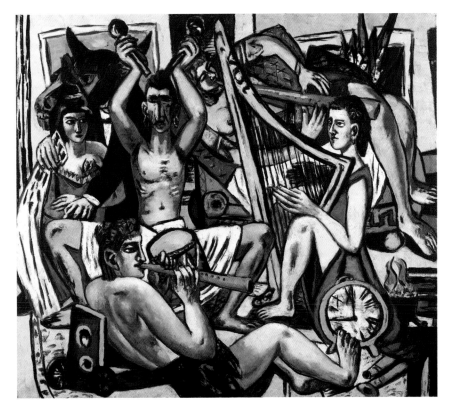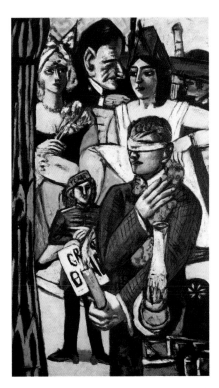

14. *Blindekuh* (*Blind Man's Buff*), 1944–45. Oil on canvas; triptych, left and right panels: 191 x 110 cm (75 ³/₁₆ x 43 ⁵/₁₆ inches), central panel: 205 x 230 cm (80 ¹¹/₁₆ x 90 ⁹/₁₆ inches). The Minneapolis Institute of Arts.

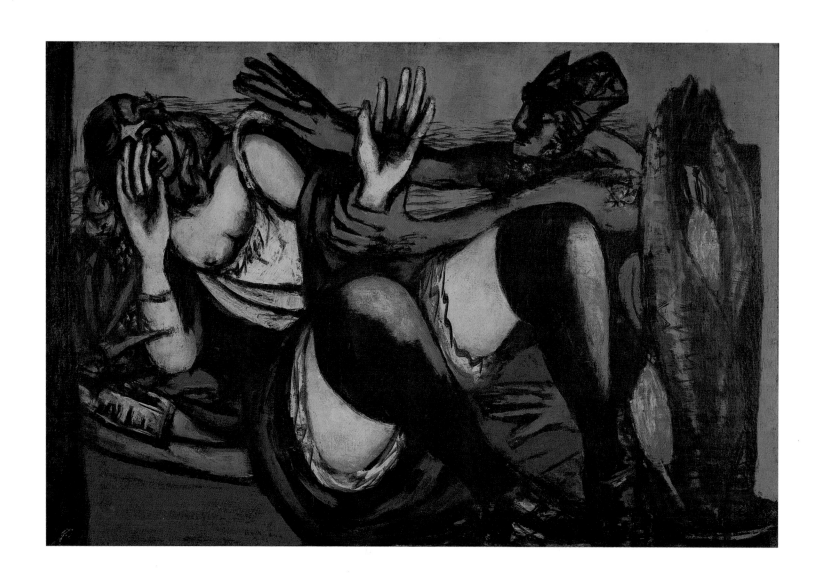

15. *Afternoon*, 1946. Oil on bedsheet, on plywood, 89.5 x 133.5 cm (35 ¼ x 52 ⁵⁄₁₆ inches). Museum am Ostwall, Dortmund.

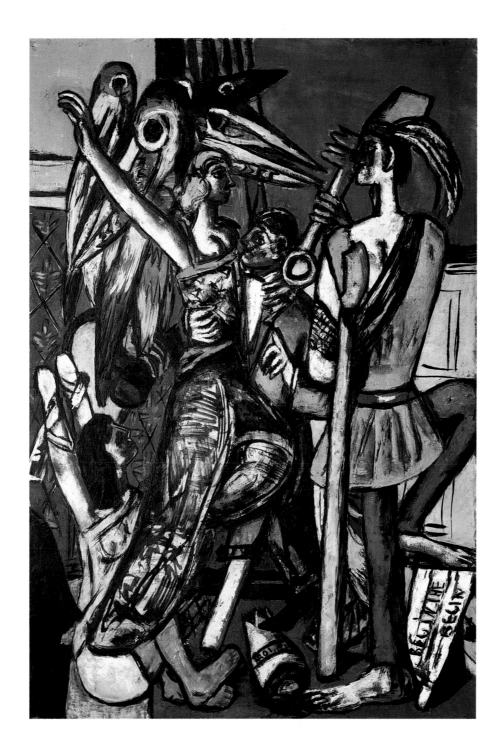

16. *Begin the Beguine*, 1946. Oil on canvas, 178 x 121 cm (70 $\frac{1}{16}$ x 47 $\frac{5}{8}$ inches). University of Michigan Museum of Art, Ann Arbor.

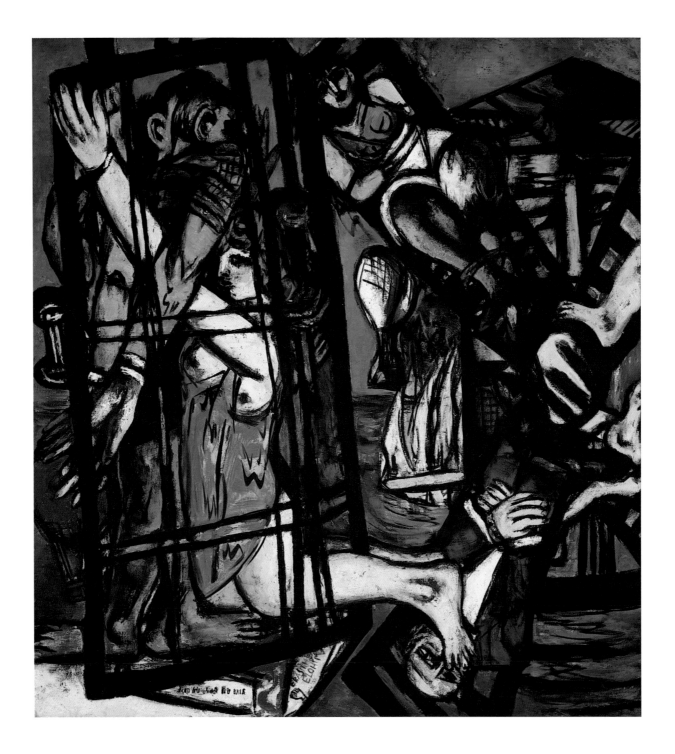

17. *Luftballon mit Windmühle* (*Air Balloon with Windmill*), 1947. Oil on canvas, 138 x 128 cm (54 ⁵⁄₁₆ x 50 ⅜ inches).
Portland Art Museum, Oregon, Helen Thurston Ayer Fund.

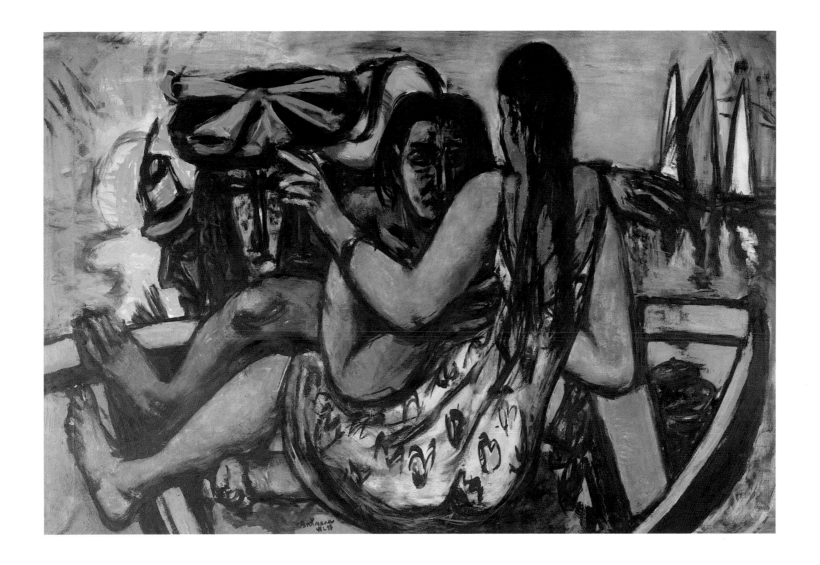

18. *Die Rettung* (*The Rescue*), 1948. Oil on canvas, 61 x 114.3 cm (24 x 45 inches). Collection of Richard L. Feigen, New York.

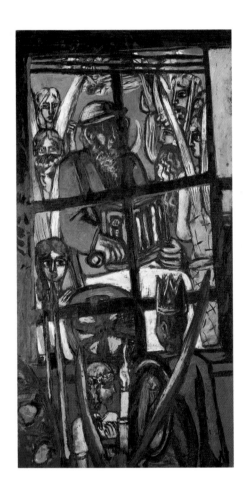
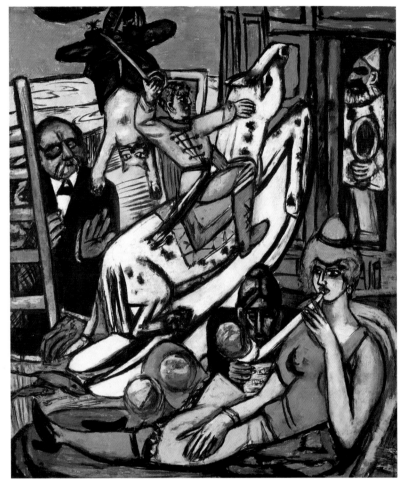
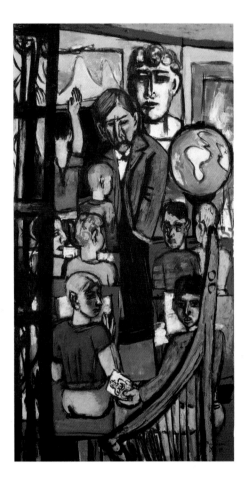

19. *Beginning*, 1946–49. Oil on canvas; triptych, left and right panels: 165.1 x 84.5 cm (65 x 33 ¼ inches), central panel: 175.3 x 149.9 cm (69 x 59 inches). The Metropolitan Museum of Art, New York, Bequest of Miss Adelaide Milton de Groot (1876–1967), 1967.

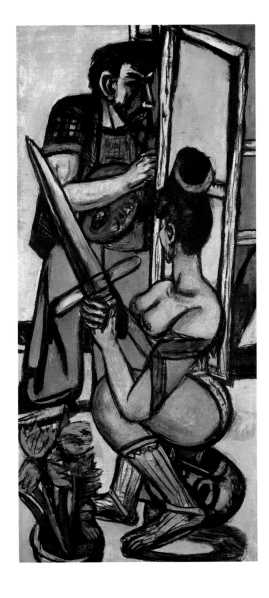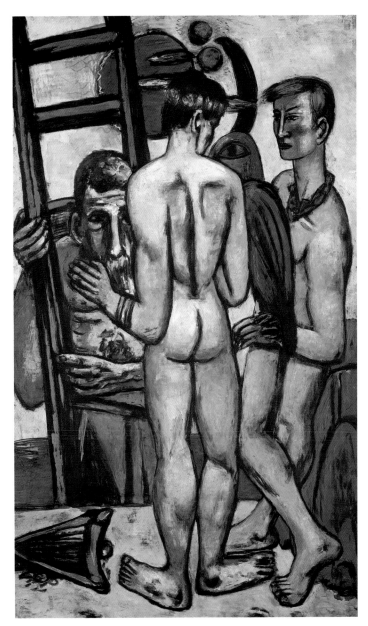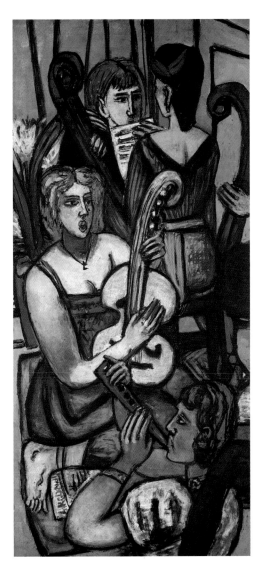

20. *Argonauten* (*The Argonauts*), 1949–50. Oil on canvas; triptych, left and right panels: 189 x 84 cm (74 ⅜ x 33 inches), central panel: 203 x 122 cm (79 ¹⁵⁄₁₆ x 48 inches). National Gallery of Art, Washington, D.C., Gift of Mrs. Max Beckmann, 1975.96.1a,b,c.

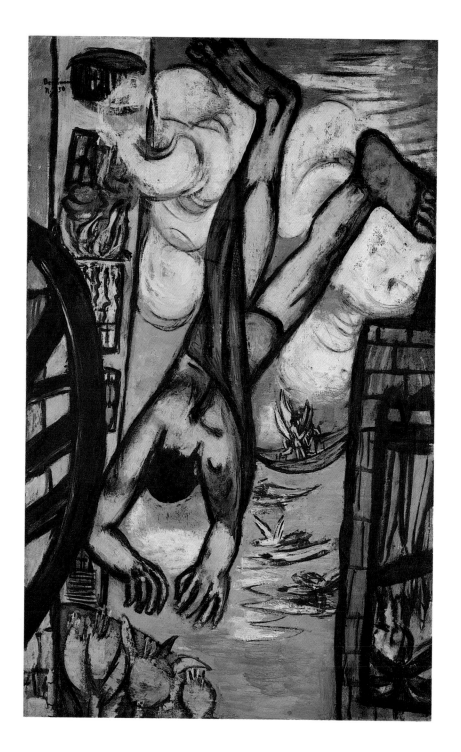

21. *Abstürzender* (*Falling Man*), 1950. Oil on canvas, 142 x 89 cm (55 15/$_{16}$ x 35 inches).
National Gallery of Art, Washington, D.C., Gift of Mrs. Max Beckmann, 1975.96.3.

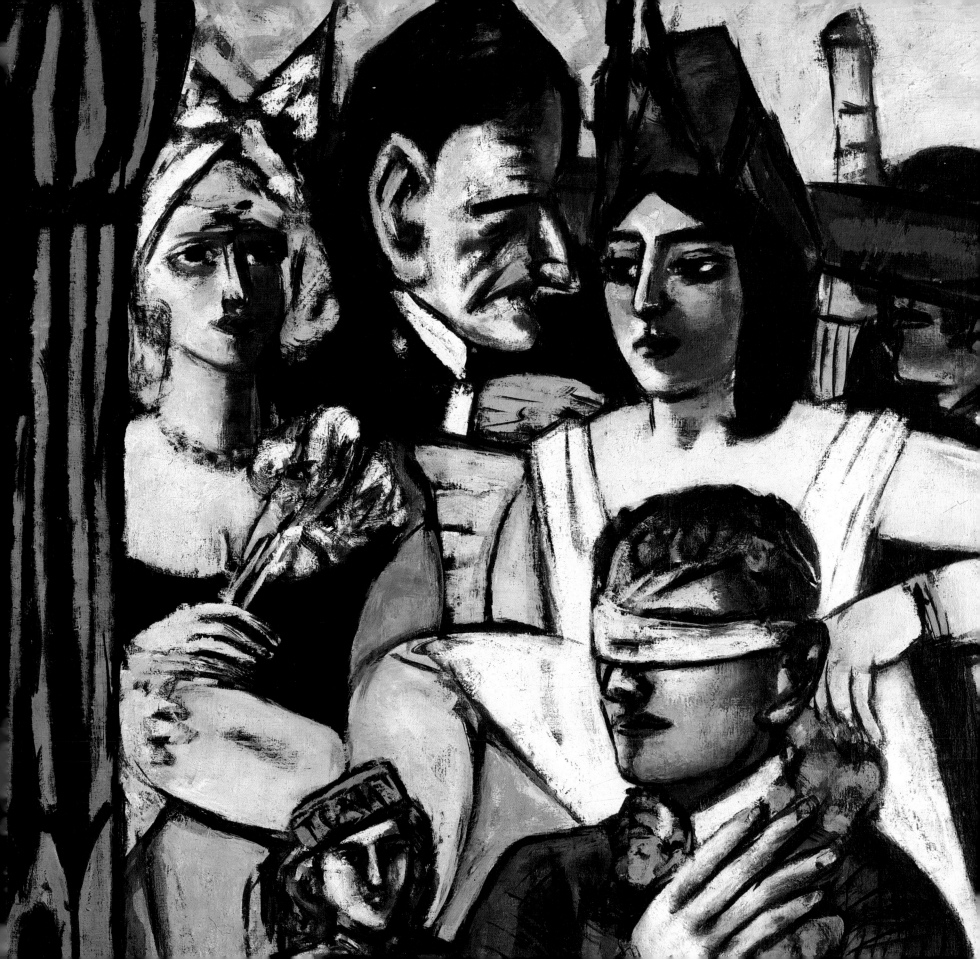

SHARED EXILE: MY FRIENDSHIP WITH MAX BECKMANN, 1933–1950

Stephan Lackner

"A refugee is someone who has lost everything except his accent." This half-humorous saying from the Hitler years applied to Max Beckmann only in part. Luckily, he was able to take many of his paintings with him when he fled Nazi Germany. Beckmann's years of exile—from 1937, when he moved to Amsterdam, to his death in 1950 in New York— were, in spite of deprivation, danger, and lack of appreciation, characterized by amazing creativity. His nine triptychs are the fruits of his sense of homelessness. Even his first triptych, *Abfahrt* (*Departure*, cat. no. 3), begun in 1932, a time when he was not yet ready to turn his back on Germany, is marked by a wild yearning to escape from the senseless tortures and restrictions of everyday life and to move on into unknown, blue distances.

Nowadays, it seems quite honorable to be a refugee from any country. However, from 1933 on, when the National Socialists took power, there was a strong oppro-brium attached to the term "émigré." Joseph Goebbels's propaganda successfully fulminated against the *vater-landslose Gesellen*, those fellows without a fatherland who spread *Greuelmärchen*, gruesome fairy tales about their former homeland. There was a prejudice against *Nestbe-schmutzer*, writers and artists who fouled their own nest in the absence of a friendly neighborhood censor.

In 1933, Beckmann lost his teaching job at the Kunstgewerbeschule of the Städelsches Kunstinstitut in Frankfurt. Museums and even private art galleries were forbidden to show his so-called degenerate works. Still, he continued to live quietly in Berlin, painting and hoping that the political situation might change for the better.

In June 1933, my brother and I traveled from Frankfurt to Erfurt, where we wanted to view a large Beckmann exhibition. But when we arrived, we found the museum closed and the Beckmann posters outside crossed out with red

Detail from right panel of *Blindekuh* (*Blind Man's Buff*), cat. no. 14.

strips reading *verschoben*, postponed. We talked to some officials who seemed quite disturbed by recent events; the Propaganda Ministry in Berlin had just advised them that a show of these "degenerate" paintings was intolerable. We said that we were friends of the painter—which was an exaggeration, since we had only met him at a few parties in the Frankfurt home of one of his patrons—and obtained permission to look at the paintings in a storage room.

The windowless room was lighted by a solitary, strong bulb dangling from the ceiling, casting shadows like bat wings over the canvases leaning against the walls. Beckmann's art had gone underground.

Surprisingly, some of these works employed classical nudes. Beckmann had become famous for his bitter satires of life during World War I, the inflation period, and the political turmoil of the Weimar Republic. He had painted contorted figures enclosed in claustrophobic spaces and tortured by hunger, lust, and degradation. Now, Beckmann had turned to free, rounded figures from Greek mythology and Nordic sagas. His love of freedom was being formulated in proud human beings unencumbered by actuality.

I was so deeply impressed that I sent a telegram to Beckmann in Berlin, offering to buy the large picture *Mann und Frau* (*Man and Woman*, 1932). He agreed. On June 23, 1933, he wrote to me, "I was delighted that a young man has the courage and energy to realize his feelings." I was twenty-three years old at the time. A little later, when I visited him in Berlin, he told me that my offer was the only sign of sympathy that he had received on that fateful day when his art became *verboten*, and that he would never forget my *beau geste*. From then on, we were friends, even though I was twenty-six years his junior.

I had the painting sent to Paris, where my parents had already found refuge, and I joined them shortly afterward. Three years later, in fall 1936, Beckmann suddenly appeared at our house in a Paris suburb. In spite of his stoic appearance, he was almost desperate about his situation in Germany. Nobody dared to buy his works anymore. Most dealers of Modern art had emigrated. All progressive artworks, be they Post-Impressionist, Expressionist, or abstract, were being eliminated from German museums. Yet he was still loath to face the utter uncertainty of emigration.

My father, who was not convinced of Beckmann's greatness as an artist but trusted my enthusiasm, agreed that we would help Beckmann were he to leave Naziland. I was eager to augment my collection of works by the artist, which consisted of two large oils, two watercolors, and several prints. As an interim step, I commissioned him to illustrate a play I had written, *Der Mensch ist kein Haustier* (*Man Untamed*). Somewhat more optimistically, Beckmann returned to Berlin.

But the situation got worse, of course. The Modern-art section of the Berlin Nationalgalerie, in which Beckmann had his own room, was closed and its director, Eberhard Hanfstaengl, dismissed on October 30, 1936. Hanfstaengl advised Beckmann to emigrate. "This is only the beginning of the avalanche," he warned. On July 18, 1937, Hitler opened his very own Haus der Deutschen Kunst in Munich with a speech condemning all Expressionist, abstract, and Dadaist art and threatening to take steps "to prevent the further hereditary propagation of these gruesome optical disturbances," in other words, to sterilize artists creating such work. The exhibition *Entartete Kunst* (*Degenerate Art*) was about to open, also in Munich, with eight paintings by

Beckmann. This was the final insult. Max and Quappi, his wife, put a few summer clothes and personal belongings into some bags and fled to Amsterdam, accompanied by Quappi's sister. Beckmann's paintings followed later. Thus began the exile of one of the greatest figures in German art.

Beckmann wrote me the following from Amsterdam on August 4, 1937:

You have perhaps no idea what such a sudden break of all circumstances entails. The last days were not funny at all, searching for living quarters and studio, registering with officials, juridical things which seem gruesome to me but necessary. Now the situation is becoming clearer. I want to stay here for a while, later maybe Paris. But as an interim station, Amsterdam is not bad. — Your drama pleased me very much. . . . I was surprised to find much in the drama which indicates our shared ideas and thoughts. Strange affinity of mental states.

My German play was soon published in Paris, and I paid Beckmann for his seven beautiful lithographs.

In September, Beckmann came to Paris. He was in a depressed mood, but when I indicated that I would stick to my promise of buying further paintings from him he was relieved. He even showed a certain trader's toughness. I still have the slips of paper on which we both scribbled our lists of desiderata, with titles of paintings and proposed prices. We agreed on an even dozen, which I selected mostly from photographs. The tremendous triptych *Versuchung* (*Temptation*, see p. 66) was among them. Some of my friends thought I had lost my mind, and I myself felt dizzy from the adventurousness of this transaction.

We were together very often in those days. Since

109

Beckmann did not own a car, I drove him and his wife around Paris. Trips to museums and restaurants and visits with friends were occasions for togetherness. Later, I went to see him in Amsterdam. We spent a few weeks vacationing on the French Riviera. When I chauffeured him along the Corniche Supérieure, I noticed that while admiring the view he sometimes closed his eyelids as if they were photographic shutters. And, sure enough, several weeks later, I could see the same landscapes on canvases in his studio.

Beckmann was an enormously impressive man. His

Max Beckmann, *Bildnis Stephan Lackner* (*Portrait of Stephan Lackner*), 1937–39. Oil on canvas, 73 x 54 cm (28 ¾ x 21 ¼ inches). Collection of Dr. and Mrs. Stephan Lackner, Santa Barbara.

solid, round head looked like a boulder. His massive body moved slowly, deliberately, swaying from side to side like that of a captain on the deck of his ship. He always wore a tie, and he sported a bowler hat that, when he strolled through Paris, gave him an exotic, Brechtian air. I remember a *Kaffeeklatsch* in my parents' garden near Paris. We walked across the lawn, and suddenly Beckmann pulled down his hat more firmly over his forehead and did some cartwheels, whirling sideways on stiff arms and legs without losing his hat. We all laughed and applauded, and Beckmann seemed happy.

He seldom smiled though. Among his numerous self-portraits there is only one with a smile, albeit a sarcastic one. Painted in 1910, it shows him holding a Berlin newspaper that had just panned his work. The figure in *Selbstbildnis mit Trompete* (*Self-Portrait with Horn*, cat. no. 6), which he produced in 1938, originally wore an eerie, sweet smile. That first version has been preserved in a photograph. Yet, newly exiled, Beckmann did not feel like smiling anymore, and he reworked the canvas to show himself deeply melancholic, listening for an echo to his horn's melodious call.

As befitted an eager young amanuensis, I jotted down a few of his more philosophical sayings:

Basically, my thing originates in an almost demented mirth, but then it aims at not leaving out anything.

My paintings are a kind of medicine through inurement and delight.

In spite of the general tragedy one has to rely on the infinite justice in all things.

To create a new mythology from present-day life: that's my meaning.

Smuttiness—that really means taking only halfway measures.

You should consider mortal danger as an agreeable titillation, and love as an especially valuable pastime. Not more than that. Always keep your eyes fixed on the main thing, on the lodestar. Freedom and justice are indeed ideas that merit a try at realization.

I did my best to further Beckmann's reputation by getting some influential critics and writers to view his paintings in my Paris apartment. But as a refugee myself, I did not have the necessary contacts. I tried a rapprochement with the Surrealist group around Max Ernst, yet its members wanted to protect their own turf. I was able to arrange Beckmann exhibitions in several Swiss museums with moderate success.

The artist himself was not striving for fame. Very characteristic of his attitude is a letter that he wrote to me from Rotterdam on January 29, 1938:

Genuine art just cannot be made effective through hurly-burly and propaganda in a journalistic sense. Everything essential happens apart from everyday noise, only to attain a more far-reaching effect. The weak and unoriginal try to obtain a shabby fame for one day, and should get it. But this is not for us. One has to wait patiently for things to happen. —Most important is the silent show in your rooms. By this, as time goes by, you will obtain a central force with which to direct everything, if you submerge yourself completely and consider the game of life as a

contest for spiritual power—the only game which is really amusing. . . . Politics is a subaltern matter whose manifestation changes continually with the whims of the masses, just as cocottes manage to react according to the needs of the male and to transform and to mask themselves. Which means—nothing essential. What it's all about is: the permanent, the unique, the true existence all through the flight of illusions, the retreat from the whirl of shadows. Perhaps we will succeed in this. Herzlichst Ihr *Beckmann*

In spite of his reticence, I convinced Beckmann to participate in one of the most momentous art-world endeavors of the 1930s, the exhibition *Twentieth Century German Art* at the New Burlington Galleries, London, in the summer of 1938. This show was conceived as an antidote to the pernicious influence of Hitler's "degenerate-art" exhibitions touring Germany's big cities. We felt that it was necessary to present to the world the genuine, unrestricted art of Germany instead of the blown-up, bellicose, and banal sculptures and paintings of Nazi-supported artists. With great difficulty, the London organizers, helped by exiled cognoscenti, persevered in assembling the banned works of Ernst Barlach, Lovis Corinth, Otto Dix, Lyonel Feininger, George Grosz, Karl Hofer, Vasily Kandinsky, Ernst Ludwig Kirchner, Oskar Kokoschka, Wilhelm Lehmbruck, Max Liebermann, Franz Marc, Emil Nolde, and other Modernists. The organizers also incorporated German and Austrian music that was *verboten* under Nazi rule into the presentation. On July 28, *The Threepenny Opera* by Bertolt Brecht and Kurt Weill had its English premiere. The chamber music of Alban Berg, Hanns Eisler, Ernst Křenek, Arnold Schönberg, and Anton von Webern stirred up puzzled delight. Six paintings by Beckmann were shown; his fan-

tastic triptych *Temptation* became the centerpiece of the exhibition. On July 14, 1938, the London *Times Weekly* published a lengthy exhibition review, the first paragraph of which is of particular interest:

Very warm thanks are due to the promoters of the Exhibition of Twentieth Century German Art because, except in fits and starts, the subject is practically unknown to most of us. It is easy to see why art of this kind is unpopular with the present régime in Germany, not because it is conspicuously Jewish but because it is characteristically German, if the literature of Sturm und Drang, not to speak of the romantic musical composers, can be taken as evidence. All genuine art is and must be subversive to arbitrary systems of government, but modern German art, with its emphasis on individual expression in direct reaction from events, is peculiarly so.

The *Times Literary Supplement* of July 23 reproduced Beckmann's *Temptation* on its front page.

On July 20, 1938, Max, Quappi, and I crossed the stormy English Channel in an enterprising, even exhilarated mood. We remained in London until August 2, our time brimming with receptions, interviews, literary teas, and sightseeing. I had been in London twice before, so I often served as the guide and interpreter.

On July 21, Beckmann gave the very first lecture of his life, before a mixed crowd of aristocrats and bejeweled ladies, anti-Fascists dressed as proletarians, and writers and critics. When Beckmann lumbered onto the podium, he looked like a bear who had just left his sylvan cave. His German lecture, followed by a good English translation, was eagerly, even enthusiastically received; it has been reprint-

111

ed many times since under the title "On My Painting" (see pp. 119–23).

The exhibition was quite influential, especially among American museum directors and collectors. But at that moment, the rewards were mostly spiritual: the artist did not sell a single painting in England.

When we returned to the continent, Beckmann was plagued by fears about the future of Europe and his own fate. To alleviate his misgivings and allow him to create without immediate worries, I proposed a contract by which I would pay him a monthly sum and acquire two paintings per month, an enterprise that, while seeming extremely foolhardy at that time, turned out to be a blessing for both of us. Very much relieved, Beckmann returned to Amsterdam, where he and his always charming and helpful wife occupied the second and third floors of a narrow old house at Rokin 85. Its only luxury was a roomy studio, a former tobacco-storage space. There, the painter was able to develop his vast visions upon large canvases, among them five of his nine mighty triptychs.

Meanwhile, I had established a certain literary reputation for myself. I had become a regular contributor to the German-language weekly *Das neue Tage-Buch*, which was published in Paris by anti-Nazi refugees. It presented articles by such authors as Winston Churchill on the right and Leon Trotsky on the left, with many famous literati in the middle. It was an honor for a young writer to be accepted into this company. Also, two of my books were published in Zurich. Of course, all these publications were strictly forbidden in Germany, but they were read in Switzerland, Austria, Czechoslovakia, New York, Hollywood, and wherever German émigrés were looking for an intellectual focus.

Exile in Paris was not as difficult for me as it was for so many other German refugees, those who had lost everything. One advantage was that I had been born in Paris, in 1910. When World War I broke out, my German-Jewish father discovered his patriotism and returned with our family to Berlin and Frankfurt. In 1933, sensing the com-

Max Beckmann in Amsterdam, 1938. Photo by Helga Fietz.

ing dangers, he moved us back to Paris, where his old connections allowed him to become a prosperous businessman again.

I loved Paris, and it was a distinct pleasure for me to drive the Beckmanns along the Seine or to Versailles. Beckmann and I often ate together at Fouquet's, drank tea in the lobby of the Hôtel Georges Cinq, wandered over bridges and through exhibitions. However, as the political horizons grew darker and darker, my parents and brothers became convinced that we should move to America. We arrived in New York on April 28, 1939.

The separation from my great friend made me sad. His many letters, which contain philosophical speculations, picturesque fantasies, and, surprisingly for this rough and self-contained character, some tender thoughts, were a consolation. Here are a few short excerpts from these letters. At the time, he addressed me by my middle name:

Paris, April 26, 1939. My dear Ernst, Thanks cordially for your friendly letter. I too was sorry not to have seen you any more, and I must confess that I miss you a little—decidedly. But some personal collaboration will surely occur again, and I'm glad that it will. . . . When you see our common friends, give them my best greetings and tell them that we have not resigned and that the spiritual Germany will again take its rightful place among the peoples. We are at work. . . . Always your Beckmann

Amsterdam, May 22, 1939. Dear Ernst, Many thanks for your letter and check which reached me before I left Paris. . . . Here I am intensely working on the new triptych number three; this will be a crazy story and gives me a heightened feeling of life, an enhanced life. . . . Did you see the Barr exhibition in the Museum of Modern Art where my first triptych is shown? I would be interested to know how you liked it, as well as further impressions from your journey.

On July 3, 1939, he wrote me a postcard:

Dear Ernst, Thanks and greetings for the missive. I'm utterly submerged in work. Le nouveau Trois is rising from dark waters up over champagne, cadavers and the small madness of the world to final clarity. —O mon Dieu life is worth living. B.

Le nouveau trois referred to his new triptych *Akrobaten* (*Acrobats,* cat. no. 8). Champagne and cadavers are only moody metaphors, but the "small madness of the world" is not. Those few sentences show Beckmann's state of elation while he was in the process of creation. Can you imagine an Impressionist, for instance, letting his temper erupt this way on a postcard?

Amsterdam, November 20, 1939. Dear Ernst, Thank you very much for letter and check. It is always a joy to hear from you, not because of the money, but because it reinforces the feeling of a metaphysical predestination between us. A somehow amplified symbol for fated necessity. It's exactly these things which I pursue with a certain sportive interest, because they are extremely rare, like gold veins or diamond finds. Nonetheless they exist, and the network of enormous, unknown calculations in which we are caught up becomes almost visible, sometimes.

The war makes them evident in other ways, too. I'm writing this during a blackout in Amsterdam, to the harmonious concert of wailing sirens. One must admit that unknown stage-directors try everything to make the situation more interesting, in the

sense of a penny-dreadful. Critically we must state that, unfor-tunately, they don't have many new ideas any more, and that we now have the right to stage something new. And that, after all, will occur sooner or later. I, for my part, am busily prepar-ing new stage sets among which the play may go on. . . . My best wishes to you, my dear, above all for concentration in your work. Write me more often about your life in New York, it is always a joy to hear from you, and it also strengthens me. Herzlichst *Yours, Beckmann*

I found, to my joy and relief, that Beckmann was receiv-ing more and more recognition in the United States. In July 1939, his triptych *Temptation*, which belonged to me, received the first prize of the foreign section at the *Golden Gate International Exposition* in San Francisco, making the painter richer by one thousand dollars. His faithful art deal-ers J. B. Neumann and Curt Valentin were exhibiting and selling his works. The *New York Times* wrote on January 7, 1940: "The pictures have terrific impact. One feels that they are the offspring of a soul that has passed through dark-ness and despair and has faced unflinchingly a world of largely alien values." And on May 9, 1940, *Time* magazine singled him out as "an 'Aryan' expressionist regarded by many, before Hitler, as Germany's No. 1 painter."

The irony of world history would have it that one day later, on May 10, the Wehrmacht overran neutral Holland. Thus, my connection with Max Beckmann, including my contractual monthly payments, was severed. For five years, his anxious friends in America had no inkling whether he was still alive.

In New York, just a week after my arrival, I met a wonder-

ful Austrian girl, "Puck," who became my wife in June 1941. I worked on a *roman-fleuve*, a series of novels that depict-ed the years from 1914 to 1943 in Germany and France. I reckoned that it would take me ten or fifteen years to real-ize this quixotic project. My wife was not dismayed by this ambitious project; on the contrary, she always encouraged me and typed thousands of pages for me.

Puck and I wished to explore this strange new land, so we traveled to Detroit, Florida, Colorado, and finally to California, settling in Santa Barbara in the fall of 1941. (By the way, we are still living here, and we are still together happily ever after.) From 1943 to 1945, I served in the American army. I saw combat in Alsace and Germany with the Thirteenth Armored division. My wife's brother fought on the other side, in Hitler's Wehrmacht, and it was an eerie feeling that, had we encountered each other, we would have tried to kill one another.

The dichotomy between my mental status as an émi-gré, an outsider, and a representative of a free country con-tinued to color my worldview and my literary production.

Max Beckmann in his studio in Amsterdam, 1938. Photo by Helga Fietz.

During the war, my thoughts often returned to my friend Max Beckmann, but there was no way of contacting him. As soon as overseas mail was reinstated, I wrote to his old address in Amsterdam. To my great surprise, I soon received an answer:

Amsterdam, Rokin 85, August 27, 1945. Dear Stephan Lackner (Quinientos Street), Ah—well. There you are living. Amazing to hear from you and California. The world is rather kaput, *but the specters climb out of their caves and pretend to become again normal and customary human beings who ask each others' pardon instead of eating one another or sucking each others' blood. The entertaining folly of war evaporates, distinguished boredom sits down again on the dignified old overstuffed chairs. Incipit novo canto* No. 2.

Well my dear, you must have experienced quite a lot, and I am curious how you will use it in your work. It is regrettable that you couldn't materialize here at the Rokin as an American archangel Gabriel. Well, now the angel has turned into a "clipper" airmail letter, which isn't without charm and leaves ample play for fantasy. I gather from some hints in your letter that you are still married and that your dear parents are well. . . .

May I report about myself that I have had a truly grotesque time, brimful with work, Nazi persecutions, bombs, hunger and always again work—in spite of everything—I've painted about eighty pictures, among them four large triptychs. I think some of it would give you pleasure, for you know a lot about me. . . .

My nerves and capacity for work are stronger than ever, and I hope to go on producing essential things.

Very cordial greetings, also from Quappi (who is all right), Yours, Beckmann

The painter, after having been vilified and driven from his country, felt no inclination to return to Germany, in spite of flattering invitations and job offers. He was eager to emigrate a little further, to America, as soon as bureaucratic and material difficulties could be overcome. In this country, his fame grew suddenly. The first exhibition of his new paintings, in April 1946 at Curt Valentin's New York gallery, was almost sold out right away. Several press reviews were enthusiastic. *Time* magazine acknowledged on May 6 that Beckmann was "Germany's greatest living artist." So his friends in the United States cast about for a teaching position to make his immigration possible.

My wife and I, together with our first infant son, traveled to Europe, where we met Max and Quappi in Paris on April 19, 1947. Beckmann had lost weight, of course, but his aura of sheer energy was undiminished. After ten years in Holland, he had relinquished his typical Berlin sarcasm; he seemed sadder, wiser, and more stoical. He scrutinized my wife with painterly glances and approved of her Austrian charm and blue eyes.

Beckmann said, "You cannot imagine what pressure has been removed from me since the nightmare exploded!" We celebrated accordingly, roaming the boulevards, museums, and cafés and taking in a cabaret show at the Bal Tabarin. My former French girlfriend guided Max and me into the old brewery building where she had hidden paintings belonging to him and to me. Had the Nazis found them, they would surely have confiscated and burned them. The master was grateful.

With great hopes for the future, we parted, the Beckmanns traveling back to Amsterdam and the Lackners to Switzerland, where we stayed for more than three years.

On May 31, 1947, Beckmann noted in his diary: "Washington University in St. Louis desires Mister Beckmann as a teacher. Hey, hold your horses so you won't stumble. I agreed by telegram, may God grant that it turns out all right." And so began the next adventure in Beckmann's odyssey.

This is how the painter described his new situation in a letter to me from St. Louis from October 1947:

Well, one is here and, I must say, quite contented. St. Louis is lovely. A truly fabulous garden city with a hunk of downtown at the Mississippi, many skyscrapers like in New York. People quite agreeable, we are being spoiled a little because they all here have a very exact knowledge of my work. School not too strenuous. Very beautiful studio in which I'm working already energetically. In short, it seems that life in its later stage has again a friendlier smile for me. . . . America makes a big effort on my behalf. In November New York, January Chicago, March very big exposition St. Louis, further Boston, San Francisco, Museum of Modern Art and Basel—thus on and on. I'm happy to sit here quietly.

Max Beckmann never set foot on German soil again.

I visited him for the last time on October 14, 1950, in New York, where he had accepted a permanent teaching position at the Brooklyn Museum Art School. We drank coffee in the lobby of the Plaza Hotel. The ambiance of a hotel always held the attraction of an enigma for him: strangers with unknown fates crossing paths and separating, in the dim light of understated luxury. Even some of his triptychs show hotel lobbies with bellhops and conspiratorial assemblies. Now the "passing show" had shifted to the New World, and Beckmann accepted the change with a knowing grin.

The following day, Max and Quappi invited my wife and me for lunch in their narrow but comfortable Sixty-ninth Street apartment. While Quappi was busy in the kitchen, the painter ushered us into his studio—an exceptional favor, for he had always avoided exposing unfinished works to unprepared viewers. On that day, however, he was eager to hear our comments about his work in progress, the ninth triptych, *Argonauten* (*The Argonauts*, cat. no. 20). We were surprised by the clarity, harmony, and peacefulness of this masterpiece. All his earlier triptychs had shown drama and cruelty, shackled innocents, torture, or at least the war of the sexes. Now the nightmare had been dissolved. Free individuals represented painting, music, and divination of the future. It was hard to ignore a foreboding that this triptych might be the end of a cycle.

Quappi was an excellent cook. With memories and projects in mind, we had luncheon in a cordial mood. The next day, we drove on to Santa Barbara.

On December 27, 1950—we had barely unpacked and hung a few Beckmann paintings on our walls—we received a telegram from New York: "Max died suddenly of heart attack today Quappi Beckmann."

A few days later, the very last letter written by Max Beckmann reached me like a voice from beyond the grave. He criticized a new novella of mine in a friendly way. Then he continued:

Yesterday I finished a new triptych, therefore I am pretty well squeezed out. It was a damned lot of work, and through many days I didn't know whether my head was still up there or falling down. Well, now I have it behind me.

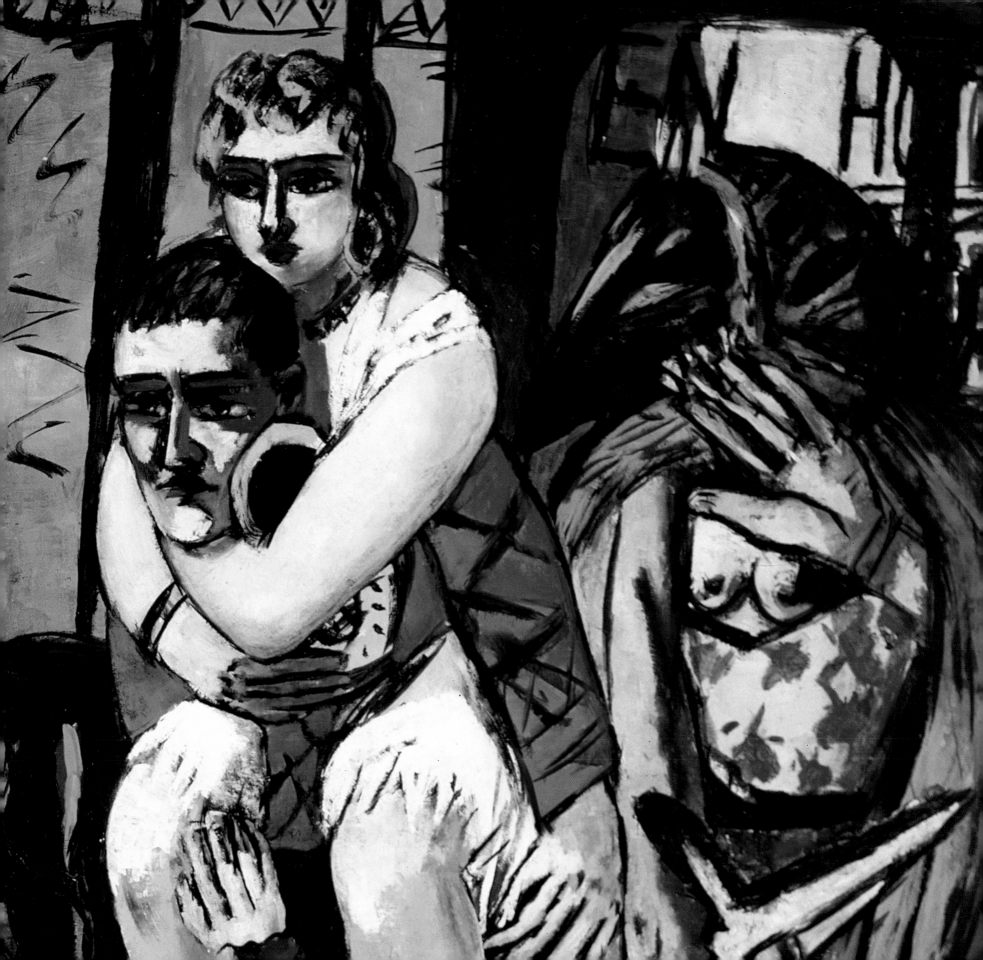

ON MY PAINTING

Max Beckmann

Before I begin to give you an explanation, an explanation that it is nearly impossible to give, I would like to emphasize that I have never been politically active in any way. I have tried only to realize my conception of the world as intensely as possible.

Painting is a very difficult thing. It absorbs the whole man, body and soul—thus I have passed blindly many things that belong to real and political life.

I assume, though, that there are two worlds: the world of spiritual life and the world of political reality. Both are manifestations of life that may sometimes coincide but are very different in principle. I must leave it to you to decide which is the more important.

What I want to show in my work is the idea that hides itself behind so-called reality. I am seeking the bridge that leads from the visible to the invisible, like the famous kabbalist who once said: "If you wish to get hold of the invisible you must penetrate as deeply as possible into the visible."

My aim is always to get hold of the magic of reality and to transfer this reality into painting—to make the invisible visible through reality. It may sound paradoxical, but it is, in fact, reality which forms the mystery of our existence.

What helps me most in this task is the penetration of space. Height, width, and depth are the three phenomena that I must transfer into one plane to form the abstract surface of the picture, and thus to protect myself from the infinity of space. My figures come and go, suggested by fortune or misfortune. I try to fix them divested of their apparent accidental quality.

One of my problems is to find the self, which has only one form and is immortal—to find it in animals and men, in the heaven and in the hell which together form the world in which we live.

Detail from right panel of *Karneval* (*Carnival*), cat. no. 13.

Space, and space again, is the infinite deity which surrounds us and in which we are ourselves contained.

That is what I try to express through painting, a function different from poetry and music but, for me, predestined necessity.

When spiritual, metaphysical, material, or immaterial events come into my life, I can fix them only by way of painting. It is not the subject that matters but the translation of the subject into the abstraction of the surface by means of painting. Therefore I hardly need to abstract things, for each object is unreal enough already, so unreal that I can make it real only by means of painting.

Often, very often, I am alone. My studio in Amsterdam, an enormous old tobacco storeroom, is again filled in my imagination with figures from the old days and from the new, like an ocean moved by storm and sun and always present in my thoughts.

Then shapes become beings and seem comprehensible to me in the great void and uncertainty of the space that I call God.

Sometimes I am helped by the constructive rhythm of the kabbalah, when my thoughts wander over Oannes Dagon to the last days of drowned continents. Of the same substance are the streets with their men, women, and children; great ladies and whores; servant girls and duchesses. I seem to meet them, like doubly significant dreams, in Samothrace and Piccadilly and Wall Street. They are Enos and the longing for oblivion.

All these things come to me in black and white like virtue and crime. Yes, black and white are the two elements that concern me. It is my fortune, or misfortune, that I can see neither all in black nor all in white. One vision alone would be much simpler and clearer, but then it would not exist. It is the dream of many to see only the white and truly beautiful, or the black, ugly and destructive. But I cannot help realizing both, for only in the two, only in black and in white, can I see God as a unity creating again and again a great and eternally changing terrestrial drama.

Thus without wanting it, I have advanced from principle to form, to transcendental ideas, a field that is not at all mine, but in spite of this I am not ashamed.

In my opinion all important things in art since Ur of the Chaldees, since Tell Halaf and Crete have always originated from the deepest feeling about the mystery of Being. Self-realization is the urge of all objective spirits. It is this self that I am searching for in my life and in my art.

Art is creative for the sake of realization, not for amusement; for transfiguration, not for the sake of play. It is the quest of our self that drives us along the eternal and never-ending journey we must all make.

My form of expression is painting; there are, of course, other means to this end, such as literature, philosophy, or music; but as a painter, cursed or blessed with a terrible and vital sensuousness, I must look for wisdom with my eyes. I repeat, with my eyes, for nothing could be more ridiculous or irrelevant than a "philosophical conception" painted purely intellectually without the terrible fury of the senses grasping each visible form of beauty and ugliness. If from those forms that I have found in the visible, literary subjects result—such as portraits, landscapes, or recognizable compositions—they have all originated from the senses, in this case from the eyes, and each intellectual subject has been transformed again into form, color, and space.

Everything intellectual and transcendent is joined

together in painting by the uninterrupted labor of the eyes. Each shade of a flower, a face, a tree, a fruit, a sea, a mountain is noted eagerly by the intensity of the senses, to which is added, in a way of which we are not conscious, the work of the mind, and in the end the strength or weakness of the soul. It is this genuine, eternally unchanging center of strength that makes mind and senses capable of expressing personal things. It is the strength of the soul that forces the mind to constant exercise to widen its conception of space.

Something of this is perhaps contained in my pictures.

Life is difficult, as perhaps everyone knows by now. It is to escape from these difficulties that I practice the pleasant profession of a painter. I admit that there are more lucrative ways of escaping the so-called difficulties of life, but I allow myself my own particular luxury, painting.

It is, of course, a luxury to create art and, on top of this, to insist on expressing one's own artistic opinion. Nothing is more luxurious than this. It is a game and a good game, at least for me; one of the few games that make life, difficult and depressing as it is sometimes, a little more interesting.

Love in an animal sense is an illness, but a necessity which one has to overcome. Politics is an odd game, not without danger I have been told, but certainly sometimes amusing. To eat and to drink are habits not to be despised, but often connected with unfortunate consequences. To sail around the earth in ninety-one hours must be very strenuous, like racing in cars or splitting the atom. But the most exhausting thing of all—is boredom.

So let me take part in your boredom and in your dreams while you take part in mine, which may be yours as well.

To begin with, there has been enough talk about art.

After all, it must always be unsatisfactory to try to express one's deeds in words. Still we shall go on and on, talking and painting and making music, boring ourselves, exciting ourselves, making war and peace as long as our strength of imagination lasts. Imagination is perhaps the most decisive characteristic of humanity. My dream is the imagination of space—to change the optical impression of the world of objects by a transcendental arithmetic progression of the inner being. That is the precept. In principle any alteration of the object is allowed that has a sufficiently strong creative power behind it. Whether such alteration causes excitement or boredom in the spectator is for you to decide.

The uniform application of a principle of form is what rules me in the imaginative alteration of an object. One thing is sure—we have to transform the three-dimensional world of objects into the two-dimensional world of the canvas.

If the canvas is filled only with a two-dimensional conception of space, we shall have applied art, or ornament. Certainly this may give us pleasure, though I myself find it boring, as it does not give me enough visual sensation. To transform three into two dimensions is for me an experience full of magic in which I glimpse for a moment that fourth dimension that my whole being is seeking.

I have always on principle been against the artist's speaking about himself or his work. Today neither vanity nor ambition causes me to talk about matters that generally are not to be expressed even to oneself. But the world is in such a catastrophic state and art is so bewildered that I, who have lived the last thirty years almost as a hermit, am forced to leave my snail's shell to express these few ideas which, with much labor, I have come to understand in the course of the years.

The greatest danger that threatens humanity is collectivism. Everywhere attempts are being made to lower the happiness and the way of living of mankind to the level of termites. I am against these attempts with all the strength of my being.

The individual representation of the object, treated sympathetically or antipathetically, is highly necessary and is an enrichment to the world of form. The elimination of the human relationship in artistic representation causes the vacuum which makes all of us suffer in various degrees—an individual alteration of the details of the object represented is necessary in order to display on the canvas the whole physical reality.

Human sympathy and understanding must be reinstated. There are many ways and means to achieve this. Light serves me to considerable extent on the one hand to divide the surface of the canvas, on the other to penetrate the object deeply.

As we still do not know what this self really is, this self in which you and I in our various ways are expressed, we must peer deeper and deeper into its discovery. For the self is the great veiled mystery of the world. Hume and Herbert Spencer studied its various conceptions but were not able in the end to discover the truth. I believe in it and in its eternal, immutable form. Its path is, in some strange and peculiar manner, our path. And for this reason I am immersed in the phenomenon of the Individual, the so-called whole Individual, and I try in every way to explain and present it. What are you? What am I? Those are the questions that constantly persecute and torment me and perhaps also play some part in my art.

Color, as the strange and magnificent expression of the inscrutable spectrum of Eternity, is beautiful and important to me as a painter; I use it to enrich the canvas and to probe more deeply into the object. Color also decided, to a certain extent, my spiritual outlook but it is subordinated to light and, above all, to the treatment of form. Too much emphasis on color at the expense of form and space would make a double manifestation of itself on the canvas, and this would verge on craft work. Pure colors and broken tones must be used together, because they are the complements of each other.

These, however, are all theories, and words are too insignificant to define the problems of art. My first unformed impression, and what I would like to achieve, I can perhaps realize only when I am impelled as in a vision.

One of my figures, perhaps one from *Temptation*, sang this strange song to me one night—

Fill up your mugs again with alcohol, and band up the largest of them to me . . . In ecstasy I'll light the great candles for you now in the night, in the deep black night.

We are playing hide-and-seek, we are playing hide-and-seek across a thousand seas, we gods . . . when the skies are red in the middle of the day, when the skies are red at night. You cannot see us, no you cannot see us but you are ourselves . . . That is what makes us laugh so gaily when the skies are red in the middle of the night, red in the blackest night.

Stars are our eyes and the nebulae our beards . . . We have people's souls for our hearts. We hide ourselves and you cannot see us, which is just what we want when the skies are red at midday, red in the blackest night.

Our torches stretch away without end . . . silver, glowing purple, violet, green-blue, and black. We bear them in our dance

122

over the seas and the mountains, across the boredom of life. We sleep and our brains circle in dull dreams . . . We wake and the planets assemble for the dance across bankers and fools, whores and duchesses.

Thus the figure from my *Temptation* sang to me for a long time, trying to escape from the square on the hypotenuse in order to achieve a particular constellation of the Hebrides, to the red giants and the central sun.

And then I awoke and yet continued to dream . . . Painting constantly appeared to me as the one and only possible achievement. I thought of my grand old friend Henri Rousseau, that Homer in the porter's lodge whose prehistoric dreams have sometimes brought me near the gods. I saluted him in my dream. Near him I saw William Blake, noble emanation of English genius. He waved friendly greetings to me like a super-terrestrial patriarch. "Have confidence in objects," he said. "Do not let yourself be intimidated by the horror of the world. Everything is ordered and right and must fulfill its destiny in order to attain perfection. Seek this path and you will attain from your own self ever deeper perception of the eternal beauty of creation; you will attain increasing release from all that which now seems to you sad or terrible."

I awoke and found myself in Holland in the midst of a boundless world turmoil. But my belief in the final release and absolution of all things, whether they please or torment, was newly strengthened. Peacefully I laid my head among the pillows . . . to sleep, and dream, again.

First read in German by Beckmann on July 21, 1938 on the occasion of the exhibition Twentieth Century German Art, *at* New Burlington Galleries, London. This text is from the English translation by Mathilde Q. Beckmann, first published in Robert L. Herbert, Modern Artists on Art *(Englewood Cliffs, N.J.: Prentice Hall, 1964), pp. 131–37. A typescript of the original German text is in the library of the Museum of Modern Art, New York.*

123

LETTERS TO A WOMAN PAINTER

Max Beckmann

I

To be sure it is an imperfect, not to say a foolish, undertaking to try to put into words ideas about art in general, because, whether you like it or not, every man is bound to speak for himself and for his own soul. Consequently, objectivity or fairness in discussing art is impossible. Moreover, there are certain definite ideas that may be expressed only by art. Otherwise, what would be the need for painting, poetry, or music? So in the last analysis, there remains only a faith, that belief in the individual personality which, with more or less energy or intelligence, puts forward its own convictions.

Now you maintain that you have this faith and you want to concentrate it upon my personality and you want to partake of my wisdom. Well, I must admit that at times you are really interested in painting and I cannot suppress a sort of feeling of contentment that you have this faith, even though

I am convinced that your really deep interest in art is not yet too much developed. For, sadly, I have often observed that fashion shows, bridge teas, tennis parties, and football games absorb a great deal of your interest and lead your attentions into idle ways. Be that as it may, you are pretty and attractive, which in a way is regrettable, for I am forced to say a few things to you that, frankly, make me a bit uncomfortable.

In the development of your taste you have already left behind certain things: those fall landscapes in brown and wine red, and those especially beautiful and edible still lifes of the old Dutch school no longer tempt you as they did before. Yes, as you have assured me, even those prismatic constructions, pictures of recent years, give you that sad feeling of boredom that you so much want to get rid of. And yet formerly you were so proud of understanding these things alone.

And now. What now? There you stand not knowing your way in or out. Abstract things bore you just as much as academic perfections, and ruefully you let your eyes fall on the violet red of your nail polish as if it were the last reality that remained to you! But in spite of it all, don't despair. There are still possibilities, even though they are at the moment somewhat hidden. I know very well that in the realm of pure concentration your greatest enemies are the evils of the big wide world: motor cars, photographs, movies—all those things that more or less consciously take away from people the belief in their own individuality and their transcendent possibilities and turn them into stereotyped humans.

However, as I have said, we need not give up the hope of searching and finding the way out of the dark circle of machine phantoms in order to arrive at a higher reality. You can see that what you need is difficult to express in words, for what you need are just the things that, in a sense, constitute the grace and gift for art. The important thing is first of all to have a real love for the visible world that lies outside ourselves as well as to know the deep secret of what goes on within ourselves. For the visible world in combination with our inner selves provides the realm where we may seek infinitely for the individuality of our own souls. In the best art this search has always existed. It has been, strictly speaking, a search for something abstract. And today it remains urgently necessary to express even more strongly one's own individuality. Every form of significant art from Bellini to Henri Rousseau has ultimately been abstract.

Remember that depth in space in a work of art (in sculpture, too, although the sculptor must work in a different medium) is always decisive. The essential meaning of space or volume is identical with individuality, or that which humanity calls God. For in the beginning there was space, that frightening and unthinkable invention of the Force of the Universe. Time is the invention of humanity; space or volume, the palace of the gods.

But we must not digress into metaphysics or philosophy. Only do not forget that the appearance of things in space is the gift of God, and if this is disregarded in composing new forms, then there is the danger of your work's being damned by weakness or foolishness, or at best it will result in mere ostentation or virtuosity. One must have the deepest respect for what the eye sees and for its representation on the area of the picture in height, width, and depth. We must observe what may be called the law of surface, and this law must never be broken by using the false technique of illusion. Perhaps then we can find ourselves, see ourselves in the work of art. Because ultimately, all seeking and aspiration end in finding yourself, your real self, of which your present self is only a weak reflection. There is no doubt that this is the ultimate, the most difficult exertion that we poor men can perform. So with all this work before you, your beauty culture and your devotion to the external pleasures of life must suffer. But take consolation in this: you still will have ample opportunity to experience agreeable and beautiful things, but these experiences will be more intense and alive if you yourself remain apart from the senseless tumult and bitter laughter of stereotyped humanity.

Some time ago we talked about intoxication with life. Certainly art is also an intoxication. Yet it is a disciplined intoxication. We also love the great oceans of lobsters and

oysters, virgin forests of champagne, and the poisonous splendor of the lascivious orchid.

But more of that in the next letter.

II

It is necessary for you, you who now draw near to the motley and tempting realm of art, it is very necessary that you also comprehend how close to danger you are. If you devote yourself to the ascetic life, if you renounce all worldly pleasures, all human things, you may, I suppose, attain a certain concentration: but for the same reason you may also dry up. Now on the other hand, if you plunge headlong into the arms of passion, you may just as easily burn yourself up! Art, love, and passion are very closely related because everything revolves more or less around knowledge and the enjoyment of beauty in one form or another. And intoxication is beautiful, is it not, my friend?

Have you not sometimes been with me in the deep hollow of the champagne glass where red lobsters crawl around and black waiters serve red rumbas which make the blood course through your veins as if to a wild dance? Where white dresses and black silk stockings nestle themselves close to the forms of young gods amid orchid blossoms and the clatter of tambourines? Have you never thought that in the hellish heat of intoxication amongst princes, harlots, and gangsters, *there* is the glamour of life? Or have not the wide seas on hot nights let you dream that we were glowing sparks on flying fish far above the sea and the stars? Splendid was your mask of black fire in which your long hair was burning—and you believed, at last, at last, that you held the young god in your arms who would deliver you from poverty and ardent desire?

Then came the other thing—the cold fire, the glory.

Never again, you said, never again shall my will be slave to another. Now I want to be alone, alone with myself and my will to power and to glory.

You have built yourself a house of ice crystals and you have wanted to forge three corners or four corners into a circle. But you cannot get rid of that little "point" that gnaws in your brain, that little "point" that means "the other one." Under the cold ice the passion still gnaws, that longing to be loved by another, even if it should be on a different plane from the hell of animal desire. The cold ice burns exactly like the hot fire. And uneasy you walk alone through your palace of ice. Because you still do not want to give up the world of delusion, that little "point" still burns within you— the other one! And for that reason you are an artist, my poor child! And on you go, walking in dreams like myself. But through all this we must also persevere, my friend. You dream of my own self in you, you mirror of my soul.

Perhaps we shall awake one day, alone or together. This we are forbidden to know. A cool wind beyond the other world will awake us in the dreamless universe, and then we shall see ourselves freed from the danger of the dark world, the glowing fields of sorrow at midnight. Then we are awake in the realm of atmospheres, and self-will and passion, art and delusion are sinking down like a curtain of gray fog . . . and light is shining behind an unknown gigantic gleam.

There, yes there, we shall perceive all, my friends, alone or together . . . who can know?

III

I must refer you to Cézanne again and again. He succeeded in creating an exalted Courbet, a mysterious Pissarro,

and finally a powerful new pictorial architecture in which he really became the last old master, or I might better say he became the first "new master" who stands synonymous with Piero della Francesca, Uccello, Grünewald, Orcagna, Titian, El Greco, Goya, and van Gogh. Or, looking at quite a different side, take the old magicians. Hieronymus Bosch, Rembrandt, and as a fantastic blossom from dry old England, William Blake, and you have quite a nice group of friends who can accompany you on your thorny way, the way of escape from human passion into the fantasy palace of art.

Don't forget nature, through which Cézanne, as he said, wanted to achieve the classical. Take long walks and take them often, and try your utmost to avoid the stultifying motor car which robs you of your vision, just as the movies do, or the numerous motley newspapers. Learn the forms of nature by heart so you can use them like the musical notes of a composition. That's what these forms are for. Nature is a wonderful chaos to be put into order and completed. Let others wander about, entangled and color-blind, in old geometry books or in problems of higher mathematics. We will enjoy ourselves with the forms that are given us: a human face, a hand, the breast of a woman or the body of a man, a glad or sorrowful expression, the infinite seas, the wild rocks, the melancholy language of the black trees in the snow, the wild strength of spring flowers, and the heavy lethargy of a hot summer day when Pan, our old friend, sleeps and the ghosts of midday whisper. This alone is enough to make us forget the grief of the world, or to give it form. In any case, the will to form carries in itself one part of the salvation you are seeking. The way is hard and the goal is unattainable; but it is a way.

Nothing is further from my mind than to suggest to you that you thoughtlessly imitate nature. The impression nature makes upon you in its every form must always become an expression of your own joy or grief, and consequently in your formation of it, it must contain that transformation that only then makes art a real abstraction.

But don't overstep the mark. Just as soon as you fail to be careful you get tired, and though you still want to create, you will slip off either into thoughtless imitation of nature, or into sterile abstractions that will hardly reach the level of decent decorative art.

Enough for today, my dear friend. I think much of you and your work and from my heart wish you power and strength to find and follow the good way. It is very hard with its pitfalls left and right. I know that. We are all tightrope walkers. With them it is the same as with artists, and so with all humanity. As the Chinese philosopher Lao-tse said, we have "the desire to achieve balance, and to *keep* it."

Written by Beckmann on an invitation to speak at Stephens College, Columbia, Missouri on February 3, 1948. Translated from German into English by Mathilde Q. Beckmann and Perry T. Rathbone, the text was read by Mathilde Q. Beckmann on that occasion. It was first published in English in College Art Journal *(fall 1949), pp. 39–43.*

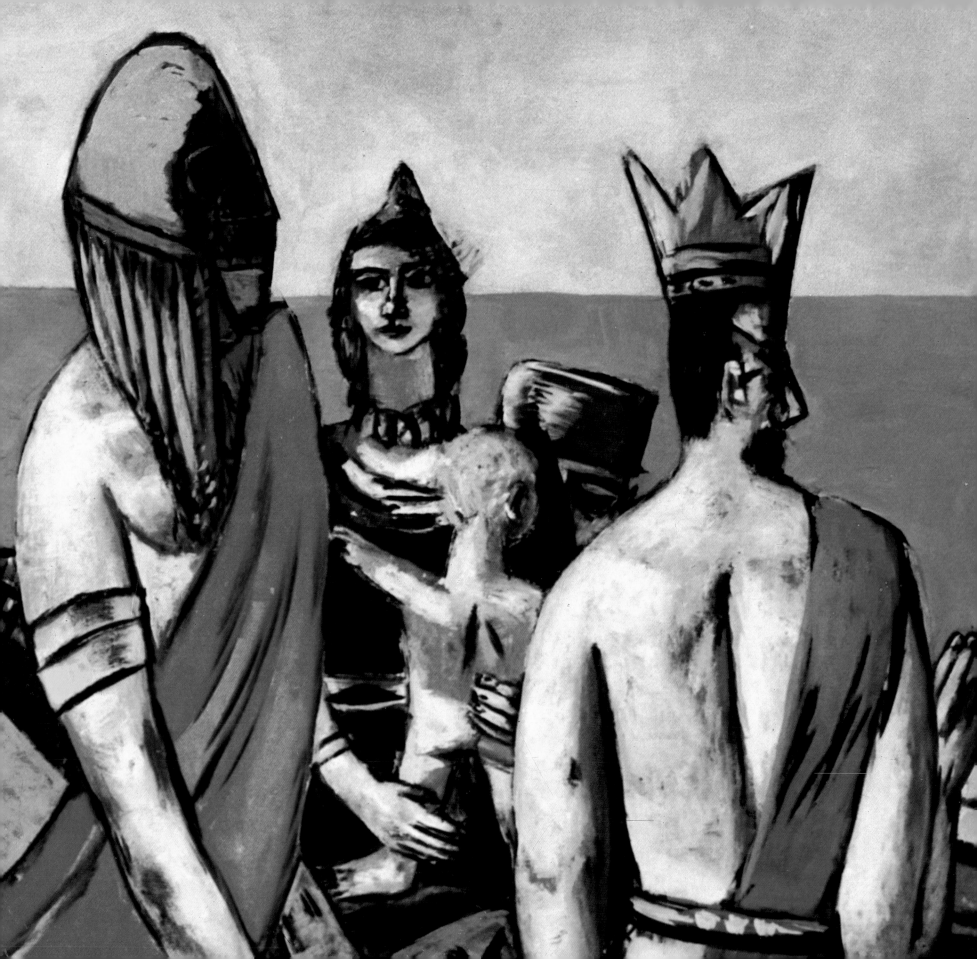

MAX BECKMANN'S *DEPARTURE*

Eric Fischl

At the time that I "discovered" Beckmann's *Departure*, in the mid-1970s, I was in a state of turmoil and discomfort over the abstract paintings that I was making. I had known Beckmann's work, mostly through reproduction, when I was still a student. Attracted as I was to his paint handling, there was such a prejudice against any kind of representation in painting that I virtually ignored him as a possible source of inspiration or as a way into narrative painting.

I visited the Museum of Modern Art on a day when I was feeling either relaxed enough or lost enough to stop in front of this great work and ask it a few questions. For me, *Departure*, like all of Beckmann's triptychs, seemed daunting. His iconography is both historical in a literary and eventful way, as well as personal almost to the point of being a private language. My fear was that I could never penetrate its content without first reading what he or others had to say about it. This I am loath to do, believing, as I do, that

painting is and should be a direct experience of audience to painting, as it is for the artist, painter to painting.

I begin today as I did then, with the left panel and with its central figure, which I described to myself as a sailor, perhaps a pirate. Why do I think that? The shirt—the purple- and black-striped shirt. It is a kind of uniform, neither military nor naval, but that of a sailor/fisherman/pirate. I think possibly pirate because of the way he wields that ax. It is malevolent. Ax? Yes, ax: like an executioner he is going to cut off the hands of the bound woman. He has already cut off one person's hands. The whole scene reeks of destruction and chaos. Ax? Wait. It is not an ax. It is a fishnet with a fish in it! How could this be? Were my associations wrong? Or has Beckmann painted images in such a way that they flip back and forth? Ambiguity reveals dualities of feelings as well as states of being. Here stands a man, executioner/fisherman/pirate/nurturer. I say nurturer

Detail from central panel of *Abfahrt* (*Departure*), cat. no. 3.

because the fisherman brings us fish to eat. Is Beckmann, by combining fishing with this violent scene, saying life feeds off death, literally?

And the woman? Tied and gagged, dressed like a whore, humiliated and offered up for sacrifice. Woman, the symbol of purity, mystery, innocence, and ruse. Beguiler and saint. Here stripped, not naked, but tarted up, debased as symbol and object of desire, object of love. Here, she is thrown over a large glass ball; her face peers into it. A glass ball? Not your usual butcher's block! A glass ball like a fortune-teller's. So, she still has powers! What does she see, this sorceress? The future? Underneath the ball is a newspaper: the front page of *Die Zeit.* "You want to know the future?" Beckmann is saying, "The future is on the front page of the newspaper. The future is what is happening today played out tomorrow!"

Why is our executioner/fisherman going to harm her? Cut off her hands, mutilate her? Is he going to kill the messenger? Beckmann had a thing about hands, and in this panel we see perhaps his most definitive and anguished statement. Hands: the first tool. What we clutch, what we release, what we build, what we destroy, and how we feel, literally and metaphorically, are expressed through the hands. So what we feel coming from this panel is a lot of anger and derision directed through the hands.

There's a guy, his back to us, waist-deep in a wine barrel filled with water (a liquid, anyway), hands tied behind his back—this guy ain't going nowhere. What an expression of impotence! There is the other man, gagged, bound to a pillar (representing cultural and male sexual power?), his hands already severed. And, of course, the woman who is about to lose hers.

In the midst of such violence, a still life, absurdly large. Its specific meaning eludes me. It is a quiet moment in this tempest of insanity. It is the only thing in this picture that doesn't need anything. Therefore, its experience must be purely aesthetic. The still life is an introspective, artistic reflection on the abstract problems of composition. Weights, balances, shapes on a flat plane and in space. Volumes, density, color, light—historically, the still life has been the humble expression of awesome metaphysical ambition. And here, Beckmann surrounds this still life with blinded eyes, gagged mouths, and mangled hands—all the tools required for the perception and expression of these values are damaged. This panel is a profound statement of outrage.

By contrast, the middle panel is the essence of calm and order, familial order. The nuclear family is here mythologized, elevated to metaphor, and given magical powers. It is the family of both royalty—king, queen, prince, and attendants—and holiness—Christ (the fisher king), the Madonna and child, and disciples. The father/king/Christ is fishing. That is to say, he is holding a fishnet, but in such a stunningly blasé way! His back is to us, to the sea, and to the fish he has captured. He stands counseling/comforting his family. Beckmann here is brilliant. If you look closely at how he has painted the fish, you will see that he has with paint created a double entendre. You cannot tell whether the fish are swimming into or out of the net. In doing this, he reinforces the reference to Christ, for the fish is the symbol of the soul and Christ is both the gatherer and releaser of the soul. So the middle panel appears to offer redemption from the chaos, violence, misery, humiliation, and disappointments that surround it.

There is in this panel, as there are in the other two pan-

els, elements that I cannot be sure about. Like the oversized beak of an exotic bird and what appears to be a mask from some exotic culture in the background of the left panel or the strange architecture of the right panel, there are some things in the boat that I just don't know what to make of. There is the man behind the mother/Madonna with what appears to be a pot on his head. A cooking pot! Why? There is also the soldier whose helmet shape makes him look very much like the large fish he is holding. What is that connection? There is also the fish itself. One could take a cynical approach to this scene by describing the king's handling of the little fish in the net as careless, rather than the way I described him above, in lofty, metaphysical terms, as the gatherer and releaser of souls. I have always felt that the calm of the middle panel is akin to the calm at the center of a storm, a very bad storm.

The right panel echoes the malevolence of the left panel, but also shows the resulting malaise. At the center is our family, no longer royal, no longer magical. The woman and man are eternally bound in a psychopathologically perverse interpretation of yin and yang. She is dressed in white and holds out a lamp, symbol of the muse, of wisdom and insight. She seems confident that she still knows the way, though I am not so sure. The upside-down man/lover/father is bound to her, and, judging from the wound on his back, is quite dead. "You always kill the one you love," Beckmann is reported to have said, and, judging from recent tabloid stories, he is probably correct. The offspring of this murderous love is, as you might expect, a dwarf homunculus, who tugs at his mother's hem. Next to them stands a messenger blinded by his hat, which has fallen over his eyes. He carries a fish, which he is perhaps trying to deliver. I think, here, the fish is no longer the mystical symbol it was in the middle panel but has become a sexual one. Perhaps the messenger awaits the answer to the question of what to do with sex after love has been destroyed.

As I said earlier, the architecture of this panel is a mystery. It is colonnaded and balustraded, arched and stairwayed. The main characters stand on what is possibly a stage. In the background are people going up and down on a stairway. Where are they going? And why during the performance? In the foreground, we find our king sporting an ill-fitting golfing cap and an ermine and velvet waistcoat. What? No long robe? He is carrying and beating a drum slung around his neck. Somewhere between a bellhop paging Philip Morris in a hotel lobby and a vendor hawking peanuts at a ballpark, our king is soliciting some kind of attention. Tucked between the straps and the drum skin is a newspaper that calls us back to the fortune-tellers in the left panel. Is that what our devoted king is doing? Pounding on the drum to get us to pay attention to the headlines?

There is no summary that can be made of this masterpiece. I have thought about it ever since I opened myself to it twenty years ago. It is not a moral tale. There are no lessons to be learned. Beckmann is not calling for a shift in course. You cannot change what comes as the result of what has been; a murderous love produces a corpse. *Departure* bears witness to this in human nature. The brilliance of Beckmann is the insight he achieved by overlapping and conflating the various structures and times, political, social, mythological, historical, religious, and familial, in which we, both culturally and individually, have placed our beliefs, desires, and needs. I can almost hear Beckmann saying, "Read it and weep."

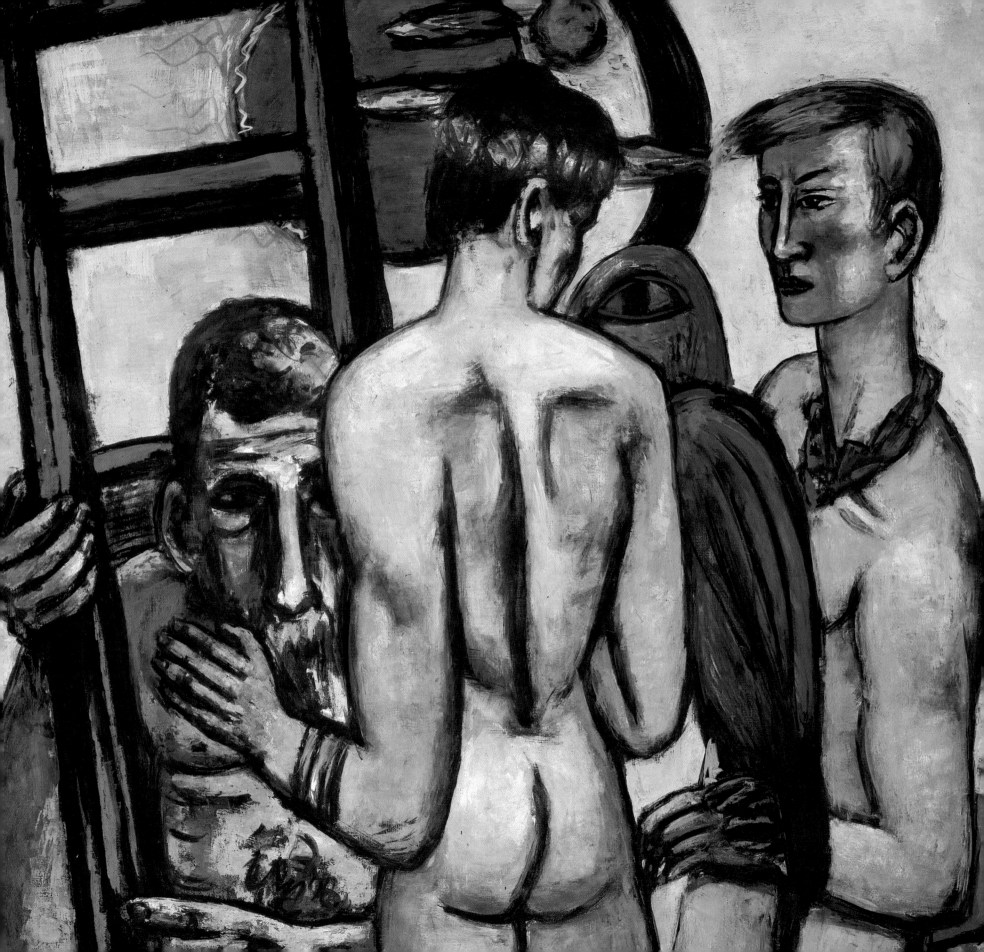

SELECT BIBLIOGRAPHY

Writings by the Artist

"Ansprache von Max Beckmann für die Freunde und die philosophische Fakultät der Washington University Saint Louis am 5. und 6. Juni 1950." In Mathilde Q. Beckmann. *Mein Leben mit Max Beckmann*. Munich: Piper, 1985, pp. 207–09.

"Drei Briefe an eine Malerin. Vortrag, gehalten am 3. Februar 1948 in Stephens College, Columbia, Missouri." In Mathilde Q. Beckmann. *Mein Leben mit Max Beckmann*. Munich: Piper, 1985, pp. 200–06. First published in English as "Letters to a Woman Painter." *College Art Journal* 9 (fall 1949), pp. 39–43. See also pp. 125–28 of this catalogue.

Max Beckmann Briefe. Ed. Klaus Gallwitz, Uwe M. Schneede, and Stephan von Wiese. 3 vols. Munich: Piper, 1993–.

Die Realität der Träume in den Bildern: Schriften und Gespräche 1911–1950. Ed. Rudolf Pillep. Munich: Piper, 1990.

"Speech Given by Max Beckmann to His First Class in the United States at Washington University, Saint Louis, 23rd September, 1947." In Mathilde Q. Beckmann. *Mein Leben mit Max Beckmann*. Munich: Piper, 1985, pp. 198–200.

Tagebücher 1940–1950. Ed. Mathilde Q. Beckmann and Erhard Göpel. Munich: Langen Müller, 1984.

"Über meine Malerei. Rede gehalten in der Ausstellung 'Twentieth Century German Art' in den New Burlington Galleries, London, 21. Juli 1938." In Mathilde Q. Beckmann. *Mein Leben mit Max Beckmann*. Munich: Piper, 1985, pp. 189–98. First published in English as "On My Painting." In Robert L. Herbert. *Modern Artists on Art* (Englewood Cliffs, N.J.: Prentice Hall, 1964), pp. 131–37. See also pp. 119–23 of this catalogue.

"Zwanzig Briefe von 1926–1950." In Doris Schmidt, ed. *Briefe an Günther Franke. Porträt eines deutschen Kunsthändlers*. Cologne: DuMont, 1970, pp. 41–44, 82–90.

Catalogue raisonnés

Gallwitz, Klaus. *Max Beckmann: Die Druckgraphik, Radierungen, Lithographien, Holzschnitte*. Karlsruhe: Badischer Kunstverein, 1962.

Göpel, Erhard, and Barbara Göpel. *Max Beckmann: Katalog der Gemälde*. Ed. Hans Martin von Erffa. 2 vols. Bern: Kornfeld und Cie, 1976.

Detail from central panel of *Argonauten* (*The Argonauts*), cat. no. 20.

Hofmaier, James. *Max Beckmann: Catalogue Raisonné of His Prints.* 2 vols. Bern: Galerie Kornfeld, 1990.

Max Beckmann: Aquarelle und Zeichnungen (exh. cat.). Ed. Ulrich Weisner and Klaus Gallwitz. Bielefeld: Kunsthalle Bielefeld, 1977.

Memoirs

Beckmann, Mathilde Q. *Mein Leben mit Max Beckmann.* Munich: Piper, 1985.

Beckmann, Peter, et al. *In Memoriam: Max Beckmann 12.2.1884–27.12.1950.* Frankfurt am Main: Lohse, 1953.

Göpel, Erhard. *Max Beckmann: Berichte eines Augenzeugen.* Ed. Barbara Göpel. Frankfurt am Main: Fischer Taschenbuch, 1984.

Lackner, Stephan. *Max Beckmann: Memories of a Friendship.* Coral Gables: University of Miami Press, 1969.

Piper, Reinhard. *Max Beckmann: Briefwechsel mit Autoren und Künstlern 1903–1953.* Munich: Piper, 1979.

Monographs and Critical Studies

Anderson, Eleanor C. "Max Beckmann's 'Carnival' Triptych." Master's thesis, State University of Iowa, 1973.

Beckmann, Peter. *Max Beckmann.* Nuremberg: Glock und Lutz, 1955.

——. *Max Beckmann: Leben und Werk.* Stuttgart: Belser, 1982.

——. *"Die Versuchung": Eine Interpretation des Triptychons Max Beckmann.* Nuremberg: Glock und Lutz, 1977.

——, ed. *Sichtbares und unsichtbares.* Introduction by Peter Selz. Stuttgart: Chr. Belser, 1965.

Belting, Hans. *Max Beckmann: Tradition as a Problem in Modern Art.* Trans. Peter Wortsman. Preface by Peter Selz. New York: Timken, 1989.

Bruegel, Eberhard. *Analyse und Interpretation: Max Beckmann, "Der Traum von Monte Carlo," 1939–1943.* Frankfurt am Main: ALS, 1985.

Buchheim, Lothar-Günther. *Max Beckmann.* Karlsruhe: Buchheim Verlag Feldafing, 1959.

——. *Max Beckmann: Eine Einführung.* Munich: Buchheim, 1960.

Buenger, Barbara C. "Max Beckmann's Artistic Sources: The Artist's Relation to Older and Modern Tradition." Ph.D. diss., Columbia University, 1979.

Busch, Günter. *Max Beckmann: Eine Einführung.* 2nd ed. Munich: Piper, 1989.

Dube, Wolf-Dieter. *Max Beckmann: Das Triptychon "Versuchung."* Munich: Hirmer, 1981.

Erffa, Hans Martin Frhr. von, and Erhard Göpel, eds. *Blick auf Beckmann: Dokumente und Vorträge.* Munich: Piper, 1962.

Erpel, Fritz. *Max Beckmann: Leben im Werk: Die Selbstbildnisse.* Berlin: C. H. Beck, 1985.

——. *Welt der Kunst: Max Beckmann.* East Berlin: Henschelverlag, 1981.

Fischer, Friedhelm W. *Der Maler Max Beckmann.* Cologne: DuMont, 1990.

——. *Max Beckmann.* Trans. P. S. Falla. New York: Phaidon, 1973.

Franzke, Andreas. *Max Beckmann: Skulpturen.* Munich: Piper, 1987.

Frosch, Beate. *Max Beckmann.* Berlin: Kulturstiftung der Länder, 1994.

Gohr, Siegfried, ed. *Max Beckmann: Symposium.* Cologne: Josef-Haubrich-Kunsthalle, 1987.

Göpel, Erhard. *Max Beckmann: Der Maler.* Munich: Piper, 1957.

——. *Max Beckmann: Der Zeichner.* Munich: Piper, 1954.

——. *Max Beckmann: Die Argonauten–Ein Triptychon.* Stuttgart: Reclam, 1957.

——. *Max Beckmann in seinen späten Jahren.* Munich: Langen Müller, 1955.

Gosebruch, Martin. *Mythos ohne Gotterwelt.* Esslingen: Stadt Esslingen, 1984.

Huneke, Andreas, ed. *Max Beckmann Colloquium 1984.* Leipzig: Verband Bildender Künstler der DDR, 1984.

Jatho, Heinz. *Max Beckmann: Schauspieler—Triptychon.* Frankfurt am Main: Insel, 1989.

Kaiser, Stephan. *Max Beckmann.* Stuttgart: Fink, 1962.

Kessler, Charles S. *Max Beckmann's Triptychs.* Cambridge, Mass.: Belknap, 1970.

Krieger, Heinz-Bruno. *Die Ahnen des Malers Max Beckmann.* Göttingen: Heinz Reise, 1959.

Lackner, Stephan. *Max Beckmann.* Bergisch-Gladbach: Bastei, 1968.

——. *Max Beckmann.* New York: Crown, 1990.

——. *Max Beckmann.* 2nd ed. New York: Harry N. Abrams, 1991.

——. *Max Beckmann: Die neun Triptychen.* Berlin: Safari, 1965.

——. *Max Beckmann 1884–1950.* Berlin: Safari, 1962.

Lekberg, Barbara. *Max Beckmann: The Triptychs.* Master's thesis, State University of Iowa, 1948.

Lenz, Christian. *Ewig wechselndes Welttheater.* Esslingen: Stadt Esslingen, 1984.

——. *Max Beckmann und Italien.* Frankfurt am Main: Deutsch-Italienische Vereinigung, 1976.

Maur, Karin von. *Max Beckmann: "Reise auf dem Fisch."* Berlin: Kulturstiftung der Länder, 1992.

Pillep, Rudolf. *Max Beckmann: Leben und Werk, neue Forschung.* Halle: Halle-Wittenberg Universität, 1992.

Poeschke, Joachim. *Max Beckmann in seinen Selbstbildnissen.* Esslingen: Stadt Esslingen, 1984.

Reifenberg, Benno, and Wilhelm Hausenstein. *Max Beckmann.* Munich: Piper, 1949.

Reimertz, Stephan. *Max Beckmann.* Hamburg: Rowohlt, 1995.

——. *Max Beckmann und Minna Tube: Eine Liebe im Porträt.* Berlin: Rowohlt, 1996.

Roh, Franz. *Max Beckmann als Maler.* Munich: Desch, 1946.

Schöne, Wolfgang. *Max Beckmann.* Berlin: Deutscher Kunstverlag, 1947.

Schubert, Dietrich. *Max Beckmann: Auferstehung und Erscheinung der Toten.* Worms: Werner, 1985.

Schulz-Hoffmann, Carla. *Max Beckmann: Der Maler.* Munich: Bruckmann, 1991.

Schwarz, Michael V. *Philippe Soupault über Max Beckmann.* Freiburg: Rombach, 1996.

Selz, Peter. *Max Beckmann: The Self-Portraits.* New York: Rizzoli, 1992.

Spieler, Reinhard. *Beckmann 1884–1950: The Path to Myth.* Cologne: Taschen, 1995.

Walden, Dagmar. *"Geburt" und "Tod": Max Beckmann in Amsterdamer Exil.* Worms: Werner, 1995.

Zenser, Hildegard. *Max Beckmann: Selbstbildnisse.* Munich: Schirmer/Mosel, 1984.

Zimmermann, Frederick. "Beckmann in America." Address delivered to the Max Beckmann Gesellschaft at Murnau on July 15, 1962. The Museum of Modern Art Library, New York. Mimeographed copy.

Exhibition Catalogues (chronological)
Exhibition of Recent Paintings by Max Beckmann. New York: Buchholz Gallery, 1938.

Max Beckmann. Bern: Kunsthalle Bern, 1938.

Exhibition of Twentieth Century German Art. London: New Burlington Galleries, 1938.

Max Beckmann: Recent Paintings. New York: Buchholz Gallery, 1939.

Max Beckmann: Paintings 1936–1939. New York: Buchholz Gallery, 1940.

Max Beckmann. Chicago: Arts Club, 1942.

Beckmann: Paintings Executed in the Netherlands from 1939 to 1945. New York: Buchholz Gallery, 1946.

The Actors by Beckmann. New York: Buchholz Gallery, 1946.

Max Beckmann: Oils. Philadelphia: The Philadelphia Art Alliance, 1947.

Max Beckmann: Paintings from 1940 to 1946. Buffalo: Fine Art Academy, Albright Art Gallery, 1947.

Beckmann. New York: Buchholz Gallery, 1947.

Max Beckmann 1948: Retrospective Exhibition. Saint Louis: City Art Museum, 1948.

Max Beckmann: Recent Works. New York: Buchholz Gallery, 1949.

Max Beckmann. New York: Buchholz Gallery, 1951.

Haus der Kunst. *Max Beckmann zum Gedächtnis 1884–1950.* Munich: Prestel, 1951.

German Expressionists and Max Beckmann from the Collection of Mr. and Mrs. Morton D. May. Chicago: Arts Club of Chicago, 1951.

Paul Klee, Max Beckmann. Hannover: Kestner-Gesellschaft, 1954.

Max Beckmann. New York: Curt Valentin Gallery, 1954.

Max Beckmann: Zeichnungen und Aquarelle aus den Jahren 1902–1950. Cologne: Theo Hill Galerie, 1955.

Max Beckmann. Santa Barbara: Santa Barbara Museum of Art, 1955.

Max Beckmann. New York: Catherine Viviano Gallery, 1955.

Kunsthaus Zürich. *Max Beckmann 1884–1950.* Zurich: Berichthaus Zurich, 1955.

Max Beckmann, 1884–1950. Wuppertal: Städtisches Museum, 1956.

Retrospective Exhibition of Portraits by Max Beckmann from 1925–1950. New York: Catherine Viviano Gallery, 1957.

Max Beckmann: Bilder, Zeichnungen, Pastelle, Aquarelle und Graphik (Sammlung Günther Franke). Cologne: Wallraf-Richartz-Museum, 1959.

Max Beckmann. Santa Barbara: University Art Gallery at the University of California, Santa Barbara, 1959.

The Eight Sculptures of Max Beckmann. New York: Catherine Viviano Gallery, 1959.

Paintings from the Collection of Mr. and Mrs. Morton D. May. Saint Louis: Washington University, 1960.

Max Beckmann: Exhibition of Paintings 1925–1950. New York: Catherine Viviano Gallery, 1962.

Max Beckmann: Das Porträt: Gemälde, Aquarelle, Zeichnungen. Karlsruhe: Badischer Kunstverein, 1963.

Max Beckmann: Bildnisse aus den Jahren 1905–1950. Munich: Günther Franke Galerie, 1964.

Max Beckmann: Retrospective, 200 Paintings, Drawings and Prints from 1905 to 1950. New York: The Museum of Modern Art, 1964.

Max Beckmann: An Exhibition of Paintings, Sculptures, Watercolors, and Drawings. New York: Catherine Viviano Gallery, 1964.

Tate Gallery. *Max Beckmann: Paintings, Drawings, and Graphic Work.* London: Arts Council of Great Britain, 1965.

Max Beckmann: Gemälde, Aquarelle, Zeichnungen. Hamburg: Kunstverein, 1965.

Kunsthalle Bremen. *Max Beckmann: Gemälde und Aquarelle der Sammlung Stephan Lackner, USA; Gemälde, Handzeichnungen und Druckgraphik aus dem Besitz der Kunsthalle Bremen.* Bremen: H. M. Hauschild, 1966.

Musée National d'Art Moderne, Paris. *Max Beckmann.* Paris: Réunion des Musées Nationaux, 1968.

Max Beckmann in America. New York: Catherine Viviano Gallery, 1969.

A Catalogue of Paintings Sculptures Drawings and Watercolors by Max Beckmann. New York: Catherine Viviano Gallery, 1973.

Marlborough Fine Art. *Max Beckmann: A Small Loan Retrospective of Paintings Centred around His Visit to London in 1938.* Uxbridge: The Hillingdon, 1974.

Kunsthalle Bielefeld. *Max Beckmann*. Ed. Ulrich Weisner and Rüdiger Jörn. Bielefeld: Kramer-Druck KG, 1975.

Max Beckmann. 180 Zeichnungen und Aquarelle aus deutschem und amerikanischem Besitz. Munich: Galerie Günther Franke, 1975.

Max Beckmann: Drawings, Sculpture. New York: Carus Gallery, 1975.

Max Beckmann: Graphik 1911–1946. Braunschweig: Kunstverein Braunschweig, 1976.

Kunsthalle Bielefeld. *Max Beckmann: Aquarelle und Zeichnungen 1903–1950*. Bielefeld: Kramer-Druck KG, 1977.

Der Zeichner und Graphiker Max Beckmann. Hamburg: Kunstverein, 1979.

Max Beckmann: The Triptychs. London: Whitechapel Art Gallery, 1981.

Max Beckmann: Paintings and Sculpture, Twenty-four Works from 1926–1950. New York: Grace Borgenicht Gallery, 1981.

Max Beckmann: Radierungen, Lithographien, Holzschnitte. Munich: Kunstgalerie Esslingen, 1981.

Max Beckmann: Grafik aus dem Kunstmuseum Hannover mit Sammlung Sprengel. Hannover: Städtische Galerie Nordhorn, 1981.

Max Beckmann. Fort Lauderdale: The Museum of Art, 1983.

Max Beckmann: Werke aus der Sammlung des Kunstmuseums Hannover mit Sammlung Sprengel. Hannover: Kunstmuseum Hannover, 1983.

Max Beckmann Graphik zum 100. Geburtstag. Esslingen: Galerie der Stadt, 1984.

Joseph-Haubrich-Kunsthalle, Cologne. *Max Beckmann*. Cologne: Wienand, 1984.

Max Beckmann: Graphik, Malerei, Zeichnungen. Leipzig: Museum der Bildenden Künste, 1984.

Max Beckmann: Paintings and Works on Paper. New York: Grace Borgenicht Gallery, 1984.

Haus der Kunst, Munich. *Max Beckmann: Retrospektive*. Munich. Prestel, 1984.

Max Beckmann, seine Themen, seine Zeit: Zum 100. Geburtstag des Kunstlers. Bremen: Kunsthalle Bremen, 1984.

Max Beckmann: Paintings and Drawings. New York: Grace Borgenicht Gallery, 1985.

Max Beckmann: Leipzig, 1884–New York, 1950. Montgomery, Ala.: Montgomery Museum of Fine Arts, 1987.

Städtische Galerie Albstadt. *Max Beckmann: Apokalypse*. Reutlingen: Oertel + Spörer, 1988.

Max Beckmann. Chicago: Worthington Gallery, 1989.

Museum der Bildenden Künste, Leipzig. *Max Beckmann: Gemälde 1905–1950*. Stuttgart: Gerd Hatje, 1990.

Städtische Galerie im Städel, Frankfurt am Main. *Hinter der Bühne Backstage: Max Beckmann 1950*. Stuttgart: Dr. Cantz'sche Druckerei, 1990.

Max Beckmann. Düsseldorf: Wolfgang Wittrock Kunsthandel, 1991.

Kunsthalle Hamburg. *Max Beckmann*. Stuttgart: Gerd Hatje, 1992.

Modern Art Museum of Fort Worth. *Max Beckmann: Prints from the Museum of Modern Art*. New York: Harry N. Abrams, 1992.

Kunsthalle Hamburg. *Max Beckmann: Selbstbildnisse*. Stuttgart: Gerd Hatje, 1993.

Max Beckmann, Welttheater: Das graphische Werk 1901–1946. Munich: Villa Stuck, 1993.

Max Beckmann: Gravures. Sable d'Olonne: Musée de l'Abbaye Sainte-Croix des Sables d'Olonne, 1994.

Michael Werner Gallery, New York. *Max Beckmann*. Bonn: Bildkunst, 1994.

Max Beckmann: Weltbild und Existenz. Albstadt: Städtische Galerie Albstadt, 1994.

Staatsgalerie Stuttgart. *Max Beckmann: Meisterwerke 1907–1950*. Stuttgart: Gerd Hatje, 1994.

Staatsgalerie Moderner Kunst, Munich. *Max Beckmann: Briefe an Reinhard Piper.* Ed. Christian Lenz. Munich: Kulturstiftung der Länder, Hypo-Kulturstiftung, 1994.

Galleria Nazionale d'Arte Moderna, Rome. *Max Beckmann.* Rome: Società Editrice Umberto Allemandi, 1996.

Articles

Amyx, Clifford. "Max Beckmann's Triptychs by C. S. Kessler." *Art Bulletin* 53 (Sept. 1971), pp. 426–27.

——. "Max Beckmann: The Iconography of the Triptychs." *Kenyon Review*, no. 13 (1951), pp. 613–23.

Anderson, Eleanor C. "Max Beckmann's 'Carnival' Triptych." *Art Journal* 24 (1965), pp. 218–25.

Ashton, Dore. "Max Beckmann: Strong Thinker, Plastic Stylist." *Studio* 169 (March 1965), pp. 138–39.

——. "New York Commentary." *Studio* 163 (April 1962), pp. 154–55.

Avgikos, Jan. "Max Beckmann (Larry Gagosian Gallery, New York)." *Art in America* 31, no. 12 (Dec. 1992), pp. 90–91.

Baker, Kenneth. "Max Beckmann Is Still in Exile." *Artforum* 23, no. 4 (Dec. 1984), pp. 48–51.

Barker, W. "The Prints of Max Beckmann." *Print Collectors Newsletter* 15 (Jan.–Feb. 1985), pp. 206–08.

Bauer, Gerd. "Braune Rindviecher: Eine Miszelle zu Max Beckmann." *Wallraf-Richartz-Jahrbuch* 52 (1991), pp. 331–32.

Berggruen, Heinz. "Beckmann Querschnitt durch das Schaffen eines deutschen Malers, der ins Exil ging." *Heute*, no. 18 (Aug. 15, 1946), pp. 20–23.

Bleyl, Matthius. "Max Beckmann (Kunstmuseum Hannover)." *Pantheon* 42, no. 2 (April–June 1984), p. 170.

Blondel, Madeline. "Le Cirque Beckmann." *Beaux Arts Magazine*, no. 127 (Oct. 1994), pp. 87–93.

Brach, Paul. "Beckmann on Beckmann." *Art in America* 81, no. 3 (March 1993), pp. 104–05.

Breeskin, Adelyn D. "Max Beckmann." *Baltimore Museum of Art News* 12, no. 2 (Nov. 1948), pp. 1–3.

Buenger, Barbara C. "Max Beckmann Ideologues: Some Forgotten Faces." *Art Bulletin* 71 (Sept. 1989), pp. 453–79.

——. "Max Beckmanns Amazonenschlacht: Tackling die grosse Idee." *Pantheon* 42, no. 2 (April–June 1984), pp. 140–50.

Burrows, Carlyle. "Beckmann Oils, Graphics Show Commanding Styles." *New York Herald Tribune*, Oct. 23, 1949.

Chaperogue, D. de. "Bilder von Max Beckmann die bisher noch nicht auf zeitgenössische Ereignisse bezogen sind." *Wallraf-Richartz-Jahrbuch* 53 (1992), pp. 209–22.

Chetham, Charles. "The Actors by Max Beckmann." *Annual Report, Harvard University, Fogg Art Museum* (1955/56), pp. 54–55, 62–64.

Clark, Margot. "The Max Beckmann Retrospective." *Art Journal* 44 (winter 1984), pp. 389–91.

Clurman, Harold. "Max Beckmann." *Tomorrow*, no. 7 (March 1948), p. 52.

Dube, Wolf-Dieter. "Anmerkungen zum Triptychon 'Versuchung' von Max Beckmann." *Pantheon* 38 (Oct.–Dec. 1980), pp. 393–97.

Evans, Arthur, and Catherine Evans. "Max Beckmann's Self-Portraits." *Art International* 18, no. 9 (Nov. 1974), pp. 13–21.

Feinstein, Sam. "Beckmann's Passionate Hardness." *Art Digest* 28, no. 9 (Feb. 1, 1954), pp. 14, 30.

Frommel, Wolfgang. "Max Beckmann: Die Argonauten, aus einem Brief." *Castrum peregrini*, no. 33 (1957/58), pp. 29–44.

Genauer, Emily. "Beckmann Exhibition at the Museum of Modern Art." *New York Herald Tribune*, Dec. 16, 1964.

——. "Triple Enigma. Max Beckmann's Seven-Foot Triptych 'Departure' Holds Many Meanings for Viewers at the Museum of Modern Art." *This Week*, Aug. 16, 1953, p. 12.

Gohr, Siegfried. "Max Beckmann und Frankreich." *Wallraf-Richartz-Jahrbuch* 47 (1986), pp. 45–62.

Göpel, Barbara. "Sammlung Reinhard Piper." *Pantheon* 39 (April–June 1981), pp. 195–97.

Göpel, Erhard. "Zirkusmotive und ihre Verwandlung im Werke Max Beckmanns: Anlässlich der Erwerbung des 'Apachentanzes' durch die Bremer Kunsthalle." *Die Kunst und das schöne Heim* 56 (June 1958), pp. 328–31.

Greenberg, Clement. [Max Beckmann]. *The Nation* 162 (May 18, 1946), pp. 610–11.

Heller, Reinhold. "Max Beckmann's Triptychs." *Art Quarterly* 34, no. 3 (fall 1971), pp. 365–66.

Hochfeld, Sylvia. "Max Beckmann (Lafayette Parke Gallery, New York)." *Art News* 92, no. 2 (Feb. 1993), p. 112.

Janson, H[orst] W[aldemar]. "Max Beckmann in America." *The Magazine of Art* 44, no. 3 (March 1951), pp. 89–92.

Joachim, Harold. "Blindman's Bluff, a Triptych by Max Beckmann." *Minneapolis Institute of Arts Bulletin* 47 (Jan.–March 1958), pp. 1–13.

Johnson, Ken. "Max Beckmann, Michael Werner Gallery, New York." *Art in America* 82, no. 7 (July 1994), pp. 92–93.

Kachur, Lewis. "The Formidable Passion of Max Beckmann's Painting." *Arts* 56, no. 3 (Nov. 1981), pp. 77–79.

Kessler, Charles. "Blindman's Bluff, a Triptych by Max Beckmann." *Gazette des Beaux Arts* 71 (Feb. 1968), pp. 127–28.

——. "Max Beckmann's Triptychs." *Arts* 39, no. 3 (Dec. 1964), pp. 44–53.

——. "Santa Barbara. Max Beckmann." *Arts* 34, no. 2 (Nov. 1959), p. 21.

Kiphoff, P. "Vom Ich zum Selbst: Max Beckmanns Selbstbildnisse." *Du*, no. 3 (1984), pp. 64–67.

Kramer, Hilton. "Another Look at Beckmann." *Art and Antiques* 17, no. 5 (May 1994), pp. 100–01.

——. "The Expressionist." *Art and Antiques* 19, no. 11 (Nov. 1992), pp. 80–81.

——. "The Place of Max Beckmann." *Arts* 39, no. 3 (Dec. 1964), pp. 30–36.

Kuspit, Donald. "Max Beckmann (Grace Borgenicht Gallery, New York)." *Artforum* 22, no. 11 (June 1984), p. 89.

Lackner, Stephan. "Bildnis des Bildnismalers Max Beckmann." *Kunstwerk* 17, no. 4 (Oct. 1963), pp. 25–26.

——. "Die Triptychen Max Beckmanns: Zum 10. Todestag des Malers." *Kunstwerk* 14, no. 5/6 (Nov. 1960), pp. 3–4.

Leinz, Gottlieb. "Max Beckmann (Josef-Haubrich-Kunsthalle, Cologne)." *Pantheon* 42 (July–Sept. 1984), pp. 276–78.

Louchheim, Aline B. "Beckmann Paints the Inner Reality." *New York Times*, June 13, 1948.

Martin, Kurt. "Max Beckmann: 'Persée.'" *Quadrum*, no. 5 (1958), pp. 76–77.

McCausland, Elisabeth. "Gallery Notes." *Parnassus* 10, no. 2 (July 1938), pp. 28–29.

——. "Max Beckmann." *Parnassus* 12, no. 1 (June 1940), p. 28.

Nefziger, U. "Max Beckmanns malerisches Dünkel." *Pantheon* 49 (1991), pp. 154–66.

Rainard, S. "Max Beckmann, Meisterwerke 1907–1950." *Burlington Magazine* 137 (April 1995), p. 269.

Rathbone, Perry T. "Max Beckmann 1884–1950." *Bulletin of the City Art Museum of Saint Louis* 35, no. 4 (1950), pp. 56–59.

——. "Max Beckmann in America." *Arts* 39, no. 3 (Dec. 1964), pp. 54–56.

Read, Helen Appleton. "Max Beckmann's Latest." *Magazine of Art* 31 (Feb. 1938), pp. 105–06.

Robbins, Eugenia S. "Max Beckmann (Museum of Modern Art)." *Art in America* 53, no. 2 (April 1965), p. 153.

Roh, Franz. "Der Maler Max Beckmann." *Prisma* 1, no. 2 (1946/47), pp. 1–11.

Roskill, Mark. "Split Worlds of Max Beckmann." *Art News* 63, no. 12 (Dec. 1964), pp. 46–48.

Seckler, Dorothy. "Can Painting Be Taught? Beckmann's Answer." *Art News* 50, no. 3 (March 1951), pp. 39–40.

Seldis, Henry J. "A Personal Collection of Beckmann." *Art Digest* 29, no. 15 (May 1, 1955), pp. 12–13.

Smith, A. Llewellyn. "Brief aus London (Max Beckmanns Tryptichen, Whitechapel Art Gallery, London)." *Kunstwerk* 34, no. 2 (1982), p. 66.

Stachelhaus, Heiner. "Max Beckmann (Haus der Kunst, Munich)." *Kunstwerk* 37, no. 3 (June 1984), pp. 87–88.

Tannenbaum, Libby. "Beckmann. Saint Louis Adopts the International Expressionist." *Art News* 47, no. 3 (May 1948), pp. 20–22.

Thesing, Susannne. "Max Beckmann Retrospektiv." *Pantheon* 42 (July–Sept. 1984), pp. 280–81.

Twohig, Sarah O'Brien. "Max Beckmann (Museum Bildende Kunst, Leipzig)." *Burlington Magazine* 132 (Dec. 1990), pp. 895–97.

——. "Max Beckmann (Whitechapel Art Gallery, London)." *Burlington Magazine* 123, no. 934 (Jan. 1981), pp. 48–49.

Werner, Alfred. "Max Beckmann: The Life." *Arts* 39, no. 3 (Dec. 1964), pp. 26–29.

Wilkin, Karen. "A Long-Smoldering Rage." *Art News* 94, no. 5 (May 1995), p. 120.

Winter, Peter. "Max Beckmann: Aquarelle und Zeichnungen 1903–1950 (Kunsthalle Bielefeld)." *Pantheon* 36, no. 1 (Jan. 1978), pp. 71–72.